THE LIBRARY OF AMERICAN ART

GEORGE CALEB BINGHAM

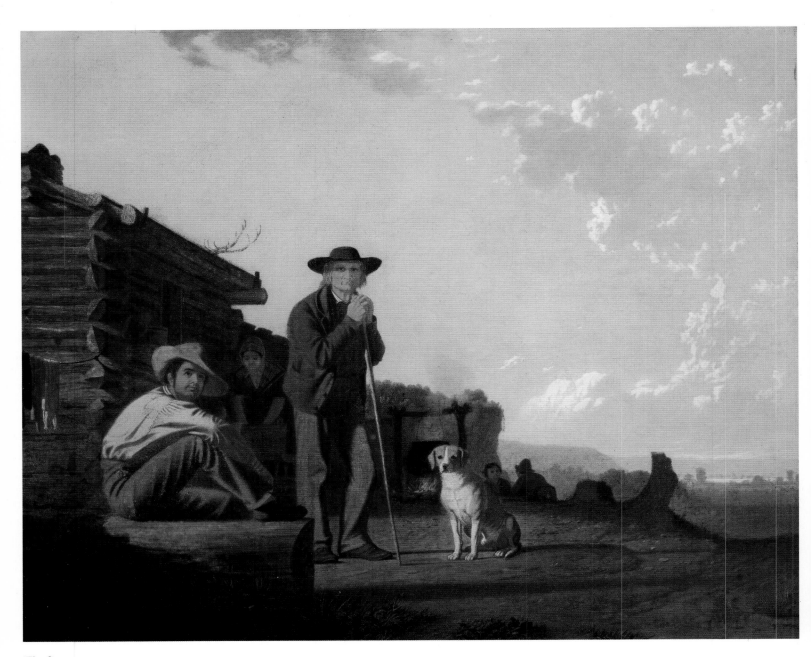

The Squatters

George Caleb Bingham

MICHAEL EDWARD SHAPIRO

Harry N. Abrams, Inc., Publishers

IN ASSOCIATION WITH

The National Museum of American Art, Smithsonian Institution

For my mother and my sister

Series Director: Margaret L. Kaplan
Editor: Margaret Donovan
Assistant Editor: María Teresa Vicens
Designer: Ellen Nygaard Ford
Photo Research: Lauren Boucher

Library of Congress Cataloging-in-Publication Data

Shapiro, Michael Edward.
 George Caleb Bingham / Michael Edward Shapiro.
 p. cm.—(The Library of American art)
 "In association with the National Museum of American Art,
 Smithsonian Institution."
 Includes bibliographical references and index.
 ISBN 0-8109-3121-4
 1. Bingham, George Caleb. 1811-1879—Criticism and
 interpretation. 2. West (U.S.) in art. I. National Museum of
 American Art (U.S.) II. Title. III. Series.
N6537.B53S48 1993
759.13—dc20 92-14936
 CIP

Frontispiece:
The Squatters.
1850. Oil on canvas, 23 x 30".
Bequest of Henry L. Shattuck
in memory of the late Ralph W. Gray.
Courtesy, Museum of Fine Arts, Boston

Published in 1993 by Harry N. Abrams, Incorporated, New York
A Times Mirror Company

Printed and bound in Japan

Contents

Acknowledgments

One of my first thoughts in coming to the Saint Louis Art Museum as Curator of 19th and 20th Century Art in the late spring of 1984 concerned the obligations and opportunities implicit in caring for the most important public collection of paintings by George Caleb Bingham. It did not take much time to realize that Bingham's work was "known," in that most of his major paintings had been located and catalogued, but that the man himself, his paintings, and his drawings remained in a sense unknown, in that they were on the brink of a new wave of contextual inquiry and interpretation. In the intervening eight years, some of those new studies have been completed, while others, such as a new look at the artist's drawings, remain to be done.

My first opportunity to participate in this fresh look at Bingham was organizing the 1990 retrospective exhibition of his work, which was held at the Saint Louis Art Museum and the National Gallery of Art. That effort built upon the achievements of many scholars, most notably the late E. Maurice Bloch. The present volume provided me with the unusual opportunity of writing an overview of the artist's life and work after I had had the benefit of organizing a retrospective exhibition.

This book has had a lengthy genesis. The subject was suggested to me by Margaret Kaplan, Senior Vice-President and Executive Editor at Abrams, as far back as 1986. In the summer of 1987, I was fortunate to spend three weeks immersing myself in the existing literature at the National Humanities Center in Research Triangle Park, North Carolina. When the plan to organize a major exhibition of Bingham's paintings and drawings began to take shape, the book project, though relatively far advanced, was put aside. It was taken up again after the 1990 exhibition was past. The manuscript that became this book was initially edited by Carey Lovelace and subsequently by Margaret Donovan and María Teresa Vicens. Photographs were expertly collected by Lauren Boucher, and the book was ably designed by Ellen Nygaard Ford. I was helped in the preparation of the manuscript by many people, most notably and efficiently by my assistant, Barbara Lieberman. Others who have assisted with research and manuscript preparation include Kathleen Heins, Dennis Henson, and Traci Sanders. The members of the publications department at the Saint Louis Art Museum, especially

Mary Ann Steiner and Patricia Woods, were always helpful on matters pertaining to Bingham.

At the National Museum of American Art, Elizabeth Broun, Director, and William Truettner, Curator of Painting and Sculpture, consistently provided constructive suggestions on the manuscript. It has been a pleasure to be associated once again with their museum.

To the many owners, both public and private, of Bingham's works, I extend my thanks for their kindness in letting us illustrate their holdings in this book. I am particularly grateful to those other Missouri institutions who, in addition to the Saint Louis Art Museum, have over the decades remained faithful and dedicated to preserving and illuminating the memory and works of Bingham, an adopted "native son" of the state. I think especially of the Nelson-Atkins Museum of Art in Kansas City; the State Historical Society in Columbia; and The Mercantile Library, The Missouri Historical Society, and The Bingham Trust, all in Saint Louis.

MICHAEL EDWARD SHAPIRO

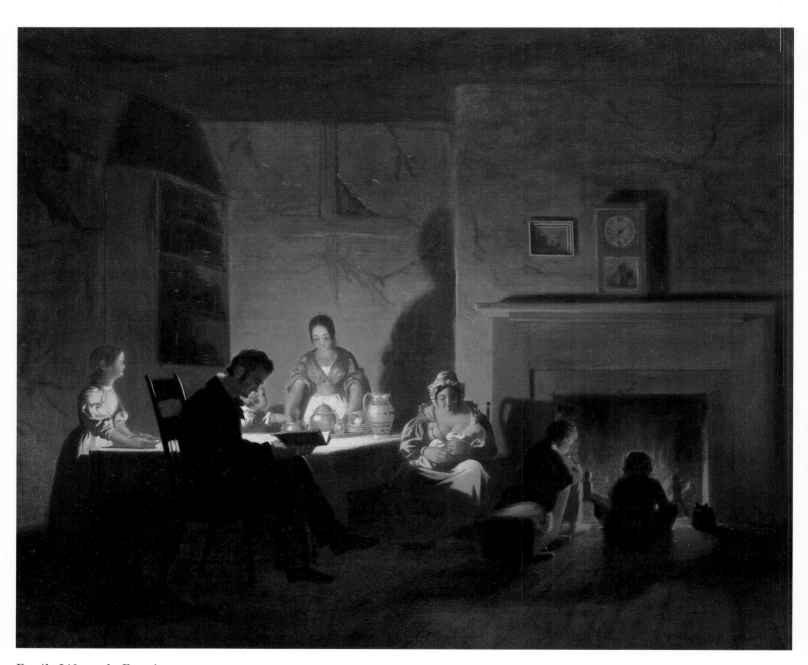

Family Life on the Frontier

I. Becoming a "Western 'Meteor of the Art'"

WHILE GEORGE CALEB BINGHAM IS CLAIMED BY the people of Missouri as a favorite son, he was actually born in Augusta County, Virginia, on March 20, 1811, the second of six children. His paternal grandfather, a Methodist minister from New England, had migrated south at the end of the Revolutionary War and had settled on a farm about eighteen miles west of Charlottesville. The Bingham farm was near the sawmill and gristmill of a widower, Matthias Amend, and his only daughter, Mary. It is said that in bringing grain to that mill, the artist's father, Henry Vest Bingham, met and began to court the miller's daughter. After Henry and Mary wed, in 1808, Henry took over the management of his father-in-law's property. George Caleb Bingham would later write that the mill's "revolving wheels were the earliest wonder upon which my eyes opened."

Financial reverses precipitated the sale of the family property, and in 1818, Henry Bingham took a preparatory journey west to the Missouri Territory. He returned to Virginia to gather his wife, father-in-law, and the eight-year-old George and his three brothers and two sisters. They left Virginia for the frontier town of Franklin, Missouri, during the summer of 1819, the year that the first steamer ascended the Missouri River and just two years before the state entered the Union.

The family's journey west was a formative event for George Caleb Bingham; it continued to echo through his mind, ultimately being transformed for him into an act that mirrored the nation's destiny. More than three decades later, for instance, in 1851, he painted a scene of westward migration in *The Emigration of Daniel Boone*. This painting, which Bingham later had produced and distributed as a print, depicts the stolid march of a national hero, the Columbus of the Woods, through the wilderness of the Cumberland Gap.

At the time of the Bingham family's arrival in Franklin, the town was described, in a contemporary account of a Western expedition, as consisting of "about one hundred and twenty log houses of one story, several framed dwellings of two stories, and two of brick, thirteen shops . . . , four taverns . . . , two billiard rooms, a court house, a log prison of two

Family Life on the Frontier
Before 1845. Oil on canvas, 23¼ x 30"
Private collection

In this painting of wholesome rustic life, Bingham seems to be recalling his own childhood in Franklin and Arrow Rock, Missouri. While the father reads and the two boys gaze at the embers of the fire, the eldest daughter helps set the table for the evening meal. In Bingham's view, the frontier family and its domestic values were stabilizing forces in the West.

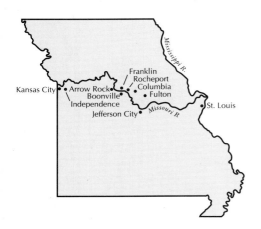

Missouri, c. 1820

The towns, cities, and rivers of Missouri constituted the core of George Caleb Bingham's world. From his early years in Franklin, Arrow Rock, and other river towns to his visits to Saint Louis, Columbia, and Jefferson City and his residence in Independence and Kansas City, he spent much of his life within the boundaries of the state.

stories, a post office, and a printing press issuing a weekly paper." The westernmost American settlement in the Missouri Territory, Franklin was the point of the wedge of settlement that was rapidly moving up the Missouri River. By 1820, with a population of 1,200 to 1,500, it was second only to Saint Louis in size.

Franklin's single most important attribute was its location adjacent to the Missouri River. Bingham literally grew up along the banks of the river, which gave its name to the state and which flows across it like a life-giving artery before merging with the Mississippi a few miles above Saint Louis. He grew up observing the fur traders, flatboatmen, and fishermen who later provided the subjects for his most accomplished paintings. The river was the reason for the existence of the trading community of Franklin and of the other river towns dispersed at intervals west of Saint Louis. This was Bingham's world. The imprint of the river upon the boy and upon the man cannot be overestimated. His finest genre paintings are wedded to his memory of his own journey west and his early experiences along the river's edge.

In 1820, Henry Bingham opened a tavern in Franklin. The following year, he purchased a 120-acre farm near Arrow Rock, a village about fifteen miles north of Franklin on the west bank of the Missouri River, in nearby Saline County. While the family lived in Franklin, Henry Bingham started to raise tobacco on the farm. Tobacco emerged as a staple crop for the area, and the elder Bingham established a business in Franklin that manufactured cigars sold primarily in Saint Louis. The flavor of Bingham's youthful life in Franklin can be felt in such later paintings as *Family Life on the Frontier* (before 1845), which seems a recollection of the Bingham family's life shortly after they had emigrated from Virginia. Inside a rustic cottage (similar to those whose exteriors are seen in other paintings), we see a father, his head outlined by a hidden light source, reading a book. His eldest daughter helps set the table, while his wife suckles a baby, and two young boys and a cat warm themselves before a fire. When he arrived in Missouri, Bingham had been about the same age as the boys in this painting.

The experience of Bingham's family typified the course of America's Western expansion, and the artist later returned to this experience as he searched for American themes and elevated his personal experience to a broader sphere. Yet, it should be understood that the term *frontier* is something of a misnomer for the region of central Missouri in the 1820s. By that time, a number of educated and prosperous Kentuckians, Tennesseans, and Virginians had participated in the migration to this area. In fact, many a fellow native Virginian became a "Missouri" portrait subject for Bingham in subsequent years.

A "WESTERN 'METEOR OF THE ART'"

A year after he moved to Franklin, an event took place that imprinted itself on George Bingham's memory and redirected his future ambitions. At the age of nine, during the summer of 1820, he had the opportunity to observe a well-known itinerant portrait painter, Chester Harding, at work on a portrait of Daniel Boone. Boone had emigrated from Kentucky to the Missouri Territory in 1798 or 1799. He was living out his old age near Femme Osage Creek, a tributary of the Missouri located between Franklin and Saint Louis. After finishing an initial sketch of Boone from life, Harding traveled to Franklin, where he painted at least two portraits of the frontiersman. These have not been located, but a contemporary print records their appearance. A recently discovered letter written by Bingham in 1872 recounts how he watched Harding complete his portraits and how he briefly served as Harding's studio assistant. Bingham noted, "I was at that time a lad ten years old and daily assisted in Harding's studio, and the wonder and delight with which his works filled my mind impressed them indelibly upon my then unburthened memory."

Watching Harding complete the likeness of the legendary Western hero was Bingham's first artistic experience, and he never forgot it. His image of Boone as a symbol of the settlement of the West and his youthful view of an artist as a recorder of historical facts and symbols stayed with Bingham for the next fifty years. When he turned to painting ten years later, his first work, a signboard for a hotel in nearby Boonville (unlocated, 1828–30), was an image of Boone. Both Bingham's signboard and his ambitious portrait of Leonidas Wetmore (1839–40) are similar in composition to the print of Boone based on Harding's painting. Bingham's letters attest that when he later traveled to Philadelphia, it was, among other things, to study Harding's portraits; near the end of his life, he retained in his personal possession an early portrait by Harding. Bingham's youthful encounter with Harding, and collaterally with his image of Daniel Boone, helped give the younger artist the idea of recording the faces of the members of his community. To become a portrait painter and to make ends meet, Bingham, like Harding and countless other American artists, would have to travel from small town to small town, painting likenesses as he went.

His formative experience with Chester Harding might have led Bingham to a portrait career at a very early age had not his father's untimely death in 1823, at the age of thirty-eight, brought financial difficulties upon the family. These setbacks, compounded by the Missouri's overflowing of its banks in 1825, led the widow and children to move from Franklin to their farm near Arrow Rock. Young George set aside thoughts of painting to assist in supporting the family. He worked on the

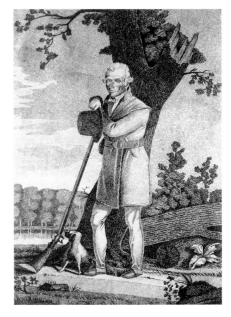

James Otto Lewis, after Chester Harding, *Daniel Boone*

1820. Stipple engraving, 11¾ x 8⅛" (sheet size) The Saint Louis Art Museum. Purchase

In 1820, at the age of nine, Bingham saw Chester Harding complete a portrait of Daniel Boone. Bingham later wrote that the "wonder and delight with which his [Harding's] works filled my mind impressed them indelibly upon my . . . memory." Bingham's first painting is thought to have been a standing figure of Boone, a subject to which he later returned.

farm and, at the age of seventeen, was apprenticed to a cabinetmaker in Arrow Rock who doubled as a Methodist minister. His second apprenticeship, from 1828 to 1832, was also to a cabinetmaker, in Boonville, just across the river.

During his time in Boonville, Bingham observed another—as yet unidentified—itinerant portrait painter at work. This second artistic experience reawakened his desire to follow the path that his experience with Harding had suggested. A later biographical statement based on information provided by the artist reported that "with such colors as a house-painter's shop could supply, and a half dozen stumps of brushes left by a transient artist in a neighboring town, he commenced his career as a portrait painter."

The portraits Bingham had observed being made served as his first models. The only other examples of art that he had had the opportunity to see—illustrations appearing in books and journals—were also influential. Since these were always in black and white, his sense of line and form, rather than color, developed first. Like the seventeenth- and eighteenth-century portrait painters of New England, Bingham began in the tradition of the limners. These untutored American artists attempted to record the appearance of their subjects in a factual manner rather than to interpret it in any way. They often based the frontal poses of their subjects on images of paintings seen in print sources. Like the limners, Bingham began to paint by concentrating on the factuality of the face before him. The shoulders, arms, and hands of the sitters, as well as the backgrounds against which they were placed, were beyond his abilities of depiction, and thus the early faces hover and float like pale oval balloons against the dark backgrounds. A more humble beginning cannot be imagined for the remarkable intellectual and artistic journey that Bingham was to take.

Though he had probably decided on his future course by the age of twenty-one, while apprenticed in Arrow Rock, Bingham did not immediately set out in search of portrait commissions. He first painted portraits (unlocated) of four young men in the town. His earliest surviving portraits were also painted there two years later, in 1834. These first portraits have an elemental force and directness and a haunting, masklike power that convey the intensity of Bingham's passionate artistic commitment. The pair of portraits of Dr. and Mrs. John Sappington (1834), two of Arrow Rock's most distinguished citizens, characterize his earliest format. Dr. Sappington, who promoted the use of quinine for the treatment of malaria, manufactured his own brand of quinine-based Anti-Fever Pills and was later to become well known for his book *The Theory and Treatment of Fevers* (1844).

Charles Bird King, *The Itinerant Artist*

c. 1825–30. Oil on canvas, 44¾ x 57″
New York State Historical Association,
Cooperstown

Bingham's contact with two itinerant portrait painters, in 1820 and 1828, inspired him to follow in their footsteps. In an age before photography, itinerant painters moved frequently from town to town, recording images of families in their homes.

Both portraits of the Sappingtons are three-quarter profile views in which the head emerges from a dark background. The features, sharply painted and clearly illuminated, contrast with the otherwise undifferentiated backgrounds. The light that falls on the edge of Mrs. Sappington's shoulders defines a shape but does not suggest the surface and form of a flesh-and-blood person, dressed in her Sunday best. The enormity of the challenge Bingham set out for himself, and what he later achieved in technical ability, becomes clearer if we look at the second portrait set of Dr. and Mrs. Sappington, executed about 1844–45. The later portraits—with their greater three-dimensionality, their more skilled handling of light and shade, and their more accurate depiction of anatomy—indicate the artist's decade-long improvement as a painter. Yet, while these later works are more smoothly executed, nowhere else in Bingham's career would his artistic ambitions be so directly, or indeed so boldly, stated as in the faces of the early portraits.

Bingham eventually exhausted the portrait possibilities among the village gentry in Arrow Rock, and he moved in 1834 to Columbia, Missouri, an increasingly important regional community with substantial potential for portrait commissions. As an entrepreneur looking for busi-

Following pages:

Dr. John Sappington

1834. Oil on canvas, 27 x 21¾″
Missouri Department of Natural Resources

A doctor who promoted the use of quinine for malaria, Sappington was living in Franklin, Missouri, the year Bingham's family arrived there. The doctor and his family subsequently moved to Arrow Rock in Saline County, Missouri, as did Bingham and his family in 1823.

Jane Breathitt Sappington (Mrs. John Sappington)

1834. Oil on canvas, 27 x 21¾″
Missouri Department of Natural Resources

Dr. Sappington *and* Mrs. Sappington *are the only two portraits in which Bingham inscribed the ages of the sitters. A dozen years after this set of portraits was painted, one of the Sappingtons' sons, Erasmus Darwin Sappington, defeated Bingham in a bitterly contested election for the Missouri legislature.*

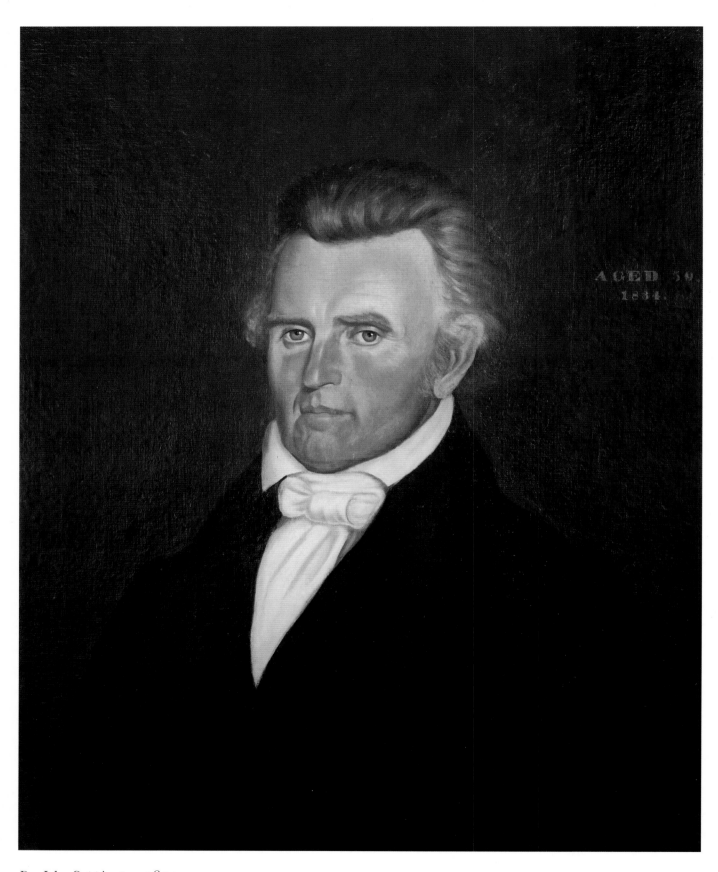

AGED 59.
1834.

Dr. John Sappington, 1834

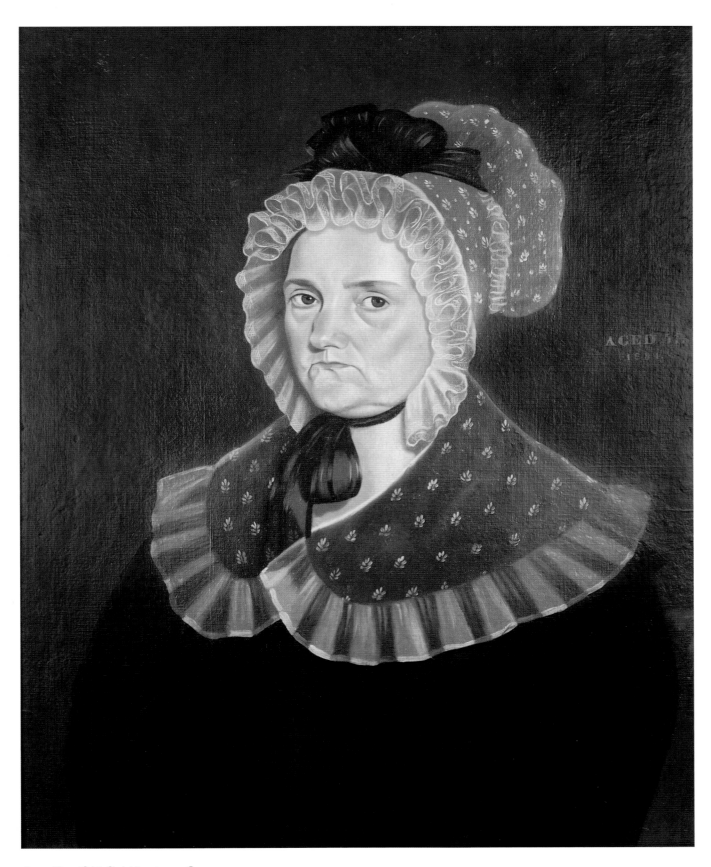

Jane Breathitt Sappington, 1834

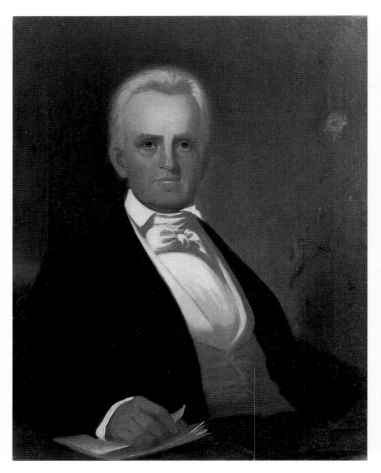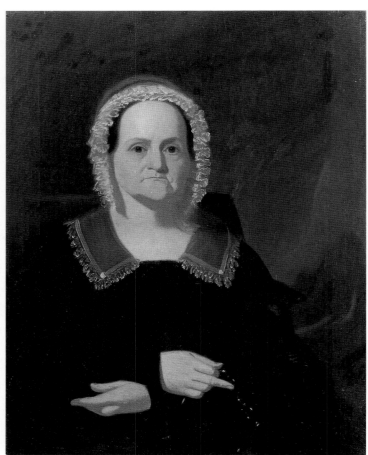

Dr. John Sappington

c. 1844–45. Oil on canvas, 36 ⅜ x 28 ⅜"
Lent by Mrs. Joshua Motter Hall and the late
Mr. Joshua Motter Hall to the Nelson-Atkins
Museum of Art, Kansas City, Missouri

When Bingham again painted the Sappingtons, his greater skillfulness allowed him to depict them frontally. While the softness of Dr. Sappington's skin, the sense of light falling upon his face, the fluent brushwork, and his more relaxed demeanor point to Bingham's advances as an artist, the earlier portraits retain a magical power.

Jane Breathitt Sappington (Mrs. John Sappington)

c. 1844–45. Oil on canvas, 36½ x 28⅜"
Lent by Mrs. Joshua Motter Hall and the late
Mr. Joshua Motter Hall to the Nelson-Atkins
Museum of Art, Kansas City, Missouri

Mrs. Sappington again appears in a bonnet and a sheer collar, though she now holds a pair of glasses.

ness wherever he might find it, Bingham conscientiously exploited his connections with the regional elite in central Missouri. Deciding to become a painter was, however, much easier than actually learning how to paint, and Bingham's first portraits were made without having seen many paintings or met many painters.

Among his earliest commissions in Columbia was a portrait of James Sidney Rollins, the man Bingham would be closest to for the rest of his life. The affinity the two men had for each other is apparent in this 1834 portrait, which seems more relaxed than others from Bingham's early career. The light of personal feeling for the sitter as well as the artist's concentration on his task shine through the stiffness of the portrait.

A young, Kentucky-born lawyer with a powerful personality, Rollins worked in the building in which Bingham had his studio. The two young men met in 1834 and established an immediate bond. Within two years, Rollins had become the editor of the *Columbia Patriot*, a local newspaper; in 1838, he was elected to the Missouri legislature. Eventually, Rollins would be so deeply a part of Bingham's life that we know far more about their friendship than about Bingham's relations with anyone else. He was Bingham's financial backer, his closest adviser and confidant, and the

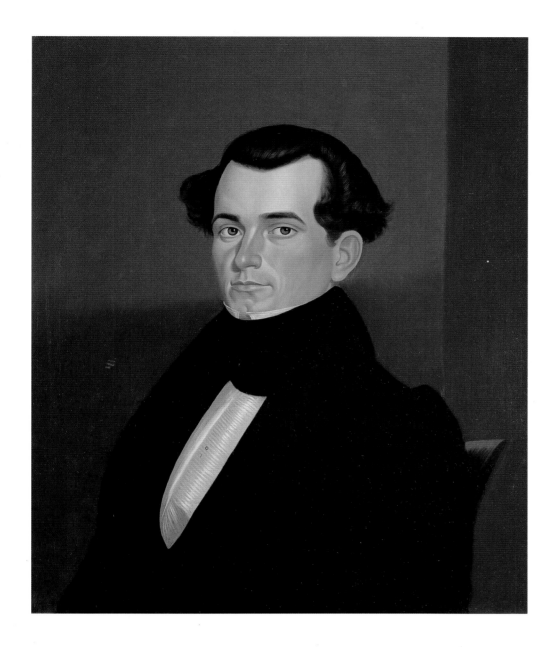

Major James Sidney Rollins
1834. Oil on canvas, 28 x 23″
Private collection

The twenty-two-year-old, Kentucky-born lawyer whom Bingham met in Columbia, Missouri, in 1834 became his closest friend and mentor. He assisted and supported the artist's career until Bingham's death in 1879, and he nurtured the artist's taste for politics and for the Whig party.

person who helped make Whig politics an important part of Bingham's life and work.

In her essay in the 1990 Bingham exhibition catalogue, Barbara Groseclose noted that, in 1834—the year Rollins and Bingham met—the Whig party, which "began as splinter groups . . . and Democrats disaffected by Andrew Jackson's stand on currency . . . [coalesced] to form a political organization to field candidates opposing Democrats on all levels of government. . . . The distinguished and unifying feature of the Whig party can be summed up as anti-Jacksonian." It was Rollins who involved Bingham when the Whig party was organized in Missouri in 1839, and it was Rollins who promoted the commissioning and sale of Bingham's paintings and prints. Rollins became a four-time state repre-

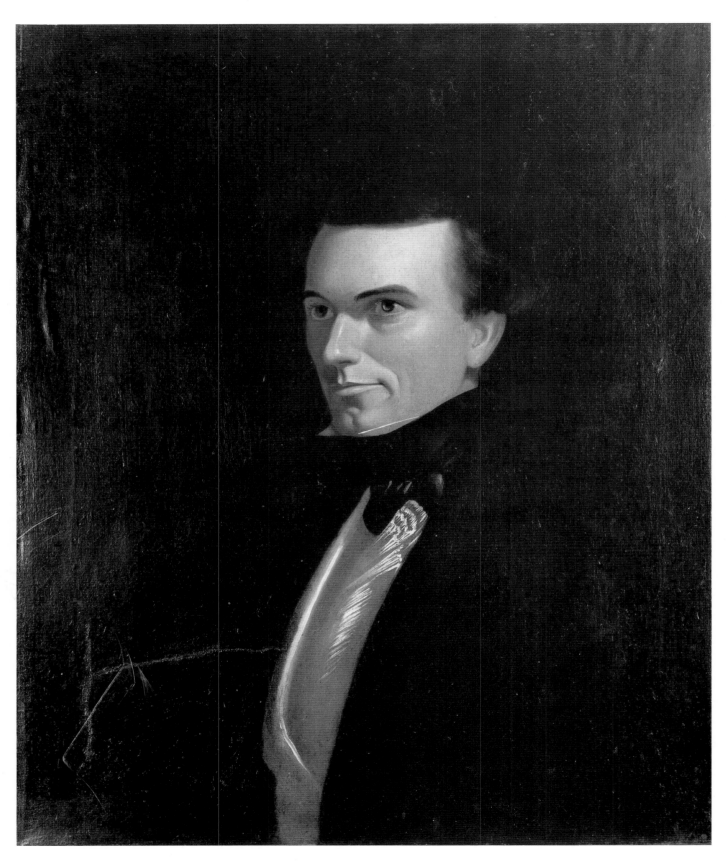

Major James Sidney Rollins

sentative and a two-time state senator to the Missouri legislature; during the Civil War, he was a two-term member of the United States Congress.

Under Rollins's influence, Bingham eventually adopted politics as his favorite topic for discussion. The young artist was a dynamic person—an eager debater who could be pugnacious and even combative. His strong temper reflected the depth of his personal convictions as well as his commitment to good government. The artist's first self-portrait, from 1834 or 1835, gives us a sense of his physical presence. He was small in stature—about 5 feet 8 inches tall, weighing about 150 pounds—and had brown eyes. His most notable physical characteristic, his baldness, was brought on at the age of nineteen by an attack of measles and was camouflaged by a toupee that he always wore.

In the self-portrait—Bingham's most dramatic painting up to that time—his highly colored cheeks and clear eyes convey his determination, passion, and energy to accomplish the ambitious goals he had set for himself. The stiletto-like slice of white shirt contrasts against the utter blackness of the jacket. His rosy complexion and the deeper pink of his full lips complement the only other reddish object in the picture: the section of the chair on which Bingham sits so erectly. The vertical arc of the white shirt and the curve of the starched collar are among the few lines in the painting that define form. Light reflects off the edge of the collar and the contours of the vest buttons, just as it would off the rim of the straw hats in Bingham's later river paintings. Erratically distributed light radiates from Bingham's wavy hair and taut skin, the softly turned black fabric of his lapels, and the intricately layered fancy black tie. With its avoidance of the unessential and its fixation on the sitter's hypnotic gaze, this self-portrait generates its own masterful energy. The artist depicted himself as the equal of any of his sitters—a gentleman with proper tie and jacket living in the westernmost state in the nation.

To a large extent, the future ambitions and limitations of Bingham's artistic career had already been determined by 1834. He was keenly aware, from the first moments of his career, of his need for additional artistic training. Over the next twenty-five years, he would work hard to complete his artistic education with experiences not available in central Missouri. Bingham was also eager to move from the portrait mode, which was held in relatively low esteem, to genre paintings and eventually, he hoped, to history painting. The latter—narrative painting depicting lofty moments in history imbued with moral truths—represented the topmost rung of the artistic ladder, which Bingham hoped to climb. But it was, ironically, his genre paintings—scenes characterizing Western ways of life, commerce, and politics—that Bingham would be remembered by.

Major James Sidney Rollins
c. 1845. Oil on canvas, 29½ x 25¼"
Private collection

From the mid-1840s until 1857, Rollins was the leader of Missouri's Whig party. As a Missouri state legislator, he effected the founding of the University of Missouri and its location in Columbia.

The course of Bingham's artistic education can be charted by his movement progressively farther east of central Missouri, first to Saint Louis and eventually to Philadelphia, New York, Washington, and, finally, to Europe. In the early spring of 1835, he went to Saint Louis, the largest metropolis in Missouri, in search of commissions. Already that year, an article in the Columbia *Missouri Intelligencer,* in a burst of pride at Bingham's abilities, had suggested that the gifted young portrait artist might become a "Western 'meteor of the art.'" The same article further remarked that Bingham's portraits played a role "in the history of Trans-Mississippian progress, towards a state of intellectual and social refinement." Bingham was thus almost immediately seized upon as reinforcing the current of social and commercial development in which all Missourians were participating. In Bingham's time, the established centers of culture in America were the metropolises that hugged the Eastern coast. However, as cities like Cincinnati and Saint Louis emerged, they also aspired to higher levels of cultural development.

In search of additional subjects as well as stimulation, Bingham left the village of Arrow Rock a second time to return to Saint Louis, remaining there over the winter of 1835–36. This prosperous city had long been an entrepôt for Western development, and its population grew from nearly 5,000 people to more than 16,000 during the 1830s. In Saint Louis, Bingham had the opportunity to see the paintings of Leon Pomerede in the newly completed cathedral. The French-born Pomerede had emigrated to New Orleans in 1830 and had come to Saint Louis two years later; he was the most notable artist working in the city in the mid-1830s. Also, in the homes of the wealthy citizens of Saint Louis (many of whom had been born in France), there were copies of European paintings, which Bingham might have had the chance of seeing. The opportunity to meet other artists and to study engravings after works of art that appeared in magazines provided further stimulation for Bingham.

On December 13, 1836, a Saint Louis newspaper, the *Missouri Republican,* noted that Bingham's copy of Thomas Sully's portrait of the actress Fanny Kemble was one of his best efforts and conjectured that the artist would become "an ornament to his profession and an honor to Missouri." Without formal artistic instruction, Bingham had to struggle painfully for each new bit of knowledge he gained about painting the human figure. As he wrote in a letter of November 30, 1835:

Though I am frequently under the influence of melancholy when my prospects appear dark and gloomy before me, yet I have never entirely despaired, and the determination to do my utmost to rise in my profession has ever remained strong in my mind. I am fully aware of my many defi-

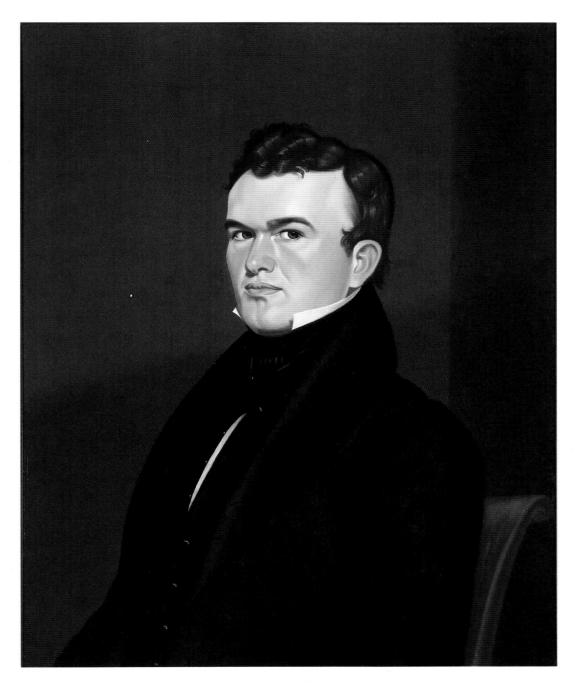

Self-Portrait

1834–35. Oil on canvas, 28 x 22½"
The Saint Louis Art Museum. Museum purchase:
Eliza McMillan Fund

The twenty-three-year-old Bingham painted this self-portrait at the beginning of his career, before he had traveled to Saint Louis or farther east to study painting.

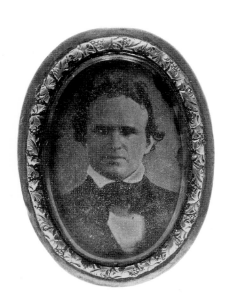

Unknown photographer,
George Caleb Bingham

c. 1840. Daguerreotype, 1½ x 1⅛"
State Historical Society of Missouri, Columbia

*Set into a brooch, this tiny portrait of
Bingham was probably worn by a family
member. The young man with
unkempt long hair over his ears has a
higher forehead than in his self-portrait
of 1834–35.*

*ciencies, and though I generally succeed in pleasing others, it is but seldom
I can please myself—in fact no work has yet gone from my hands with which
I have been perfectly satisfied. Very few are aware of the mortifications and
anxieties which attend the work of a painter; and the toil and study which
it requires to give him success and raise him to distinction. Nearly three years
have elapsed and I have yet scarsely [sic] learned to paint the human face,
after having accomplished which, I shall have ascended but one step toward
that eminence to which the art of painting may be carried.*

This letter was addressed to Sarah Elizabeth Hutchison, a Boonville
schoolgirl who became Bingham's fiancée in 1835. The couple were mar-
ried in Boonville in April 1836. The first of their four children, Newton,
was born eleven months later.

Although he was often despondent about the "mortifications," the
"anxieties," and the "toil" of achieving his goals, Bingham clung to his
ambition to climb the ladder of artistic success. He worked, as a Saint
Louis newspaper reported, "with unceasing industry." His tenacious will
drove him onward through his moments of doubt to attain a vision of his
own future that seemed to hover before him, as sharply delineated and
as elusive as the faces he painted at this time.

The double portrait *Sophia Lamme (Mrs. David Steele Lamme) and Son
William Wirt* (1837) reflects the conflict between Bingham's technical
inadequacies and his high ambitions. The painting confirms how strong
his anguish over his "many deficiencies" and his artistic anxieties must
have been. Mrs. Lamme, who was Rollins's mother-in-law and the wife of
a prosperous merchant in central Missouri, is depicted here in the three-
quarter view typical of the early portraits. Bingham has, however, added
new elements that expand the repertoire of the format for him: an inte-
rior, with a couch and a swatch of tassel-fringed red drapery; a landscape
view seen from a window; the hands of the primary sitter; and the sug-
gestion of cast shadows and human anatomy. While Bingham's viewpoint
had broadened with his exposure to other works of art, the interior and
figures depicted here are unconvincing. The couch is barely sketched in,
the curtain at the upper right is a pallid convention, the sitter's fingers
are tubular in shape, and the son's head appears as if it were on a swivel
rather than connected to his torso by muscle, sinew, and bone.

This double portrait is a fusion of genres: the limner tradition of
itinerant portraiture, the mother-and-child conventions of religious
painting, and (prophetically for Bingham) the Romantic landscape tra-
dition. The view out the window of the sailing boat, moving gently along
the placid waters, is the first glimmer of Bingham's future contribution
to American art. Water—as a natural conduit of commerce and a mirror

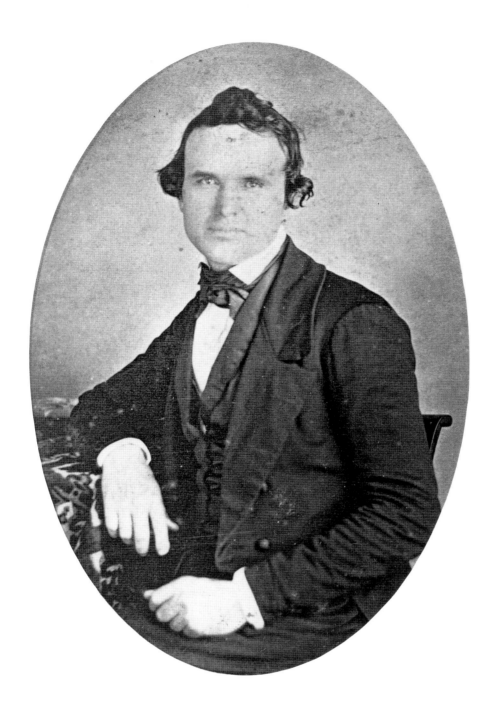

Frank Thomas, *George Caleb Bingham*

c. 1840. Photograph
State Historical Society of Missouri, Columbia

The artist's endearing and direct expression conveys a sense of him as a fair-minded and straightforward person. In this photograph, taken in Columbia, Missouri, Bingham is seated in what seems to be the same chair he used in his Self-Portrait (1834–35) and in several other of his earliest portraits. While at this time he always depicted his sitters in three-quarter view, he himself appears full-face here.

reflecting the natural world—would be central to Bingham's ability to create paintings that spoke to both the Western and the Eastern regions of America. Despite its technical inadequacies, therefore, this painting of Mrs. Lamme and her son provides an early glimpse of Bingham's vision, which, once it was nurtured and matured, would ensure him a national recognition that few American artists in the mid-nineteenth century achieved.

Bingham was well aware that he needed further training and practice, that he needed to see more pictures by other painters, and that he

needed to carefully consider the nature of his future works of art. A letter written to Rollins in the spring of 1837 indicates the seriousness with which he considered his future. It invoked the names of two portrait painters, Chester Harding and Thomas Sully, as his models: "I cannot foresee where my destiny will lead me, it may become my interest to settle in some one of the eastern cities. The greater facilities afforded there, for improvement in my profession, would be the principle [*sic*] inducement . . . I am aware of the difficulties in my way, and am cheered by the thought that they are not greater [than] those which impeded the course of Harding and Sully . . . it is by combatting that we overcome them and by determined perseverance, I expect to be successful." Bingham, by perseverance and determination, would will himself to be successful.

A year after this letter was written, the artist traveled to Philadelphia, where he resided from March to June 1838. He was attracted by the presence of one of the nation's few museums and schools of art, the Pennsylvania Academy of Fine Arts, and by the city's proximity to New York, then, as now, the central marketplace for American art. His early encounter with Chester Harding might also have suggested this trip; just prior to coming to Missouri, Harding, too, had gone to Philadelphia to study the works of Thomas Sully and other artists of the Pennsylvania Academy. Sully, the most prominent portrait painter in Philadelphia, worked in a style that was ultimately based on the work of Thomas Lawrence, an eighteenth-century British painter known for his ingratiating depictions of aristocratic subjects.

Bingham's sojourn in Philadelphia was a turning point in his career. It exposed him for the first time to original works of American and European art, to plaster casts of ancient sculpture, and to an abundance of engravings of paintings and sculpture. He seems to have looked carefully and, probably, to have drawn copies of many works. He wrote to his young bride: "I have just been purchasing a lot of drawings and engravings, and also a lot of casts from antique sculpture which will give me nearly the same advantage in my drawing studies at home that at present are to be enjoyed here." The drawings, engravings, and plaster casts provided Bingham with a portable inventory of compositions and models that he could take home with him to refer to and adapt at a later date.

Information about this period in Bingham's life is scanty; however, he probably ventured to New York during his three months in Philadelphia, at least to see the annual exhibition at the National Academy of Design. A school and exhibition venue, the National Academy honored achievement by selecting works of art from those submitted to its annual exhibition, held in May and June. Artists aspired to be associates, and subsequently members, of the Academy. If he did

Sophia Lamme (Mrs. David Steele Lamme) and Son William Wirt
1837. Oil on canvas, 35¼ x 28″
Private collection

This important transitional painting was made shortly after the subject's daughter was wed to the artist's friend Major James Sidney Rollins. The double portrait, which attempts to place the sitters in a specific interior, reflects the influence of portraits Bingham would have seen in Saint Louis homes during his visits to the city.

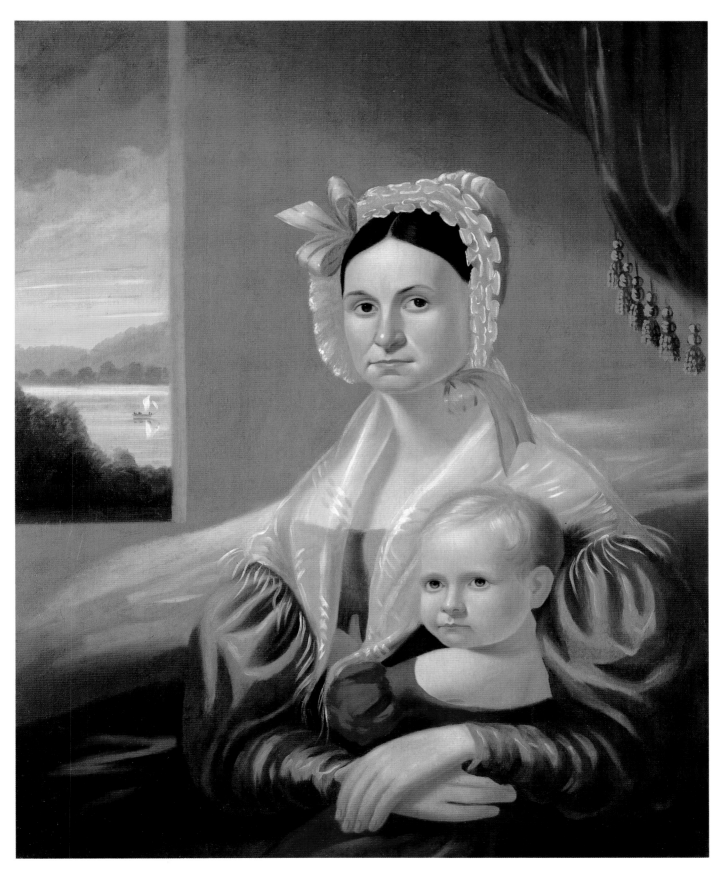

Sophia Lamme (Mrs. David Steele Lamme) and Son William Wirt

attend the exhibition of 1838, it was perhaps there that Bingham became intrigued with the thought of contributing his own work to such group exhibitions.

In New York, Bingham may also have seen pictures by such American genre painters as William Sidney Mount, whose depictions of rural Yankee life provided Eastern analogues to Bingham's own later work. (Mount exhibited at the National Academy every year from 1828 and was named a member in 1832.) In the 1837 Academy exhibition, Bingham would have seen the relaxed and playful poses of farm workers resting in Mount's *Farmers Nooning*. The bucolic setting of the young farm workers resting at noon, as a young boy playfully teases a black worker, is from a more established, domesticated society than Bingham's West. While appearing innocent, the scene veils and reveals tensions about slavery—a lesson that would not have been lost on Bingham. In the 1838 exhibition, Mount's *The Tough Story—Scene in a Country Tavern* was shown. Its rusticity may have rung true to Bingham's own experience, but it is still a far cry from the plain rural tavern that he painted in *The Checker Players* or the interior scene, *Canvassing for a Vote,* that he based on the composition of the Mount work. (A postscript in an 1852 letter from Bingham to the American Art-Union, which says "give my regards to Mr. Mount," provides our only firm evidence that the two artists knew each other personally.) Whether Bingham saw Mount's paintings in New York or prints made after them, the implications of Mount's pictures took time for him to absorb and to translate in ways appropriate to his own perceptions of the emerging communities in the West. Concentrating on improving his portraits was, for the moment, more to the point, and to this end he studied the rosy flesh tones of Sully, Gilbert Stuart, and Harding.

After Bingham's return to Missouri in the fall of 1838, his first river picture, entitled *Western Boatmen Ashore* (unlocated), appeared at the inaugural exhibition of the Apollo Gallery in New York. To have painted such a scene just after his exposure to contemporary genre scenes in Philadelphia and New York indicates how much Bingham was stimulated by paintings of rural Yankee workers to create images of similiar Western types. Sending his painting of Western boatmen to New York for exhibition underscores, as well, Bingham's growing realization that Easterners might have an appetite for the regional flavor of the West. He vowed to create works that were authentic to Westerners yet also capitalized on Eastern curiosity about life in the West. The fact that *Western Boatmen* predates his earliest surviving river picture by seven years indicates how lengthy the process of refining his vision of life along the river actually was.

Eliza Pulliam Shackelford
(Mrs. Thomas Shackelford)
1838–39. Oil on canvas, 35½ x 29½"
Private collection

Bingham's study of portraiture in Philadelphia and his assiduous copying of prints and drawings enabled him to paint portraits like Eliza Pulliam Shackelford, *in which the subject is convincingly enveloped by light and shade. In this depiction, however, Bingham retained from earlier works the dramatic contrast of white and black, which makes the sitter's moonlike face hover within the picture.*

A portrait from the same time as the Western scene, *Eliza Pulliam Shackelford (Mrs. Thomas Shackelford)*, reflects Bingham's broadening abilities as a painter. The light enters gently from the left and falls delicately on the sitter's face. Framed by the bonnet, Mrs. Shackelford's beneficent visage, with its slight smile and controlled shadows, demonstrates Bingham's improved control as a painter of human form. Putting his energies into the mastery of light and shade lessened both the severity and the intensity of his earliest portraits.

Another portrait suggesting that the artist had passed a turning point in his career is *Miss Sallie Ann Camden* (1839), Bingham's first painting to successfully integrate a figure into a landscape. The bare-

Miss Sallie Ann Camden
1839. Oil on canvas, 36 x 29½″
Private collection

As his technical skills grew, Bingham was able to place his subjects outdoors. Sallie Ann Camden reflects the artist's attempt to integrate the figure in the landscape, an effort that would reach fruition in his genre painting, little more than five years later.

Leonidas Wetmore
1839–40. Oil on canvas, 60⅛ x 40⅛″
Private collection

Bingham's large painting of Leonidas Wetmore marks a dramatic step forward in the artist's portrait style. The young playwright stands at the river's edge, wearing a flamboyant buckskin hunting costume.

shouldered young girl sits in a white dress above the rocky banks of a river; in the background, the rose tint of twilight dusts the pale green trees with its color. The girl's contrapposto pose, with upper torso and hips oriented in opposite directions, reveals Bingham's newfound ability to render the human form in space.

Finally, Bingham's portrait of Leonidas Wetmore (1839–40), his largest known painting of the period, also incorporates a river as the chief feature of its landscape setting. The artist had known the Wetmore family in Arrow Rock, and here he shows the twenty-three-year-old Leonidas in an extraordinary buckskin hunting suit. While the pose of the hunter might recall the ancient sculpture known as the *Apollo Belvedere* (Vatican Museum), it more immediately suggests Harding's

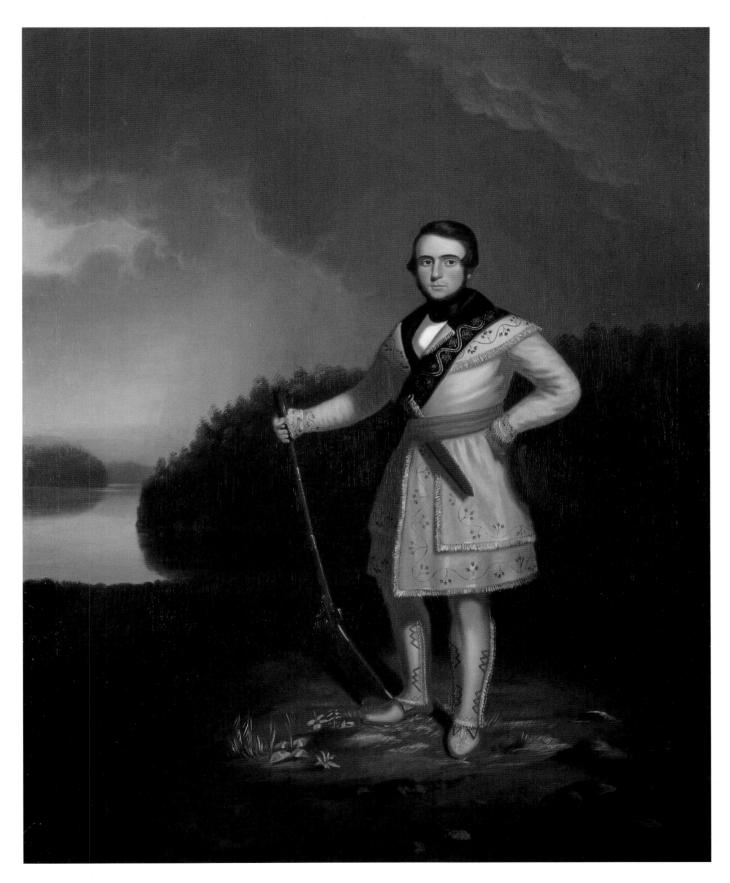

Leonidas Wetmore

adaption of the same pose in his portrait of Boone. Bingham's figure
seems oddly out of proportion and not convincingly integrated within
the setting. Despite the flamboyant clothing and pose, it is not the sitter
but rather the landscape, and particularly the water, that beckon the
viewer. Bingham's river pictures grow naturally out of these transitional
portraits of the late 1830s. It is as if the prominent subjects of the por-
traits eventually disappear and leave behind landscape settings for
Bingham to populate with smaller, more generic figures. In the back-
ground of this painting, for instance, is the compellingly hazy mist later
found in *Fur Traders Descending the Missouri.*

After exhibiting *Western Boatmen Ashore* at the Apollo Gallery in
October 1838, Bingham sent six paintings to the National Academy of
Design for its annual exhibition of 1840. Though none of the works have

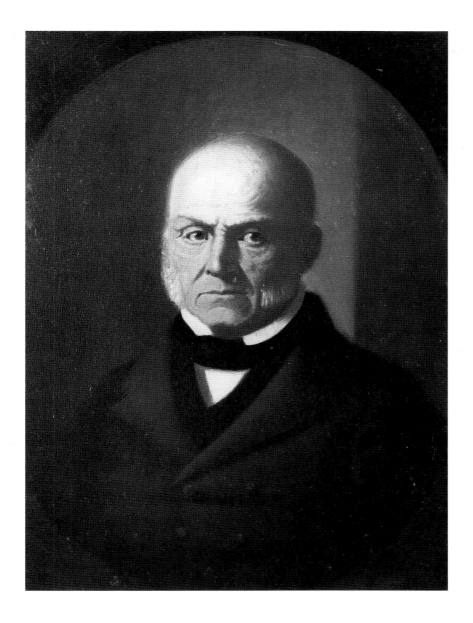

John Quincy Adams
1844. Oil on panel, 10 x 7¾"
Collection James S. Rollins

Bingham painted this small portrait (and replicas) of the former president—who was then serving as a United States congressman—in Washington, where he shared a studio in the old United States Capitol building. Adams and Bingham are reputed to have had an animated political discussion at the time the portrait was made.

been located, their conventional-sounding titles, like *Tam O'Shanter* and *Pennsylvania Farmer,* indicate that the artist had not yet firmly formulated his own viewpoint or had not come to understand the kinds of paintings that would be favorably received in the East. (Only two other times would Bingham exhibit paintings at the National Academy—*Going to Market,* in 1842, and *The Stump Orator* in 1848.)

In a letter written shortly after his return from Philadelphia, Bingham told Rollins that he was already thinking of going back East. It would, however, be a few years before he would actually make the journey. In 1840, he attended a Whig convention at Rocheport, Missouri, in connection with William Henry Harrison's successful presidential campaign; his presence there may have strengthened his growing attraction to Whig politics and to Washington, D.C. After its establishment in

Missouri in 1839, the Whig party enjoyed nearly two decades of existence; its collapse was due largely to conflicts over slavery in pre–Civil War Missouri. Nearly always the minority party to the Democrats, the Whigs developed their agenda primarily by opposing the Democrats. Shortly after Harrison's victory over the Democratic incumbent, Martin van Buren, Bingham decided to move with his family to Washington, arriving there by late December 1840.

Why did Bingham choose to live in the nation's capital rather than in New York, where the artistic opportunities would have been far more numerous? For one thing, the prospect of observing the first Whig presidency was a strong incentive. Bingham also undoubtedly hoped to obtain distinguished commissions from the newly appointed Whig members of the government. Yet Bingham remained in Washington after Harrison's premature death on April 4, 1841, for the city had other attributes that appealed to him. It was close to his native Virginia, and judging from his reaction to Paris a decade later, he may also have preferred a smaller city in which to live and work. Upon his arrival in Washington, Bingham expressed his pleasure with himself in a letter to Rollins. "I am a painter," he wrote, "and desire to be nothing else. . . . I shall be content to pursue the quiet tenor of a painters life, contending only for the smiles of the graces. . . ."

Yet the years in Washington were personally and professionally difficult for Bingham. During most of his four years there, he lived with his family in a boardinghouse on Pennsylvania Avenue. He noted in a letter that this was the only paved street in the city, and that he was the only Whig in the boardinghouse. Bingham's son, Newton, died in March 1841 at the age of four; his second son, Horace, was born that same month. For a time, the artist shared a studio in the lower levels of the United States Capitol Building with the painter John Cranch. His skill in portraiture developed further during this time, and he gained additional credibility by painting portraits of such famous Americans as John Quincy Adams. However, Bingham's portrait output in Washington was limited in number and scope. He did not obtain the commissions he had moved there for, and by 1844, he and his family wanted to return to Missouri.

His time in Washington afforded Bingham an extraordinary opportunity to view the democratic process in action. The sophistication—and depravity—of what he observed enabled him to look freshly at the forces present in the same process on the frontier. Neither did he neglect pictures of rural life during this period. Just as he had painted *Western Boatmen Ashore* while still influenced by his trip to Philadelphia, he continued to be drawn to subjects relating to country life when he was

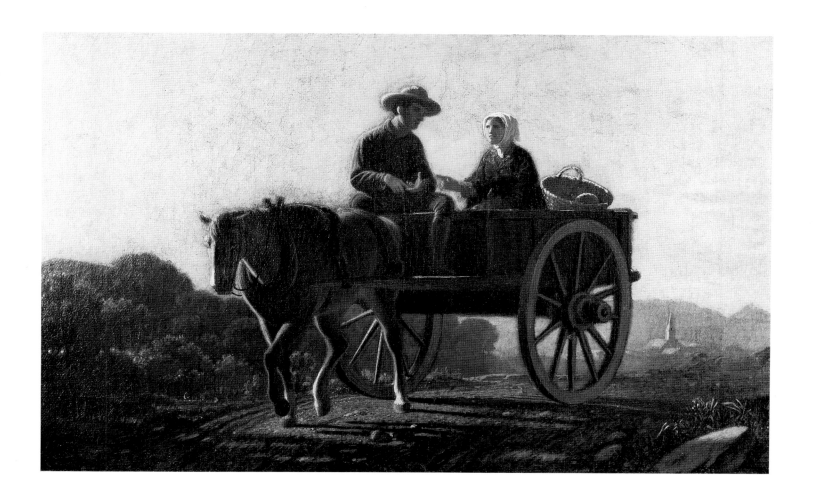

in Washington. *Going to Market* (about 1842) portrays a husband and wife conversing in the early morning light as they take their wagon down a dirt road. The painting is so generic, however, as to be bland. *The Dull Story* (1843–44), a sweet Victorian picture also of the Washington period, depicts his young wife, Sarah, who has apparently fallen asleep while reading. Despite its faults, *Going to Market* represented a new area in which Bingham might develop as a painter; *The Dull Story,* on the other hand, suggested the dangers that sentimental subjects held for him.

Shortly after the Bingham family's return to Missouri, preparations began for the national Whig convention to be held in Boonville, to endorse Henry Clay's candidacy for the presidency. Clay's belief in commerce and economic development, which he characterized as his American System, formed a basic tenet of the Whig party. The Whigs were more interested in developing existing settlements than in establishing new ones, and Rollins and Bingham fervently embraced the prospect of a Clay presidency as a potential boon for Missouri. Accordingly, Bingham threw himself into producing for the convention a series of political banners—large portable paintings—illustrating

Going to Market or *Market Day*

c. 1842. Oil on canvas, 14⅝ x 23⅛"
Virginia Museum of Fine Arts, Richmond.
The Adolph D. and Wilkins C. Williams Fund

The depiction of conversation, one of the defining characteristics in Bingham's paintings of Western life, appears for the first time in this picture of a husband and wife on their way to market.

Overleaf:

The Dull Story

1843–44. Oil on canvas, 50½ x 39⅛"
The Saint Louis Art Museum. Museum purchase:
Eliza McMillan Fund

Traditionally thought to depict the artist's wife, Sarah, who has dropped off to sleep while reading, this painting, with its relaxed and dreamlike sensibility, indicates how far Bingham had come from the wide-eyed, unblinking portraits of a decade before.

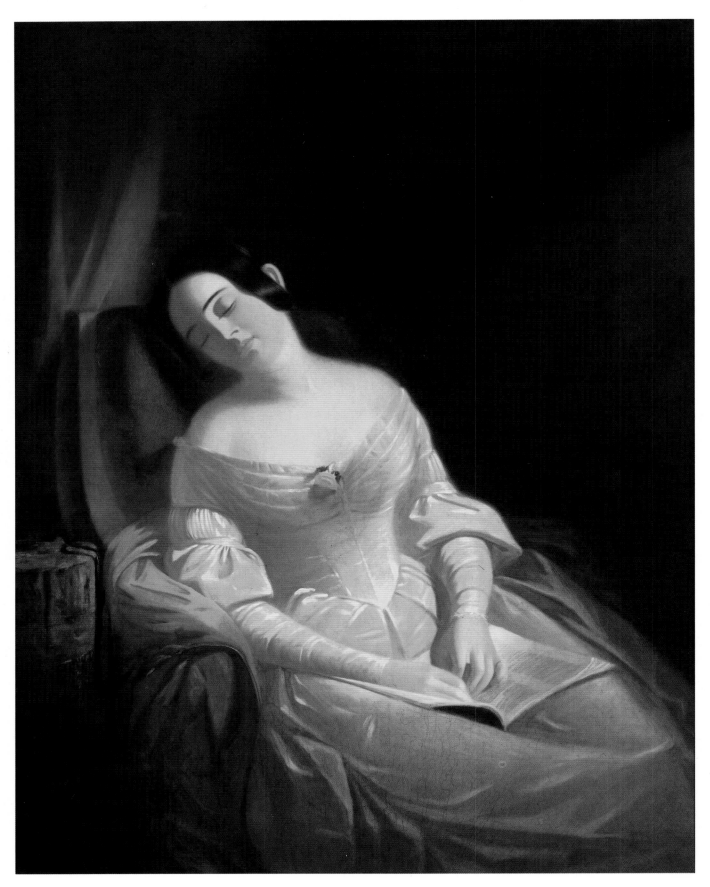

The Dull Story

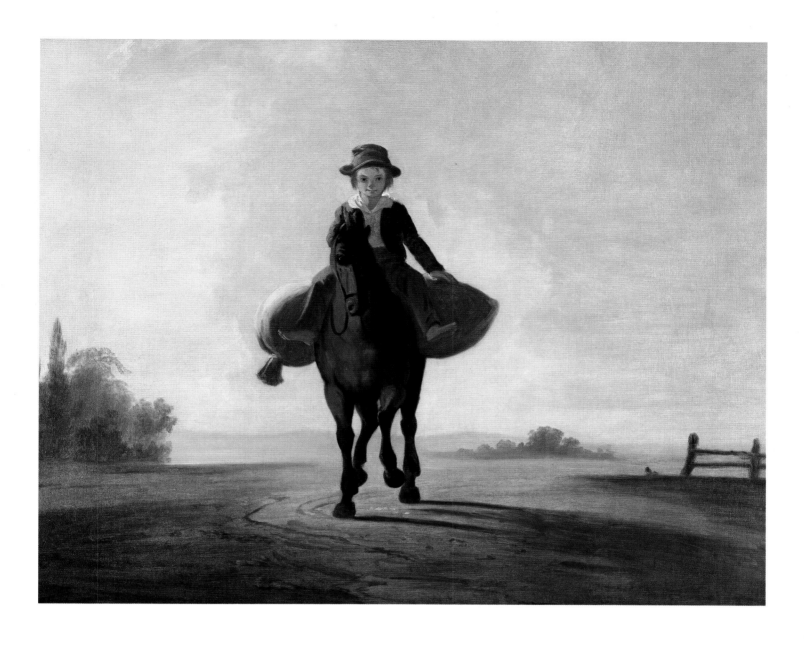

aspects of Clay's life. (He had previously designed banners for the 1840 Whig convention in Rocheport.)

Bingham's *The Mill Boy: The Boonville Juvenile Clay Club Banner* (1844), painted in Boonville, is the only surviving banner from the two-day convention, held on October 10 and 11, 1844. As in our political conventions today, banners were held aloft to identify various groups attending the convention. The proceedings were initiated by a lively procession featuring marching bands and groups holding their banners high. The *Boonville Observer* commented, "The Juvenile Club also bore a most beautiful banner; on one side of which is represented a mill-boy riding merrily . . . on the reverse side is a little fellow carving the name of Henry Clay. A mere description of the devices on these banners, howev-

The Mill Boy: The Boonville Juvenile Clay Club Banner
1844. Oil on canvas, 37½ x 46¾"
Private collection

In 1844, Bingham painted a number of banners representing various counties and political clubs for the Whig party's presidential convention in the river town of Boonville, Missouri. The Mill Boy, which promoted the presidential candidacy of Henry Clay and depicts him in his youth, is the only surviving banner.

er, conveys no idea of their real beauty. They, as also the Howard banner, were painted by Mr. Bingham, a noble young artist of this city."

The Mill Boy shows a boy on a horse taking wheat to market. Aside from being a symbol of commerce, an effective theme for a political banner, the image also alludes to the past history of Bingham's family—in particular, to the mill of his grandfather. The boy who appears here, and in subsequent genre-like landscapes, reflects Bingham's increasing use of childhood recollections at this time. Such memories furnished him with the nostalgic domestic sensibility that fills his works. Beyond its function as a political banner, *The Mill Boy*, more than *Going to Market*, begins to bring into maturity the mood of rustic reflection that informs Bingham's later works.

Bingham's stay in Washington no doubt continued to nourish his growing interest in politics. Shortly after returning to Missouri, Bingham painted a dramatic portrait of the state's new governor, John Cummings Edwards. The artist probably knew the governor in Washington, for Edwards served in Congress from 1841 to 1843. Bingham's years in the capital also gave him insights into the national political process that showed up later in his work. It also may have kindled a dream that would neither disappear nor be fulfilled—that of receiving a national commission for the United States Capitol. The same dream frustrated many painters and sculptors of Bingham's generation.

Yet, with the technical skills and greater artistic maturity gained during his stay in Washington, Bingham had grown beyond portraiture. He went home as determined as ever to define a place for himself in the annals of American art. Upon his return to the familiar setting of Missouri, he began to paint the pictures for which he remains best known today.

John Cummings Edwards
1844. Oil on canvas, 36¼ x 29"
Missouri Historical Society, Saint Louis

This painting, executed shortly after Bingham returned to Missouri from his four years in Washington, D.C., is one of the artist's most striking full-length portraits. It depicts the newly elected governor of Missouri standing on a bluff above the Missouri River, with the State Capitol in Jefferson City in the background.

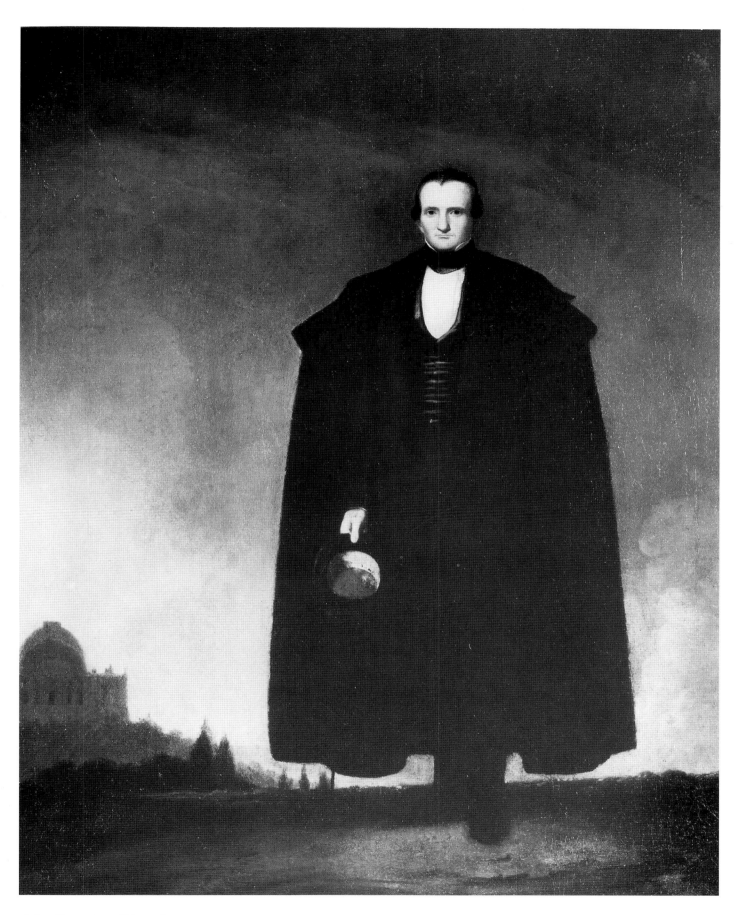

John Cummings Edwards

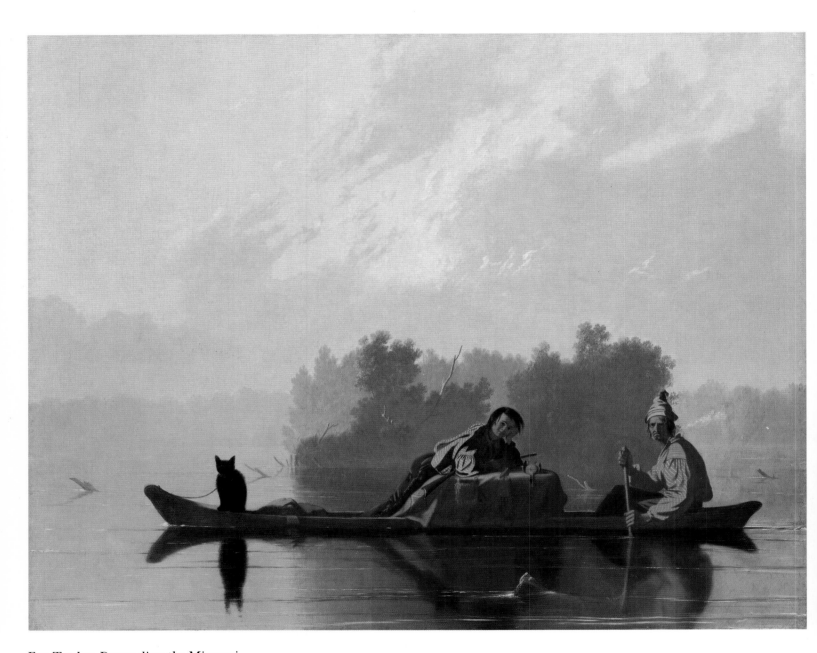

Fur Traders Descending the Missouri

II. The River Paintings, 1845–57

WHEN GEORGE CALEB BINGHAM RETURNED TO Missouri from Washington, D.C., in December 1844, he was on the brink of the most creative period of his career. During his travels east, he had absorbed much more than the principles of picture making. He had become increasingly oriented toward a new subject matter, one that he knew well and whose visual formulation he had already begun to explore: life along the Missouri and Mississippi rivers. Bingham's motivation was to attain artistic success by creating paintings that mediated Eastern perceptions of the West with his own experience of it. His idea was not simply to extract vignettes of river life but to communicate a convincing, appealing, and truthful view of how the river, and the men and craft that plied its waters, were agents of democracy on the frontier.

The lure of indigenous subjects was first forcefully felt in American art during Bingham's age. The search for a national, indisputably American subject matter for works of art was articulated first in landscape paintings by Thomas Cole, Asher B. Durand, and other members of what came to be known as the Hudson River School—painters who defined the particular topography of the Northeast as an index to our specific nationality. Increasingly, for American artists, the configurations of the land outside the cities hugging the East Coast, the wild, Edenic expanses beckoning settlers to tame them, were nothing less than a gift of God.

Similarly, William Sidney Mount created paintings in which the characterization of the social practices of agrarian life in the East also appeared typically American. While Durand, Cole, and Mount painted images of the Northeastern United States, the nationalist spirit in their work inspired Bingham. It encouraged him to find equivalent experiences in Missouri and to show how Western boatmen and settlers reflected the progressive nationalist agenda of the period. Both Bingham in the West and Mount in the East provided strong images of self-affirmation to a nation eager to define its own national culture and to distinguish itself from Europe.

At mid-century, American artists were attempting more and more to

Fur Traders Descending the Missouri

1845. Oil on canvas, 29 ¼ x 36 ¼"
The Metropolitan Museum of Art, New York.
Morris K. Jesup Fund, 1933 (33.61)

Against the pale light and humid sky of dawn, the wooden boat glides past the viewer as the young man displays the duck he has shot. The painting harks back to an earlier stage in the development of the West. The French trapper and his half-breed son are harbingers of subsequent white immigration.

39

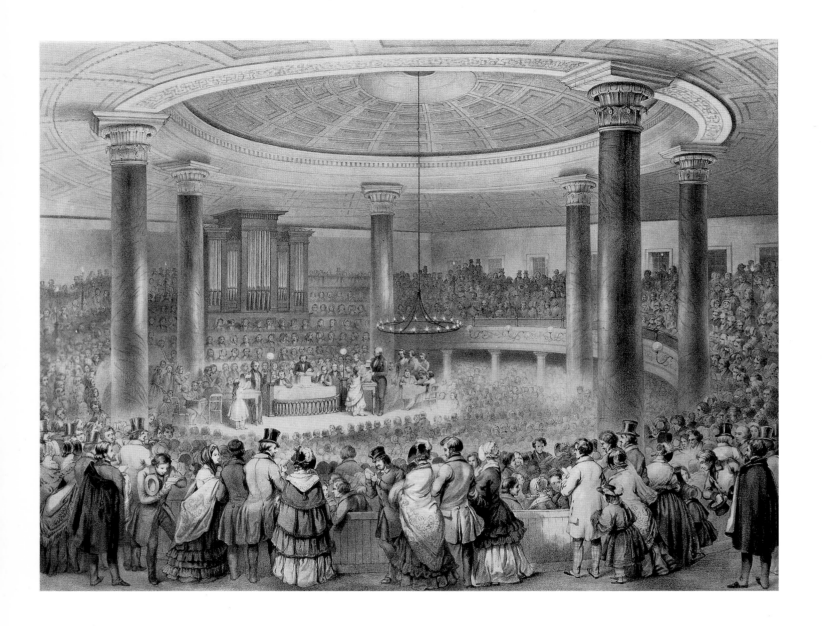

Francis Davignon, after T. H.
Matteson, *Distribution of the
American Art-Union Prizes, at the
Tabernacle, Broadway, New York:
24th December 1847*

Lithograph. Published in 1848 by
John P. Ridner, New York

*The raffling of paintings purchased by
the Art-Union to its members was a pop-
ular annual event. Through its pur-
chases of paintings, its publication and
distribution of prints, and its favorable
publicity, the Art-Union exerted a pow-
erful influence upon many American
artists and Bingham in particular.*

describe their nation through depictions of its social customs and situa-
tions. Although European and ancient models suggested compositional
formats (as they did in the work of practically every American artist), the
actual subjects and activities depicted were particular to America. To
describe aspects of the larger democratic whole, artists looked to
American political heroes as portrait subjects, to the configurations of
the Hudson River Valley in landscape painting, and to the relaxed, rural
subjects of William Sidney Mount in genre scenes. Bingham's travels
"abroad" in the East made him aware that the depiction of nationality
and democracy was a key artistic issue of his time. His travels helped fuse
his ambition and his response to the genre paintings he saw in New York
and Philadelphia with his own deep attachment to the region where he
was raised. He realized he could become an interpreter of the challenges

THE RIVER PAINTINGS

of bringing commerce and democratic practices to a new and relatively unsettled land. It was an inspired and ambitious goal.

Bingham's journey to artistic maturity was aided by the Apollo Association in New York and its successor, the American Art-Union. Initially started as an exhibition venue in 1838 by the versatile painter and publisher James Herring, the Apollo Gallery exhibited one of Bingham's paintings at its opening. The name of the organization was soon changed to the Apollo Association for the Promotion of the Fine Arts in America. In 1844, the name was changed once again, to the American Art-Union, in an effort to emulate the art-unions in a number of European countries. The principle behind the group was that the nominal five-dollar annual membership fee provided a pool of funds that would be used to purchase works from artists and to distribute them, by lottery, to the membership. Some of the paintings purchased by the Union were chosen to be engraved; prints were made and an impression distributed to each member. In addition, the group's bulletin informed the members of its activities and disseminated its opinions on the state of contemporary American art.

The Apollo Association and the American Art-Union were both highly visible and effective promoters of American art. They organized well-attended exhibitions and created opportunities for artists to sell their paintings at a time when there were few commercial galleries, art museums, or art collectors. By allotting paintings by chance, the Art-Union democratized the distribution of works that might otherwise have been beyond the means of average citizens. In the context of the thin, difficult soil for native-born artists in mid-nineteenth-century America, these organizations played a seminal role in financially and spiritually nurturing artists and in disseminating their works to a broad national constituency. The Art-Union was not, however, merely a neutral supporter of American artists. By carefully selecting the works it purchased and engraved, it soon became a powerful influence on the development of American art.

The Art-Union distributed its original paintings to subscribers through a series of raffles held in December of each year. At its peak, the membership numbered nearly twenty thousand, and many more people attended the group's exhibitions, which annually drew nearly two hundred fifty thousand. In 1847, when Bingham's *Jolly Flatboatmen* was selected for engraving and distribution, ten thousand impressions were made for the members. The Union's ability to draw a huge attendance to its exhibitions, to purchase works of art, and to commission and disseminate thousands of prints made it one of the most powerful patrons of American art.

Cottage Scenery

1845. Oil on canvas, 25½ x 30″
In the collection of The Corcoran Gallery of Art,
Washington, D.C. Museum Purchase, Gallery
Fund and gifts of Charles C. Glover, Jr., Orme
Wilson and Mr. and Mrs. Lansdell K. Christie

*This painting is one of four by Bingham
purchased by the American Art-Union
in 1845. It appears to be a pendant
painting to* Landscape: Rural Sce-
nery, *another of those four works. The
canvas depicts a relaxed conversation
between an older man and a young
woman and man, gathered around the
entrance to a rustic farm. It suggests a
cozy and bucolic, if generic, view of
rural life.*

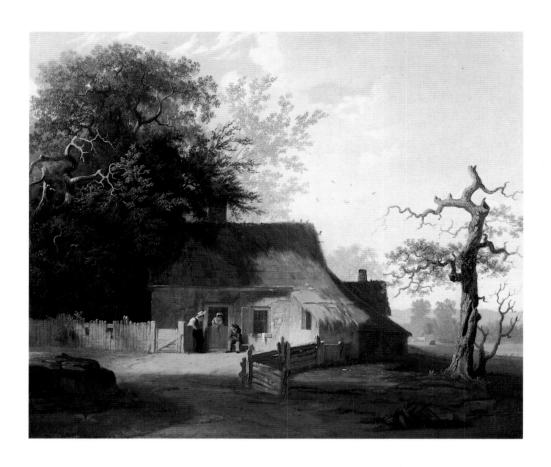

Landscape: Rural Scenery

1845. Oil on canvas, 29 x 36″
Private collection

Both this painting and Cottage
Scenery *depict scenes of family life in a
rustic environment. They contrast with
the more specifically Western subject
matter of the other two Bingham paint-
ings that the Art-Union acquired in
1845,* Fur Traders Descending the
Missouri *and* The Concealed Enemy.

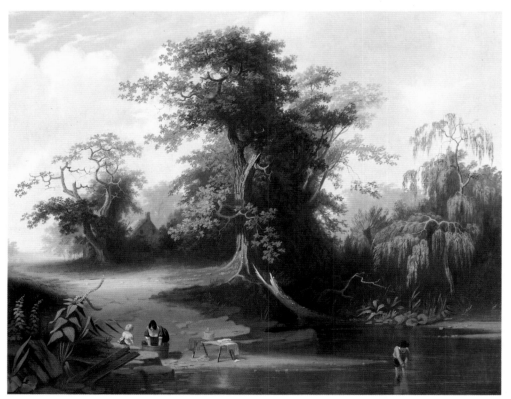

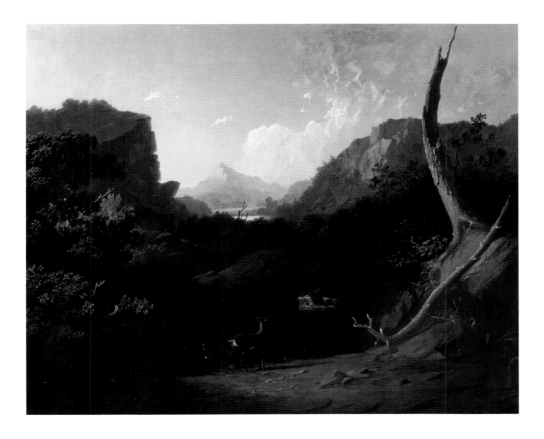

Deer in Stormy Landscape

c. 1852–53. Oil on canvas, 25 x 30″
Courtesy The Anschutz Collection, Denver

Bingham often used the device of a rocky outcropping or a tree in the middle ground of his paintings to block the sun. This technique allows the viewer to project himself or herself more deeply into the picture and also makes the rays of the sun more tangible. In this case, the sunlight illuminates the profile of the rock, modulates the blue of the sky, and etches the profile of the blasted tree in the right foreground. The formulation of the land in this painting is very similar to that in The Emigration of Daniel Boone *(1851).*

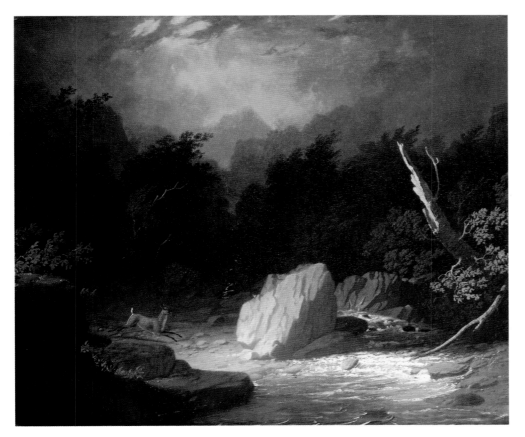

The Storm

c. 1850–55. Oil on canvas, 25 x 30 ⅛″
Wadsworth Atheneum, Hartford. Gift of Henry Schnakenberg

Deer in Stormy Landscape *(c. 1852—53) and* The Storm *appear to be pendants depicting the passive and active states of nature and their effects. Bingham usually shows nature as an abundant provider, but his darker view in* The Storm *makes clear the impact that Romantic European and American painting had upon him.*

In 1843, the Apollo Association published and distributed a print of Mount's *Farmers Nooning*. With this choice, the Association turned away from historical and neoclassical subjects for its engravings and toward images of contemporary rural life. The subsequent year, Francis Edmonds's *Sparking*, depicting a young couple by the fire in a simple cottage, continued this new direction.

The American Art-Union's patronage further encouraged Bingham to paint pictures that characterized aspects of the world he had grown up in but that also sought to explain frontier life to those in the East. At least nineteen of his paintings were purchased and distributed by the Union from 1845 to 1852. Other Bingham paintings were purchased and distributed by one of the American Art-Union's sister institutions, the Western Art-Union in Cincinnati.

When Bingham submitted *Western Boatmen Ashore* in 1838 to the Apollo Gallery, the painting appears to have been scarcely noticed. By the time he submitted more works to the Art-Union, seven years later, he met with considerable success, probably because of the increasing sophistication of his painting and his astute perception of the kinds of art the Union was looking for. Of the four paintings Bingham sent to the Union in 1845 (including the work generally regarded as one of his masterpieces, *Fur Traders Descending the Missouri*), two were landscapes and two were Western genre scenes. All of the four were purchased by the Union.

Cottage Scenery (1845), the first of these works, was painted within six months of Bingham's return to Missouri from Washington. The intimate tone of relaxed rural family life glimpsed in *The Mill Boy* appears more fully in *Cottage Scenery*. Three people converse: a straw-hatted youth, an old man seated on a bench, and a young woman who leans out from a Dutch door. A river flows in the distance, and on its banks, contented cows graze. As is true with many of Bingham's paintings, conversation, set within the larger harmonic structure of nature, is the focus of the work. Later, in *Canvassing for a Vote* (1851–52), Bingham adapted the device of depicting informal conversation taking place in front of a rustic building to a more specifically political use.

The language of forms that Bingham chose for *Cottage Scenery* reflects the influence of eighteenth-century French and English paintings of rustic life. The trees and cottage have been compared to those in works by Joshua Shaw, an English-born painter who emigrated to Philadelphia in 1817, or to the barnyard scenes of the late-eighteenth-century British genre painter George Morland. *Cottage Scenery* combines the British tradition of rustic genre painting with an American desire to depict the informal, contented attitudes and poses of native farmers.

Bingham, like the artists of the Hudson River School, was Americanizing a European prototype.

The tone of domestic and natural harmony continued in the second work Bingham sent to the Art-Union in 1845. *Landscape: Rural Scenery* (1845) depicts a young woman, who appears to be the same one as in *Cottage Scenery,* bending over her wash bucket by the side of a stream. One of her two young children plays in the water, while the other, seated on a flat rock, observes his mother. Cozily enclosed within the woods, the family cottage, which bears a resemblance to the one in *Cottage Scenery,* can be glimpsed in the middle ground of the picture. The pair of paintings, *Cottage Scenery* and *Landscape: Rural Scenery,* with their similarities of setting and characters seem to be complementary, albeit generic, views of rural family life.

Several years later, Bingham again painted a pair of works that are complementary in mood and composition—*Deer in Stormy Landscape* and *The Storm* (both about 1852–53). As with *Cottage Scenery* and *Landscape: Rural Scenery,* these paintings appear to be Bingham's attempt to rival the more dramatic landscapes of the Hudson River School. But nature usually appears more passive in Bingham's work, and the placid water, the abundance and stillness of nature, and the soft reflections on the surface of the stream link *Landscape: Rural Scenery* with Bingham's fully realized masterpiece of the same year, *Fur Traders Descending the Missouri.*

While the purchase of *Fur Traders* by the Art-Union encouraged Bingham, its awarding to a Union member in Mobile, Alabama, effectively removed the painting from public view until it reappeared on the art market in 1933. Thus, though the painting marked a turning point in Bingham's career, it was not seen again for nearly ninety years after its exhibition at the Art-Union's galleries. There are formal and iconographic similarities between *Landscape: Rural Scenery* and *Fur Traders Descending the Missouri,* but the distance between them in artistic achievement and innovation is great. In the latter work, Bingham speaks with his full voice and charts in mature and original visual terms the new direction his finest paintings would take.

First titled by the artist as *French Trapper and His Half-Breed Son,* the painting was renamed by the Art-Union to specifically refer to the Missouri River. The change also de-emphasized the particular nature of the relationship between father and son, possibly to give a more positive picture of life in the West to curious Easterners. The scene is typical of those Bingham must have witnessed as a child sitting on the banks of the Missouri, watching the almost silent passage of trappers as they swiftly and expertly guided their canoes around the snags in the river.

The picture has a hallucinatory quality, illuminated as it is by the

soft, tranquil light of dawn. Traveling in the boat are a grizzled older figure, wearing a pink-and-white-striped shirt and a yellow and red cap, and a younger one, dressed in a blue-and-white-striped shirt and maroon buckskin pants. The son leans forward over a rifle, fringed bag, red sash, and the duck he has just shot. Their pet animal, thought by various later writers to be a bear cub, a cat, or a fox, is tied to the prow. John Demos's suggestion that the animal was perhaps intended to be a mysterious hybrid rather than a specific creature may be the soundest view.

As viewers, we look at this work almost at eye level with the boat and its passengers. Since the banks of the river are not visible in the foreground, we might be positioned sitting low on the bank or, perhaps, in our own boat. In either case, our viewpoint is just above the water level. This viewpoint adds immediacy, as does the fact that *Fur Traders* is the first of Bingham's pictures in which the figures directly engage the viewer, looking into our eyes with an honest and simple gaze. While the black-haired, full-faced boy regards the viewer amiably, his pipe-smoking father stares with greater seriousness. Bingham's penchant for having his genre figures confront the viewer so vividly is an effective device, perhaps inspired by the steady gaze of his portrait subjects.

The two figures and the canoe are the only crisply defined elements in the painting. Their softly blurred reflections in the water beneath them and the atmospheric depiction of the moist air behind them give the painting its dreamy quality. The distant landscape disappears in the early morning fog. In fact, with its air of an unreal journey, the painting seems a Western equivalent of Thomas Cole's four-part allegorical painting, *The Voyage of Life* (1845). (The image of moving water as a metaphor for the passage of life was a popular, sentimental one in the nineteenth century.)

Fur Traders has been frequently compared to Mount's *Eel Spearing at Setauket* of the same year. The two works do share uncanny formal affinities, despite the obvious differences between rustic life on Long Island Sound and the rugged, yet no less romantic, life on the Missouri River. Both works are drawn from recollections of the artists' childhoods. Both employ the contrast between sharp delineation and soft reflection, and both balance outer calm and inner equanimity. In formal terms, therefore, they are kindred spirits. Nevertheless, Mount's young boy in a boat with his black nurse and with farm buildings in the distance is far from the completely self-reliant father and son in the wilderness. While both paintings depict a form of hunting, in one it is recreational; for the fur traders, it is their livelihood and means of survival. The grizzled old man and his dreamy-eyed son are independent characters, the equals of nature.

Fur Traders is the first of Bingham's river paintings for which drawings exist. These drawings were among 112 in a portfolio that John How, the former mayor of Saint Louis, gave in 1868 to the city's Mercantile Library. The portfolio remained in the library's collection until 1975–76, when its contents were saved from dispersal by a statewide fundraising effort. Purchased in the name of the people of Missouri by an organization known then as Bingham Sketches, Inc., and now known as the Bingham Trust, the drawings are housed both at the Saint Louis Art Museum and the Nelson-Atkins Museum of Art in Kansas City. The drawings suggest that Bingham worked from carefully posed models whose outlines he occasionally transferred to prepared canvases. The models appear more generalized in the finished works than in the preparatory

William Sidney Mount,
Eel Spearing at Setauket

1845. Oil on canvas, 29 x 36"
New York State Historical Association,
Cooperstown

Mount's painting and Bingham's Fur Traders *were made the same year. The two canvases—of almost identical size—are mirror images of each other; each has two main figures and a pet in a shallow draught boat that glides through smooth water. Both pictures reflect childhood memories. The Mount was exhibited at the National Academy in 1846 as* Recollections of Early Days—Fishing along Shore.

*This sketch of the old trapper is one of
the earliest known Bingham drawings.
It demonstrates how the artist modified
the craggy appearance of an individual
as he moved from a drawing, probably
based on a posed model, to the finished
painting.*

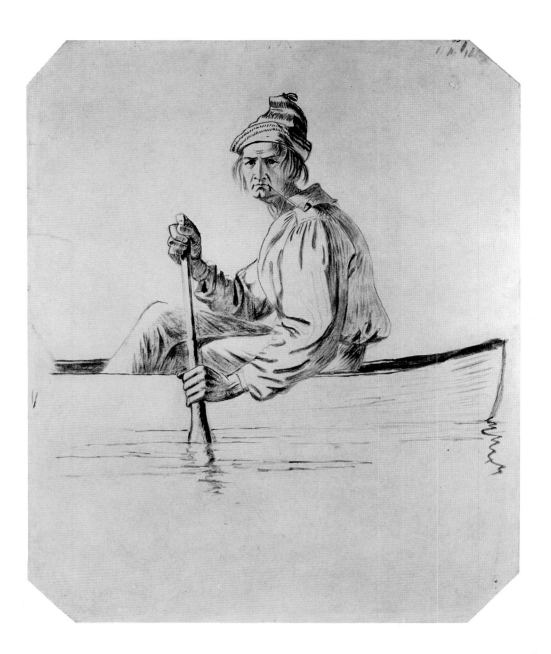

studies. Thus, the head of the old man in the drawing for *Fur Traders* is more specific than in the completed painting. Half a dozen years later, Bingham came back to the subject of trappers returning downriver by canoe in a second version of *Fur Traders*. Entitled *Trappers' Return* (1851), it was also purchased by the Art-Union.

The other Western genre painting that Bingham sent to the Art-Union in 1845 was *The Concealed Enemy* (1845). This work depicts a lone Indian about to cock the hammer of his rifle as he peers over the edge of a cliff. Its dominant formal element is the repetition of the foreground shape of the Indian and the hill ever more deeply into space. While the narrative situation, an Indian observing unseen foes, seems unresolved, the painting nevertheless operates successfully at a formal level: the cen-

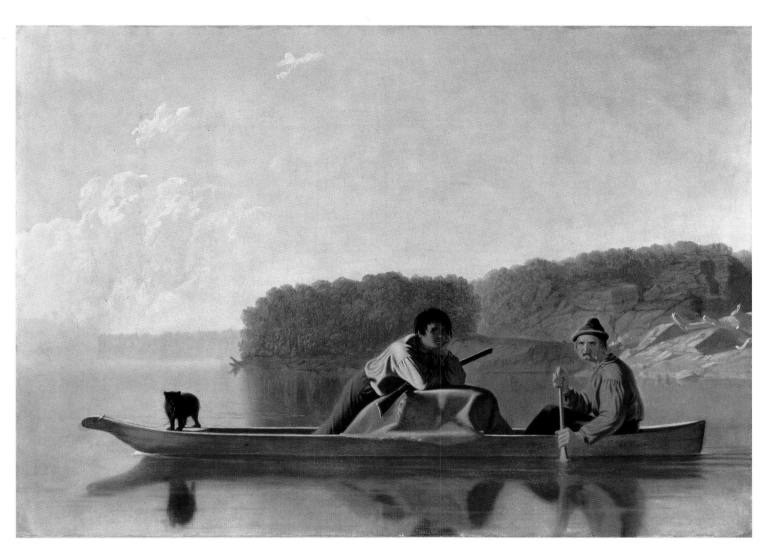

Trappers' Return

1851. Oil on canvas, 26¼ x 36¼"
The Detroit Institute of Arts, accession no. 50.138.
Gift of Dexter M. Ferry, Jr.

This painting is a second version of **Fur Traders Descending the Missouri** *(1845), but does not compare favorably with the earlier canvas. Eliminating the boy's beaded pouch and bird, clearing away the snag in the water, and animating the pose of the bear cub breaks the hypnotic spell of the initial work.*

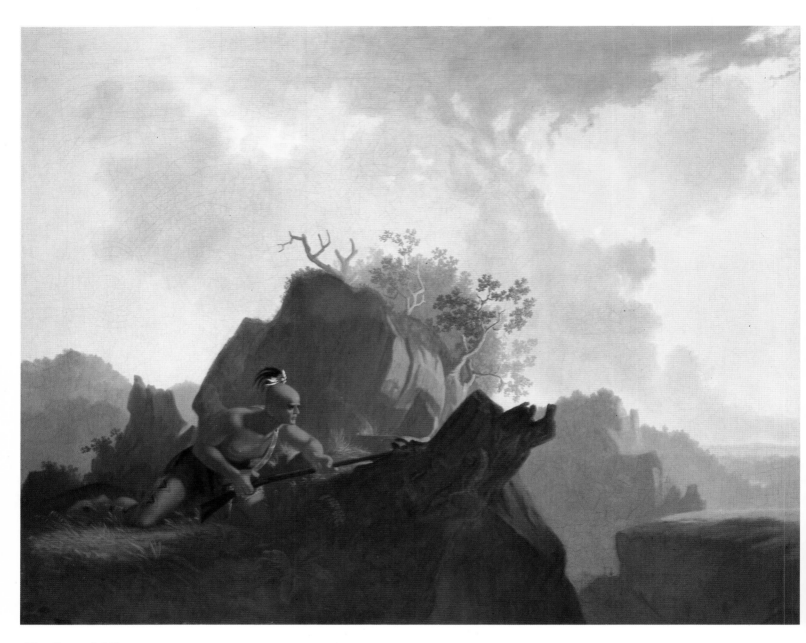

The Concealed Enemy

tral motif becomes a continuing echo of itself in the landscape.

Fur Traders Descending the Missouri and *The Concealed Enemy* translate into an American vocabulary the styles of two seventeenth-century European landscape painters, Salvator Rosa and Claude Lorrain. Art historian and curator Henry Adams has suggested that *The Concealed Enemy* reflects the wild, uninhibited style of Rosa, while *Fur Traders* follows the more classical, civilizing model of Claude. Adams discussed the two paintings as pendants: the first demonstrating the end of Indian civilization, and the second representing the dawning of a new age of settlement. In this scheme, the grizzled trapper and his son are nothing less than the spearhead of Western civilization and progress. The Indian's position is more circumscribed, limited to observing and retreating in the face of the trappers' advance.

So-called pendants, like *The Concealed Enemy* and *Fur Traders Descending the Missouri* or *Cottage Scenery* and *Landscape: Rural Scenery,* may not have been intended as fixed pairings. They may reflect, rather, the dualistic operations of the artist's mind. As a portrait painter, Bingham had made many pairs of images of husbands and wives, which may have prompted in him a binary viewpoint expressed in pairs of loosely related genre paintings. In any event, each of the four paintings was purchased and dispersed separately by the Art-Union in December 1845. While *The Concealed Enemy* was sold for forty dollars and *Cottage Scenery* for thirty-five, *Fur Traders* was acquired for seventy-five dollars (still a relatively modest price, considering that in a couple of years, Bingham's works would command four times as much).

Bingham's great success at the Art-Union at the end of 1845, and the premium paid for *Fur Traders,* encouraged him to focus his attention on paintings of river life. *Boatmen on the Missouri,* which Bingham painted in the first half of the following year, was also purchased by the Union, for one hundred dollars. It was in this painting, among the most beautifully composed of Bingham's works, that the artist found his heroes of Western American life: the river and its workers. Three figures, etched firmly, crisply, and simply against the hazy bank of trees on the far shore, represent a stage of settlement after the one symbolized by the fur traders. Soon all three men will be transferring wood to the steamboat, which is fast approaching in the distance. Just as *Fur Traders* was the harbinger of a new age of civilization, the approaching steamer here is a more contemporary vehicle of social and commercial advance. The finished drawings that exist for each of the figures in this painting show how carefully Bingham constructed the central image out of its constituent elements.

In nineteenth-century accounts, Missouri boatmen are characterized as a boisterous, vulgar lot. Here Bingham acknowledges their individual-

The Concealed Enemy
1845. Oil on canvas, 29¼ x 36½″
Stark Museum of Art, Orange, Texas

For a "Western" painter, Bingham did few images of American Indians. His central interest—unlike that of George Catlin, Karl Bodmer, or Peter Rindesbacher—lay with the white settlers and their communities. In that context, this "enemy" is shown in isolation and in hiding, with the implication of his inevitable retreat.

ity and their toughness, but he also elevates them to the position of ancient river gods, guardians of commerce. Imbued with classical restraint, they beckon the viewer into their world and gaze forward with confidence into the future. The boatmen do not appear wise in the bookish sense; rather, they stand for physical well-being, psychological balance, and practical good sense.

In contrast to Bingham's paintings of the 1840s, the rich nineteenth-century literature and folklore surrounding the riverboatmen portrays them as powerful, violent heroes of the waterways. The legendary boatman Mike Fink, "half horse, half alligator," was the prototype for the popular view of these men. Written stories about Fink began to appear in the late 1820s. The first published work, Morgan Neville's *The Last of the Boatmen* (1828), describes Fink as possessing "a figure cast in a mould that added much of the symmetry of an Apollo to the limbs of a Hercules." It goes on to say that "he possessed gigantic strength, and accustomed from an early period of life to brave the dangers of a frontier life, his character was noted for the most daring intrepidity." In 1829, the Reverend Timothy Flint, who traveled widely in the Mississippi Valley, wrote in the *Western Monthly Review* that Fink had become famous as "the best shot in the country" and could drink a gallon of liquor in a day without noticeable effect. According to the reverend, Fink's language was "a perfect sample of the half-horse and half-alligator dialect of the then race of boatmen." Fink was quoted in the article as saying, "I am a salt river roarer; and I love the wimming [women], and how I'm chock-full of fight." It was such robust source material that Bingham transformed into his dreamy-eyed boatmen. Bingham wanted to create likeable boatmen, not the wild men of legend, both to be truer to reality and to appeal to those Easterners who viewed the West as a safe and stable place.

In *Boatmen on the Missouri*, there is little to distract from the impression that these men are the beacons of the future. Two of the three relaxed figures return the viewer's glance with equanimity, while the third, closing the composition, holds his head down as he works. If *The Concealed Enemy* and *Fur Traders* suggest the decline of Indian civilization and the dawn of a new age, *Boatmen* refers to the end of the era of the flatboat and its replacement by the steamboat, which plied the Missouri with increasing frequency from the 1820s on. It seems that, in his landscapes and genre paintings, Bingham is more comfortable depicting the commerce of an age that by the 1840s had already largely passed.

The mood of river stillness was broken by Bingham's next picture, *The Jolly Flatboatmen* (1846). Instead of portraying a wood boat awaiting a steamer, Bingham goes back to a time when the flatboat (essentially a large raft with oars) floated along the river, transporting food and

Boatmen on the Missouri

1846. Oil on canvas, 25 x 30″
By permission of The Fine Arts Museums
of San Francisco. Gift of Mr. and
Mrs. John D. Rockefeller III

Bingham's riverboatmen represented a dramatic change from the citizens who commissioned their own portraits. While the portraits depicted the pillars of their communities, the boatmen were essentially roughhousing laborers.

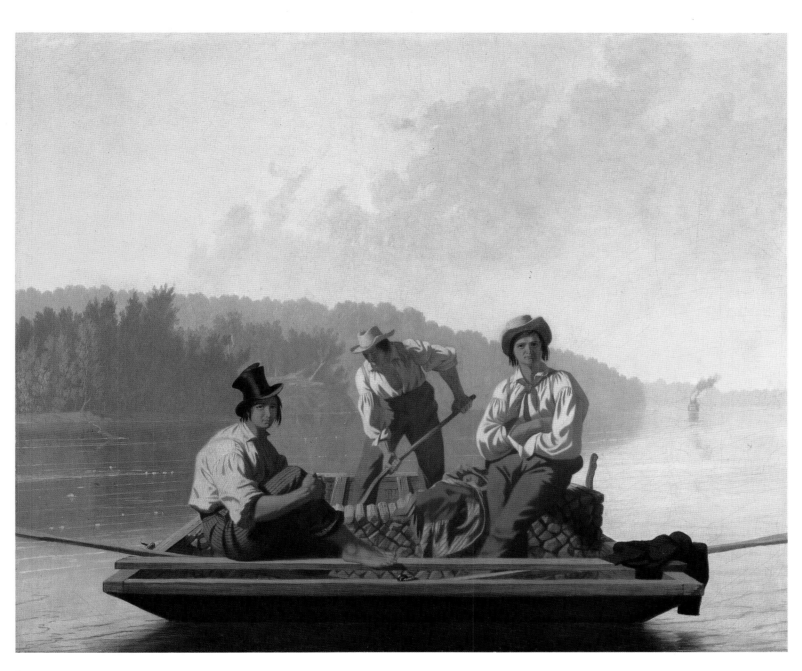

Boatmen on the Missouri

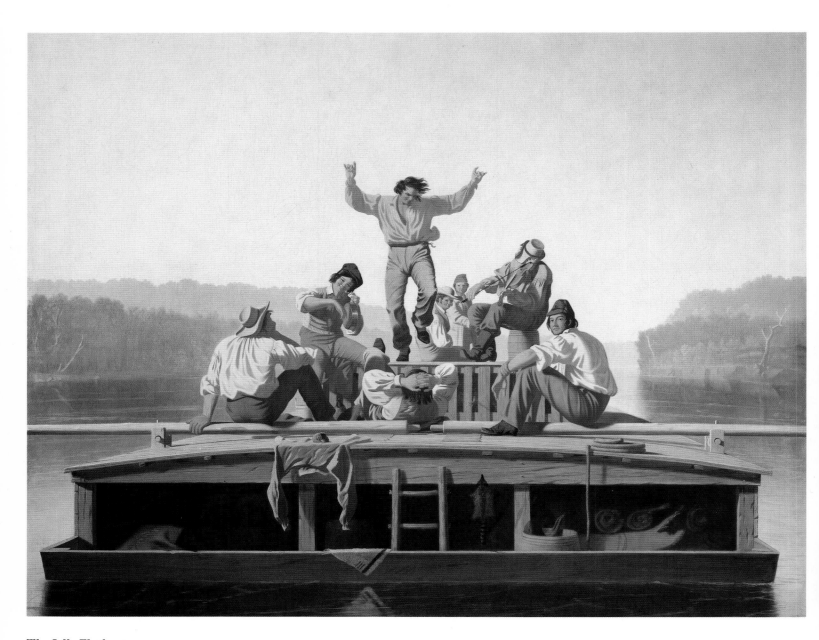

The Jolly Flatboatmen

freight. Constructed as sparsely and cleanly as possible, the painting features eight men on a flatboat, set against a cloudless but gently modulated sky. The central figure dances as the boat floats gently down the calm waters.

Dancing figures and people making impromptu music had also been effective elements in works by William Sidney Mount—*Dance of the Haymakers* (1845), for example. Bingham's dancing figure, however, is a robust response from the West to Mount's agrarian celebrations. Unfettered by the strictures of civilization, the dancing flatboatmen seem instead to be its advance guard, carrying its confident message through the dramatic compositional device of the single, silhouetted figure clothed in red and blue. The dancing figure performs on a stage made out of a wooden turkey coop, set at the center of the flatboat. We can almost hear the humble sound of the boy tapping on the tin plate, the scratchy music of the country fiddle, and the snap of the dancer's fingers breaking the silence of the day. It is—as much as Walt Whitman's poetry would be, just after mid-century—a song of the open road.

As in *Boatmen on the Missouri,* the oars lock the painting into the picture plane, as does the edge of the boat, which is absolutely parallel to the lower edge of the painting. We see into the lower section of the flatboat, with its hanging animal pelt, drying blue shirt held in place by a rock, and bedrolls stowed below. A cloth hanging over the lower edge of the flatboat is reflected in the water with the same softness that the image of the canoe has in *Fur Traders.* Of the eight figures, four acknowledge our gaze; the others are absorbed in dancing or playing. That the viewer is both acknowledged and ignored suggests that the moment observed, though carefully constructed, is spontaneously unfolding before our eyes.

The painting was submitted to the Art-Union as *Dance on the Flat Boat,* a title that was close to Mount's *Dance of the Haymakers.* It was purchased for two hundred ninety dollars, almost three times as much as *Boatmen on the Missouri* and four times as much as *Fur Traders.* When it was raffled off by the Union, it was under the more compelling title of *The Jolly Flatboatmen.* The Union twice made the painting into a print: first to be used as a frontispiece to its *Transactions* of 1846 and then, the following year, as a black-and-white engraving made in New York by Thomas Doney. Up to ten thousand of Doney's prints were distributed to the Union's membership.

The distribution of the 1847 line-and-mezzotint engraving of *The Jolly Flatboatmen* probably did more to spread Bingham's fame than any other single event in his career. For Bingham, the combination of selling his painting and then distributing its image to thousands of people was

The Jolly Flatboatmen
1846. Oil on canvas, 38⅛ x 48½"
Private collection, on loan to the National Gallery of Art, Washington, D.C.

When it was originally submitted to the American Art-Union, this painting was called Dance on the Flat Boat, *a title which alluded to William Sidney Mount's* Dance of the Haymakers *(1845). The Art-Union made this image well known. An etching of* The Jolly Flatboatmen *appeared as the frontispiece of its publication for 1846, and in 1847 the work was issued by the Art-Union as an individual print and distributed to all its members.*

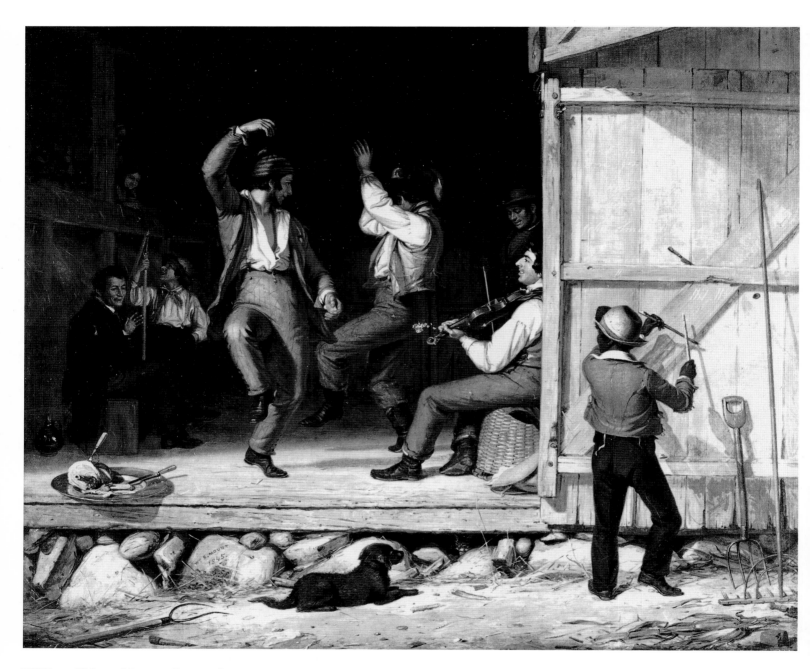

William Sidney Mount, *Dance of
the Haymakers*

1845. Oil on canvas, 24 x 29″
The Museums at Stony Brook, New York. Gift of
Mr. and Mrs. Ward Melville, 1950

Mount's Dance of the Haymakers *incorporates dancing and music making
in a rustic setting, just as Bingham combined the two in his painting of the subsequent year* The Jolly Flatboatmen.

Thomas Doney, after
George Caleb Bingham,
The Jolly Flatboatmen

1847. Engraving, 22⅝ x 23⅞″ (image)
The Saint Louis Art Museum. Museum purchase

*The distribution of this line-and-mez-
zotint engraving by the Art-Union prob-
ably did more to spread Bingham's name
than any other single event. It also made
Bingham aware of prints as important
vehicles for marketing his works.*

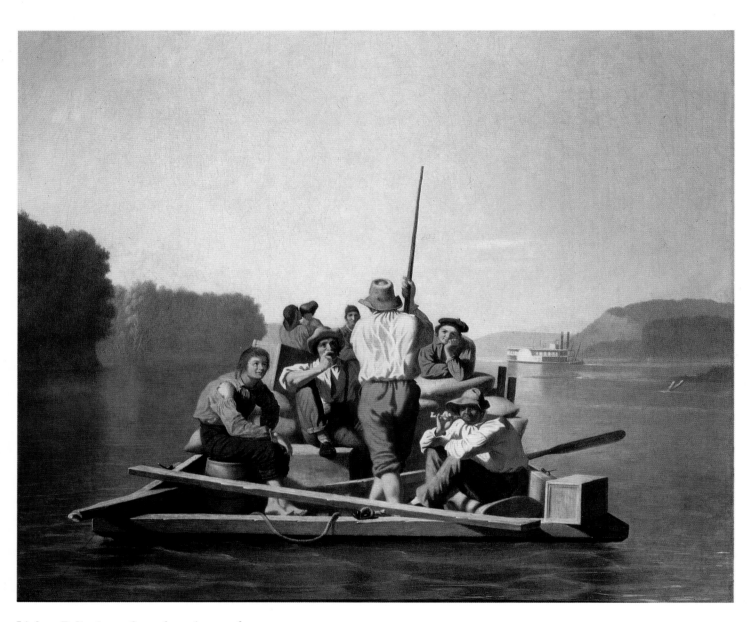

Lighter Relieving a Steamboat Aground

convincing proof that the print process could be an important vehicle for the marketing of his works. Though not the first print after one of Bingham's paintings, *The Jolly Flatboatmen* was the first to depict one of his Western genre subjects.

Another river painting, *Lighter Relieving a Steamer Aground* (1846–47), was described in the *Saint Louis Republican* of April 21, 1847, as depicting "a steamboat, in the distance, aground on a sand bar. A portion of her cargo has been put upon a lighter or flatboat, to be conveyed to a point lower down the river. The moment seized upon by the artist is, when the lighter floats with the current, requiring neither the use of oar nor rudder, and the hands collect together around the freight to rest from their severe toil." The writer astutely observes that Bingham does not depict a particularly dramatic incident, but instead "has taken the simplest, more frequent and common occurrences on our rivers . . . such as would seem, even to the casual and careless observer, of the very ordinary moment, but which are precisely those in which the full and undisguised character of the boatmen is displayed." Sandbars and snags in the river threatened navigation on the inland waterways. As Nancy Rash has indicated, the clearing of such dangers as an aid to commercial development was an important concern in the 1840s and an issue that the Whig party, in particular, was involved in promoting. This painting, then, can be read as a Whiggish warning that proper maintenance of the waterways was a necessity for commercial development.

In *Raftsmen Playing Cards* (1847), for the first time the viewer is on board the raft itself, as it is poled through the shallow water between the snag on the right and the sandbar on the left. The painting was sold to the Art-Union for three hundred dollars, a new record price for a Bingham work. Recent infrared examination of the painting indicates that Bingham carefully drew pencil lines, with the aid of a ruler, where he would paint the wooden boards of the flatboat. These boards act as a stage, upon which the artist placed his figures.

When Bingham exhibited *Raftsmen Playing Cards* in Saint Louis, prior to sending it to New York, the *Saint Louis Republican* of April 21, 1847, described the painting: "Two men are playing a game of cards, well known in the West as *Three Up.* The two players are seated astride of a bench—one has led the *ace,* and the other is extremely puzzled to know what to play upon it. As often occurs, he has two friends, on either side of him, each of whom are giving advice as to which card he ought to play." Of the rivermen themselves, the anonymous author wrote, "Their employment, the dangers, fatigues and privations they endure—the river and its incidents and obstacles—its wild and beautiful scenery—its banks of rocks, or its snags, sawyers and sand bars, draw out, as it were, the *points*

Lighter Relieving a Steamboat Aground

1846–47. Oil on canvas, 30½ x 36⅛"
The White House Collection, Washington, D.C.

The grounding of a steamboat on a sandbar has been interpreted as an allusion to the Whig party's concern that snags should be cleared from inland waterways to promote commercial development.

Raftsmen Playing Cards

1847. Oil on canvas, 28 x 36″
The Saint Louis Art Museum. Museum purchase:
Ezra H. Linley Fund

*The raftsmen in Bingham's paintings
are modeled on the legends of early-nine-
teenth-century boatmen such as Mike
Fink, who was described as "half horse,
half alligator."*

of these hardy, daring, and often reckless men."

The six figures in the painting are either entirely preoccupied with the game of cards or lost in their own thoughts, in the kind of meditative self-absorption that is a recurring theme in Bingham's work. The sunlight casts long shadows across the boat. In the foreground are the charred remains from the previous night's fire. And the figure who sits rather groggily at the left appears not to have fully awakened. Infrared examination also indicates that Bingham first painted the skillet in the right foreground, then replaced it with the pair of shoes, and finally painted it near the ashes of the fire.

In 1808, the subject of card players had been treated by the British genre painter Sir David Wilkie, and Bingham might have been inspired by that model. The year before Bingham painted *Raftsmen Playing Cards*, Richard Caton Woodville's interior view *The Card Players* (1846) was exhibited and purchased by the American Art-Union. By contrast, Bingham's painting is less involved with anecdotal incident than Woodville's, and Bingham transports the traditional interior gaming picture, with its disreputable associations, to the outdoors. Bingham's card players are clearly workers, unfettered by the constraints of "civilization."

A study of Bingham's river pictures makes it obvious that the artist planned their evolution with an almost cinematic self-awareness. He moved the viewer from the riverbank onto the raft itself and from the format of the two fur traders to the six raftsmen. The series of paintings stands out as a unit, a group of interrelated images that unfold over time. In *Raftsmen Playing Cards*, instead of the geometry of the extended oars in the woodboat and the flatboat, Bingham used the foreshortened trape-

Left:

William Greatbach, after
Sir David Wilkie, *Card Players*
1808. Engraving, 6⅛ x 8⅝" (image)
Published in the *Wilkie Gallery* (1848–50)

Engravings after Sir David Wilkie's paintings were widely disseminated and may have encouraged Bingham to do a picture of flatboatmen absorbed in a card game as they float downriver.

Right:

Richard Caton Woodville,
The Card Players
1846. Oil on canvas, 18½ x 25"
The Detroit Institute of Arts, accession no. 55.175.
Gift of Dexter M. Ferry, Jr.

The year before Bingham painted his view of raftsmen playing cards, Woodville completed this interior of a similar subject. Woodville, who had left the United States to study painting in Düsseldorf, had a greater interest in anecdotal incident than Bingham.

As the sun sets, three men sit on the sandy bank of the river. The two in front engage the viewer, while the young boy is preoccupied with starting the campfire. In the distance, other figures in a tiny boat remove cargo from a steamboat which lists helplessly on a sandbar.

zoidal form of the raft to project us more deeply into the picture space and to keep our concentration on the six men who travel with us. The two prongs of the shoreline and the hazy banks in the distance gently enfold the form of the raft.

The Jolly Flatboatmen and *Raftsmen Playing Cards* were conceived to suggest, respectively, active and passive aspects of life among the raftsmen. In that sense, they might be considered loose pendants, and they are further similar in that they both depict amusements—music making and card playing. In subsequent paintings, Bingham would continue to expand his depictions of rural leisure activities to include checker playing and riflery contests.

After *Raftsmen*, the artist executed a group of four works of rivermen onshore. Of these, only one, *Watching the Cargo* (1849), has been located. It depicts a group of three figures placed to the side, rather than at the center of the composition, and lounging on a river sandbank. The

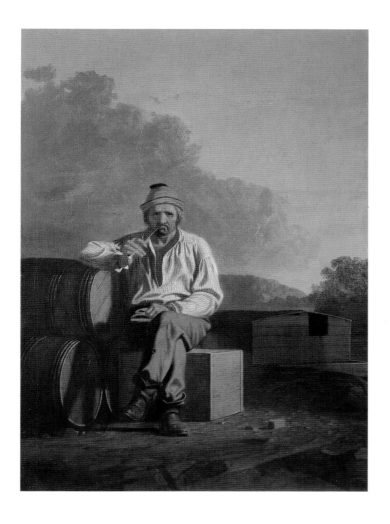

Mississippi Boatman
1850. Oil on canvas, 24⅛ x 17½"
Private collection

With his arm resting on the stacked barrels, the wizened old boatman sits calmly yet forcefully in the foreground, with his flatboat tied up behind him. The figure appears closely related to Watching the Cargo, *a painting of the previous year.*

viewer, who was located on the raft in the previous picture, is now firmly ashore. The cargo has been removed from the listing steamboat shown in the distance, and an improvised lean-to protects it from the chance of rain. The fading light on the freely painted clouds announces the arrival of evening. In the distance, we see a tiny skiff whose two occupants continue to unload cargo from the steamboat.

The viewer seems to be within conversational distance of the three men, who have done their work and now rest. The man in the foreground is casually posed like an ancient river god. Both he and the frontally placed older man in a blue cap return the viewer's gaze, while the most youthful member of the trio is absorbed by his amusing attempts to start a fire. Painted with simplicity and directness, these three "rude" types have successfully improvised their accommodations for the night. They are frontier models—energetic, pragmatic, entrepreneurial.

It seems contradictory that an artist as devoted to hard work and diligent effort in his personal and professional life as Bingham was should create so many paintings in which one of the central concerns appears to

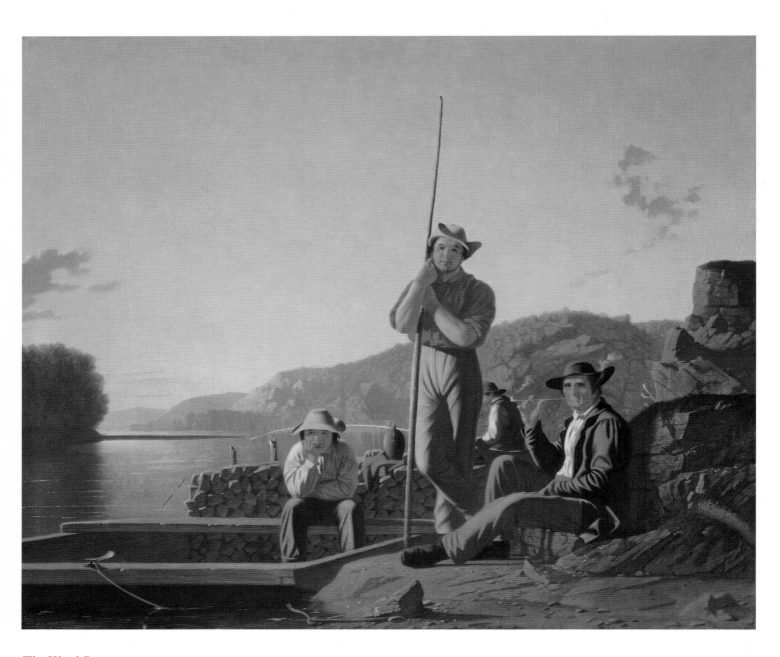

The Wood-Boat

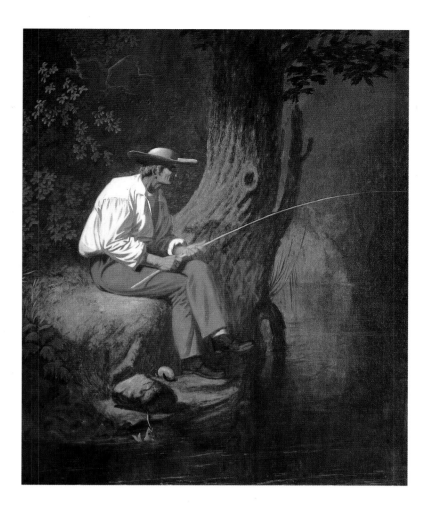

be inaction. Yet, there are many virtues to rest—contemplation, moderation, and deliberation being just a few. And when we consider that the subjects who pause before us, impassively smoking long-stem pipes or gazing toward bobbing fishing lines in the river, are anonymous members of a working class, then we can more clearly realize that Bingham was celebrating the common man as he defined a new American type, the frontier American. In the rivers, rafts, and people of the 1840s, Bingham found a Western American ideal. Cleansing these stevedores of their flaws, he displayed them as poised, hearty men in tune with themselves and their place in creating the nation's future.

Rivers and boats are metaphors for commerce and progress, and Bingham's pictures depicting them are animated by similar notions. *The Wood-Boat* (1850), like *Watching the Cargo,* features an off-center composition. The three main figures await the arrival of a steamboat, which will need to be loaded with their freshly chopped wood. As dawn breaks, we are, once again, far from any urban location. The poleman, with his endearingly cocked head and strong form that breaks the horizon line, is the heroic center of this work. His pose and appearance as-

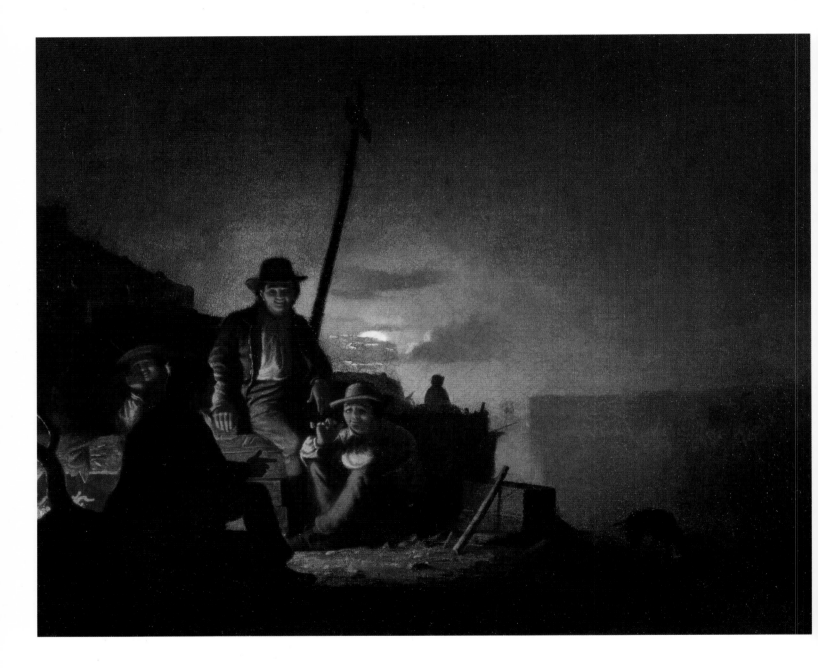

Watching the Cargo by Night or
Raftsmen at Night

1854. Oil on canvas, 24 x 29"
Courtesy of the Museum of Western Art, Denver

*In 1854, probably when he was paint-
ing* Stump Speaking *in Philadelphia,
Bingham did this and another noctur-
nal scene of riverboatmen. Although
usually preferring the nuances of early
morning or late afternoon light, in the
mid-1850s Bingham explored the effects
of moonlight and campfires on his fig-
ures and boats.*

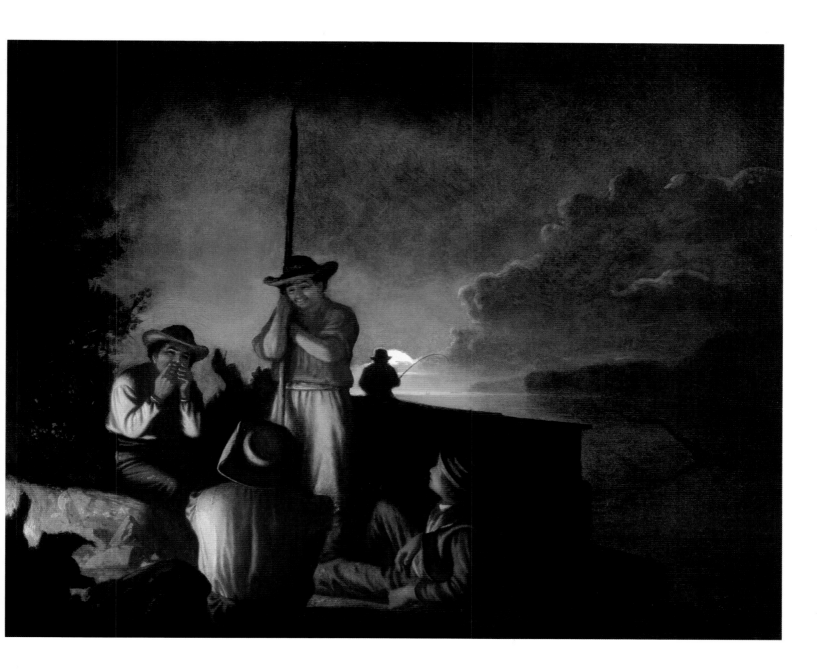

Wood-Boatmen on a River

1854. Oil on canvas, 29 x 36¼″
Amon Carter Museum, Fort Worth

The two nocturnes from 1854 show an intimate gathering of figures positioned asymmetrically on the banks of a river. In one canvas the men listen to a story, in the other to music. Both scenes open on the right to the moody landscape of night on the river.

Fishing on the Mississippi

sert strength, industry, and abundant good health. In the world of Bingham's river paintings, there is little sense of danger or death.

A raking pink light washes across *The Wood-Boat* and casts its rosy glow on the stony bluffs, the edges of the stacked wood, and the rocks by the river. All of the figures—the wizened old man puffing on his thin pipe, the simple, round-faced boy sitting with his hand on his chin, the ruddy-cheeked central figure, and the slouching, half-hidden fisherman—are lost in their own thoughts. Their job is to wait, and they do it with equanimity. Equally content to sit and wait is the figure in Bingham's *Mississippi Fisherman* (1850). Bingham later returned to the subject of riverboatmen resting on the side of the river in two nocturnes—*Watching the Cargo by Night* and *Wood-Boatmen on a River*—that he painted in 1854.

The year after *The Wood-Boat,* Bingham painted *Fishing on the Mississippi* (1851), which also groups figures on the banks of the river. The rope that moors the fishermen's unseen boat is tied to a tree stump in the foreground; a taut fishing line extends from a rock into the water. As in *The Wood-Boat,* the figures patiently wait, in this case for a fish to bite. As a counterpoint to the inaction of the fishermen, three men in the middle ground vigorously maneuver their flatboat. *Fishing on the Mississippi* has one of Bingham's most dramatic skies. The clouds range in color from green in the foreground to pink in the background; the light casts rosy highlights on the stones of the rocky bank.

During the same period as the river paintings, Bingham made a small group of landscapes that continued to develop his view of the West as a benign realm to be peopled by the entrepreneurs and settlers of the future. In apparent emulation of the Art-Union's system, one such painting, *Landscape with Cattle* (1846), was put up for raffle in 1846 in Saint Louis at five dollars a chance. On September 18, 1846, the *Weekly Reveille,* a Saint Louis newspaper, described the work as "representing the majestic old woods rising on the rich bottom; the herd reclining beneath their shade; the river winding its way in the distance, and in the background a bold bluff rearing its high summit, in wild grandeur, besides the father of waters." The Mississippi Valley was as Bingham depicted it, an Edenic and tranquil world that beckoned settlement.

In *Landscape with Cattle,* two flanking trees frame the deep central space. On one side, an intimate woodland glen closes off our view into the distance, while on the other, a purple mountain blocks further recession into depth. The cows, symbols of human settlement, point the viewer into the scene. They sit with the same stolid, comfortable placidity as Bingham's riverboatmen, Mississippi fishermen, or villagers. And though people are not depicted, the painting expresses as deeply a homocentric view as the figural works do.

Fishing on the Mississippi
1851. Oil on canvas, 28¾ x 35⅞"
The Nelson-Atkins Museum of Art, Kansas City, Missouri (Nelson Fund) 33–4/4

Fishing on the Mississippi *is an unusual composition for Bingham, in that he uses the fishing pole to create a connection between the figures on the left and the flatboat in the distance. The standing figure in the foreground, who is fastening the hook on the line, is visually related to the pole men in* The Wood-Boat *(1850) and* In a Quandary *(1851), and to the older man in* The Squatters *(1850).*

Landscape with Waterwheel and Boy Fishing (1853) was more closely tied to Bingham's own memory of his youth than to the time in which it was made. For this painting, Bingham adapted the rustic cottage in *Cottage Scenery* into a mill. The children who appear in both works reflect not only Bingham's reminiscence of the homes of his youth, but also his involvement with his own growing young family. Like a number of Bingham's landscapes, this work does not seem specifically rooted in the American West; it has a more generic quality that ties it closely to European paintings of rural life.

There is another common element in these various landscape paintings: the use of water. Water is a soothing, almost continual presence in Bingham's landscapes and in many of his genre paintings. Its movement and reflection are visual metaphors for the passage of time. In Bingham's West, the rivermen are alert to the passing of time, for it is only with time that the future they are building will come. Water was also the conduit that allowed Bingham to create images out of his own past. Not only was it a primary component of his own upbringing in Franklin and in Arrow Rock, but its shifting, yet constant nature also filtered out extraneous details and suggested dreamlike recollection in the hazy light.

At the same time that Bingham was working on the river and landscape paintings, he was deeply committed to Missouri state politics. In 1846, less than two years after returning from Washington, D.C., Bingham ran, with the encouragement of Rollins, as the Whig candidate for the Missouri state legislature. In the race for representative from Saline County, in which Arrow Rock is located, his adversary was the Democrat Erasmus Darwin Sappington (the son of Dr. and Mrs. Sappington, who lived in Arrow Rock and whose portraits Bingham had painted). Bingham was initially declared the winner by a margin of only three votes. Sappington demanded that the outcome be determined by the legislature, which was controlled by the Democrats. Bingham countered by requesting a new election. After months of debate, Sappington was declared the winner by a vote in the legislature. As one can imagine, Bingham found the partisan political warfare to be deeply unsettling. He bitterly characterized the experience in a letter to Rollins: "An Angel could scarcely pass through what I have experienced without being contaminated. *God help poor human nature.* As soon as I get through with this affair, and its consequences, I intend to strip off my clothes and bury them, scour my body all over with sand and water, put on a clean suit, and keep out of the mire of politics *forever.*"

Nevertheless, less than two years later, in 1848, Bingham campaigned again for the same seat. This time, he defeated Sappington to earn a two-year term as a representative in the Missouri Legislature.

Landscape with Cattle
1846. Oil on canvas, 38 x 48″
The Saint Louis Art Museum.
Gift of Mrs. Chester Harding Krum

For Bingham, the depiction of "peaceful fields and lowing herds" suggested the "advancement of civilisation."

THE RIVER PAINTINGS

Landscape with Cattle

During this, his only term of elected office, the question of how the United States should legislate the slavery question in its recently acquired territories was hotly debated. In his later years, Bingham held several appointive offices such as state treasurer, and he even contemplated running for the governorship of the state and for Congress.

The intensity of Bingham's involvement in Missouri's political life in the 1840s cannot be overestimated. He was not only concerned in the broadest terms for the future of the country, but also for how the structures of government could be applied to the undefined experience of Western life. This concern for the transfer of democracy to the West manifested itself in Bingham's other great series of paintings. In these works, the artist's attention shifted away from the commerce of river life toward the definition of political life in the West.

Landscape with Waterwheel and Boy Fishing

1853. Oil on canvas, 25⅛ x 30″
Robert J. Edwards Fund. Courtesy, Museum of Fine Arts, Boston

Many of Bingham's canvases include young children at play. In other paintings, fishing would be more specifically tied to the Mississippi and Missouri rivers, while here it is presented in a pastoral mode.

Landscape with Waterwheel and Boy Fishing

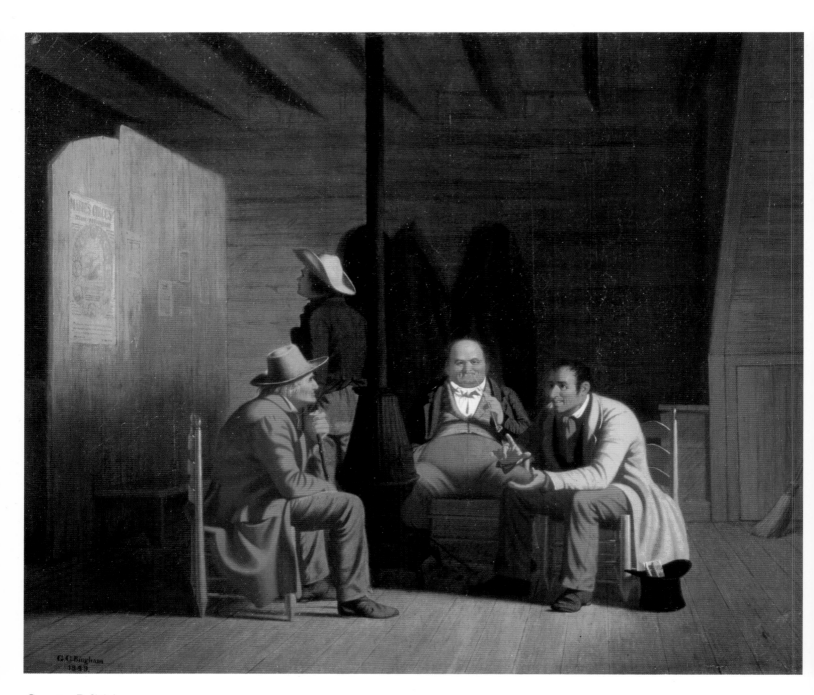

Country Politician

III. *Life and Politics in the West,*
1849–57

JUST AS BINGHAM'S FAMILIARITY WITH RIVER LIFE, as an artery of commerce and national progress, led him to select boatmen and their craft as subjects for paintings, so did his involvement in electoral politics result in a number of works devoted to that theme. Again, Bingham would bring national issues—slavery, sectional political differences, and Western development—into focus through the lens of small town life. His paintings of Western life and politics operate at local and national levels simultaneously, with Bingham encoding specific regional concerns in ways that might, in his time, appear generic to Eastern eyes and today might not be sensed by viewers at all.

Less than a year after Bingham's stinging electoral defeat at the hands of Erasmus Darwin Sappington (scion of one of the state's most powerful Democratic families), he completed his first important political painting. *The Stump Orator* (1847) was exhibited at the National Academy of Design in 1848 and was purchased by the Art-Union the same year. The painting is, however, unlocated and is known today only from a photographic image. On November 30, 1847, the *Daily Missouri Republican,* a Saint Louis newspaper, described *The Stump Orator* as follows: "The artist has fixed at the moment of time, (late in the evening) when the orator is arriving at the climax of his argument. The speaker is evidently well pleased with the impression he is making. He is mounted on the *stump* of a fresh cut tree. In front of him 'whittling a stick', sits his 'opponent', with his brows knit, and the blood veins swollen, mouth compressed, and rage and opposition depicted on his countenance."

From his recent close campaign for the state legislature, Bingham knew firsthand the challenge of these open-air campaigns. The enraged and frustrated opponent, who listens to the orator's speech while occupying himself by whittling, may well represent Bingham and his powerful feelings of being unjustly defeated in the election of 1846. But even if he perceived the political system to be imperfect, Bingham maintained his belief in it; rebounding from his first defeat, he ran successfully against Sappington in 1848.

While serving his term as state representative from Saline County,

Country Politician

1849. Oil on canvas, 20 x 24"
By permission of The Fine Arts Museums of San Francisco. Gift of Mr. and Mrs. John D. Rockefeller III

Bingham always tried to depict the chronological and physiognomic range of the human form in his genre paintings, often arranging "types" of men as distinct and at times humorous counterpoints to each other. For example, the corpulent, red-cheeked sitter who smokes a pipe in this painting plays off the older hatted figure with the cane and the tousle-haired young politician, as well as the uninterested young man.

75

Although unlocated since it was distributed by the American Art-Union to William Duncan in Savannah, Georgia, The Stump Orator *is known through this daguerreotype, which actually shows the painting reversed. It depicts the type of public debate that Erasmus Sappington and Bingham participated in during the summer of 1846, when they were both campaigning for a Missouri state legislature seat. The painting was completed the year after Bingham's narrow defeat in this contested election. It set the stage for his political series of the 1850s, and was in fact the basis for* Stump Speaking *(1853–54).*

Bingham painted his second political work, *Country Politician* (1849). While reflecting Bingham's continuing sympathy for and adaptation of Mount's intimate, congenial scenes, the painting also mirrors Bingham's ongoing fascination with the process of electoral politics. A simple tavern shelters the four men in *Country Politician.* The wooden slats of its floor, walls, and ceiling create an austere box that contains the protagonists, just as the structure of the flatboat provided an outdoor stage for the boatmen. The composition is centered on the black shaft of the potbellied stove and counterbalanced by the pair of figures on either side of it. Bingham transposed the format of Wilkie's *The Village Politicians* (1814) and Mount's *The Tough Story* (1837) to a spare frontier town. In this simple, rustic environment, light articulates the edges of the ladderback chairs, the rims of the hats worn by the old man and the young boy, and the hands of the speaker and also creates subtle nuances of muted color within the wooden box.

There is a political as well as artistic agenda to this painting. A reporter for the Saint Louis *Daily Missouri Republican,* on April 17, 1849, described the scene as depicting men discussing the Wilmot Proviso. The Proviso, antislavery legislation that would apply to new territories entering the Union, was intensely debated about this time. In 1849, Missouri Democrats were discussing the Jackson Resolutions (named after the proslavery Democrat Claiborne Fox Jackson), which would

Abraham Raimbach, after Sir David Wilkie, *The Village Politicians*

1814. Engraving, 19⅞ x 24″ (image)
Yale Center for British Art, New Haven.
Paul Mellon Collection

Sir David Wilkie's richly detailed paintings and engravings of rustic life inspired many nineteenth-century American genre painters. Bingham used both Wilkie's animated discussion around a table and—as counterpoints—his figures who are uninvolved in the central activity. However, he rejected Wilkie's penchant for vignettes that are independent of and incidental to the main activity of the painting, for he preferred a more spare and classically composed format.

William Sidney Mount, *The Tough Story—Scene in a Country Tavern*

1837. Oil on panel, 17 x 22″
In the collection of The Corcoran Gallery of Art, Washington, D.C. Museum Purchase

Bingham may have seen Mount's The Tough Story *at the 1838 annual exhibition of the National Academy of Design in New York. The painting is the closest formal analogue to Bingham's* Country Politician *(1849). The most dramatic difference between the two is the shift in emphasis from the recounting of a lengthy anecdote by an imbibing invalid in the painting by Mount to an earnest political dialogue in the Bingham.*

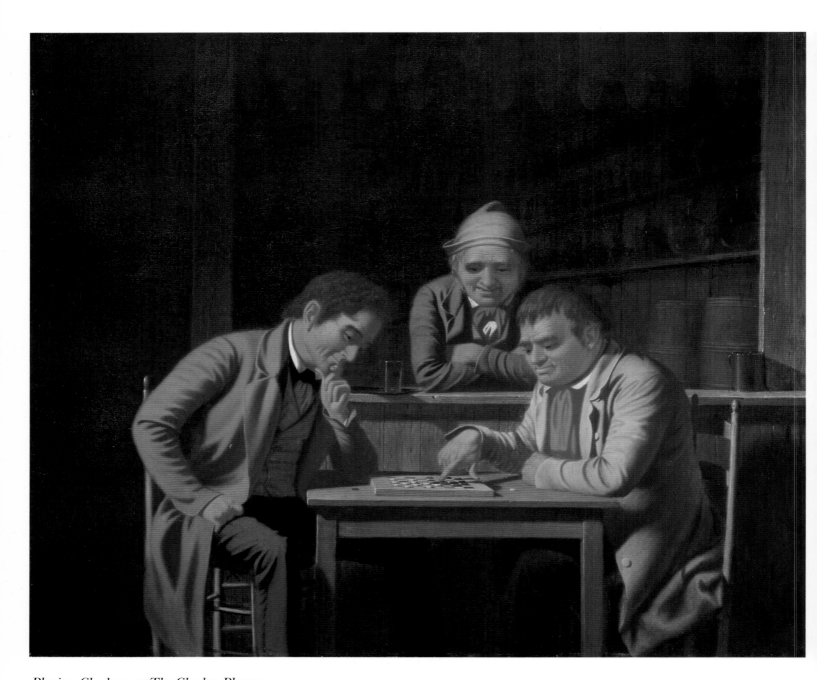

Playing Checkers or *The Checker Players*

bind the Missouri congressional delegation to attempt to break the Proviso. Bingham unsuccessfully tried to have his own moderate legislation, called the Bingham Resolutions, adopted. Local people in Saint Louis might well have thought of the Wilmot Proviso in viewing *Country Politician,* but audiences in New York would have seen it more generically.

The painting depicts the intersection of differing temperaments and viewpoints: the energetic self-confidence of the politician is met by the benign skepticism of the older listeners. The ruddy-cheeked young politician, who underscores his point with raised index finger and outstretched hand, is a more polished, pictorial descendant of the stiffly posed speaker in *The Stump Orator.* His eagerness and the restraint on the part of the other two primary figures is contrasted here with the uninterested attitude of the boy reading the posters on a side wall. One of the posters he looks at, for Mabie's Circus, may indicate Bingham's commentary on how easily individuals could be distracted from important issues by trivialities such as a local circus. Then again, Bingham might be commenting on the circus-like discussions at the State Capitol in Jefferson City on such issues as the Jackson Resolutions.

In its presentation of activity and involvement, passivity and uninvolvement, *Country Politician* presents modes of behavior similar to those of the boatmen in the river paintings. Bingham thus adapted the inventory of human responses found in his river paintings to his political works as well. Here, the same freedom that permits unencumbered speech also provides the liberty to ignore or dispute it. This spirit of free discourse helps to define Bingham's political paintings as images of a rambunctious society that incorporates both positive and negative attributes as parts of an inclusive, ungainly, but ultimately positive electoral process.

In the year following *Country Politician,* Bingham painted another tavern scene. The focus of *Playing Checkers* (1850) is not on political debate, but on a different sort of contest. The clean-shaven man who campaigned for election in *Country Politician* appears here in another guise: playing checkers against the squat and stubble-chinned rustic. They are an unlikely pair, but in the open atmosphere of the West, social distinctions are more fluid and less stratified than in the East. Bingham seems to be saying that in the West differences of wealth, education, and appearance may be suspended, as the forces of open competition come into play.

The competitors' table seems to be placed in the open air, in front of the simple bar. Thanks to the gentle light, the figures emerge from the inky recesses of the bar. One can vaguely see liquor bottles lined up on the shelves to the right of the bartender. Just as Bingham clarified the

Playing Checkers or
The Checker Players

1850. Oil on canvas, 25 x 30″
The Detroit Institute of Arts, accession no. 52.27.
Gift of Dexter M. Ferry, Jr.

Many of Bingham's paintings have central groups of three people; Raftsmen Playing Cards *(1847),* Country Politician *(1849), and* Playing Checkers *(1850) are among them. In these arrangements, the flanking individuals face each other, while the central figure faces outward. The viewer completes this intimate grouping and becomes a fourth element that balances the central figure.*

Canvassing for a Vote

James Goodwyn Clonney,
Politicians in a Country Bar
1844. Oil on canvas, 17⅛ x 21⅛"
New York State Historical Association,
Cooperstown

Clonney's Politicians in a Country
Bar *precedes Bingham's two paintings
set in or outside taverns,* Playing
Checkers *(1850) and* Canvassing for
a Vote *(1851–52). In the former,
Bingham groups a tavern keeper and
two checker players at a table, and in the
latter, a persuasive politician encoun-
ters local voters. In Bingham's paint-
ings, the two checker players and the
politician and the electorate confront
each other directly; Clonney's composi-
tion is more diffuse. The two artists are
closest in their effective use of gesture to
communicate an engaging politician's
attempts at persuading his skeptical lis-
teners.*

interior space of Mount's *The Tough Story* when he painted *Country
Politician,* so he does with James Clonney's *Politicians in a Country Bar*
(1844) and Richard Caton Woodville's *The Card Players* (1846), two pro-
totypes for *Playing Checkers.* Bingham's painting is more spare and bal-
anced, more harmonious, than Woodville's work. There, the older man's
disputing of a hand sets a sinister tone in contrast with the friendly con-
test in Bingham's picture.

The third of Bingham's tavern paintings is *Canvassing for a Vote*
(1851–52). It is one of two paintings (the other being *In a Quandary,*
1851) commissioned from Bingham by Goupil & Co. of Paris and New
York as the prototype for a print; the color lithograph of the work
appeared in 1853. *Canvassing for a Vote* transports the figures in *The
Country Politician* to the out-of-doors. The simple wooden tavern in the
earlier work is now a handsome red brick structure, as if time had passed
and the frontier town had reached a higher stage of development.

The politician from *The Stump Orator,* now in his third incarnation
in Bingham's political paintings, appears here with his top hat on. This
handsome young protagonist makes a gesture similar to his previous one:
raising the index finger of his right hand over the open but slightly
cupped lower hand. The gesture serves as a sign of rational discourse.

Canvassing for a Vote
1851–52. Oil on canvas, 25⅛ x 30¼"
Nelson-Atkins Museum of Art, Kansas City,
Missouri. Nelson Fund

*Commissioned by the publishing firm
of Goupil & Co. of New York and Paris,
this painting served as the basis for a
print the company published. It is re-
lated to Bingham's earlier interior scene*
Country Politician *(1849).*

Shooting for the Beef

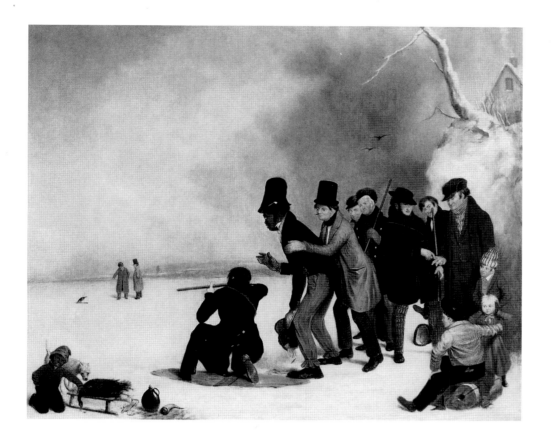

Charles Deas, *The Turkey Shoot*

c. 1836. Oil on canvas, 24½ x 29½"
Virginia Museum of Fine Arts, Richmond.
The Paul Mellon Collection

Like Bingham's Shooting for the Beef
(1850), Charles Deas's The Turkey
Shoot *depicts a congenial outdoor game
of marksmanship. In Bingham's paint-
ing, however, the grisly aspects of the
competition are implied but not depicted.
Deas, whom Bingham probably encoun-
tered in Saint Louis in the 1840s, sub-
mitted this canvas to the National
Academy of Design's 1838 exhibition,
which Bingham might well have at-
tended. The previous year, William
Sidney Mount had exhibited another
painting about competing for game,*
Raffling for the Goose *(1837).*

The gloriously squat and potbellied central figure is similar to the port-
ly central figure in *Country Politician,* and he continues to listen with
good humor. The older man in the earlier picture has been replaced by
a more youthful, better-dressed man, who also receives the speech with
good-natured equanimity. The grizzled tavern owner in *Canvassing for
a Vote* wears his apron and plays the role of observer (as the bartender
had done in *Playing Checkers*), while the man who peers through the win-
dow of the tavern and the sleeping dog are cast as casual and uninterest-
ed bystanders.

Bingham's own life provides important source material for the devel-
opment of his tavern subjects. Having had a father who owned a tavern,
in Franklin, Missouri, the artist may be using such works as *Playing
Checkers* and *Canvassing for a Vote* to recollect that fact, to record the
important, positive role taverns played in rustic American life, and to
document the types of people who frequented them. While the harmful
effects of alcohol are depicted in Bingham's subsequent political pic-
tures, they are not critically referred to in these earlier works. Although
Bingham himself was a teetotaler, he appreciated taverns as important
gathering spots for rural discourse.

The tavern pictures depict men engaged in competition, whether

Shooting for the Beef

1850. Oil on canvas, 33⅝ x 49⅜"
The Brooklyn Museum, New York.
Dick S. Ramsay Fund

In Shooting for the Beef, *the tree
stump in the left foreground, the parallel
lines of the "Post Office Grocery" roof,
and the line of the pointed rifle serve to
"aim" and "fire" the viewer's attention to
the target—the plank that leans against
the dead tree in the distance. The small
sign above the plank, which reads "To
Boonsborough 14 miles," places the scene
in a Western region explored by Daniel
Boone, underscoring the enduring im-
portance of Boone in Bingham's mind.*

attempting to win in politics or to be victorious in such games as cards or checkers. These paintings are about the means by which groups make decisions and attempt to reach a consensus and also about the competitive nature of all activities among men (of whatever social level or political viewpoint) in the open-ended environment of the West.

The final, and largest, of Bingham's genre paintings showing a rural contest is *Shooting for the Beef* (1850). Country marksmen stand beside a bend in a rutted road and take their turns firing rifles at a target marked on a board that leans against a distant tree. Most of the men, like the two stocky, rosy-cheeked, half-smiling marksmen who face toward the viewer, watch the man who is about to pull the trigger. Only the ox, who stands chained to a stump and who will be awarded to the victor, wryly acknowledges the viewer's presence. The game is being played in a remote Western locale, alongside a log cabin that serves as both post office and grocery. The two pairs of dogs—a canine version of a Greek chorus, as Barbara Groseclose has pointed out—provide a witty counterpoint to the groups of figures.

Shooting for the Beef evokes a typical pastime of mid-century America, in which the human players engage in rustic sport—competing for the prize ox in the foreground. (Nearly fifteen years earlier, Charles Deas had depicted a wintry turkey shoot in the East.) The *Daily Missouri Republican* of June 4, 1850, described the painting as representing "a group of characters with life-like fidelity. There are seen the eager marksmen, in the attire of the backwoodsman; the log cabin at the cross roads, with sign above the door lintel 'POST OFFICE GROCERY;' the prize in contest, a fat ox, chained to a stump hard by."

This is one of the rare scenes in Bingham's work in which guns play a role, and it is telling that the armaments are used for sport, as a rural game, rather than against man. In the "Western" art of Frederic Remington, at the end of the nineteenth century, guns would be employed as weapons to annihilate human and animal enemies rather than as a means of communal recreation. Ironically, at mid-century, the West was depicted by Bingham as a more settled and civilized place than it would be fifty years later.

Rural contests—whether shooting or playing checkers—were metaphors in Bingham's paintings for the competitive new society then emerging in the West. For him, competition was synonymous with progress, and it was entrepreneurial energy and faith in the future that drove the citizenry forward. The social and institutional conventions that held sway in the East did not exist in these rural outposts; here we find people searching for new ways to piece together and evolve a democratic system that worked for them.

Even in the painting *Captured by Indians* (1848), in which a white woman and her child are held captive by armed Indians, Bingham's tone is emotionally restrained rather than sensational. In fact, by the time he painted this picture, the Indians had long since ceded and abandoned their Missouri lands. Bingham was responding to his recollection of the Indians by creating an image that would interest curious Easterners. He was also addressing the captivity novel, a popular literary form from the late eighteenth through mid-nineteenth century, in which a white woman is usually captured by threatening and malevolent Indians. This abundant literature served not only to reinforce the conventional view of the helplessness of women but also to justify the need for subduing and removing the Indians from the path of white settlement.

Unlike many previous horrific treatments of this theme, Bingham's work chooses to depict the mother, the child, and the Indians with dignity. Not since *Cottage Scenery*, in 1845, had Bingham included a woman as one of the central characters in a painting, but in *Captured by Indians* and the subsequent *Emigration of Daniel Boone*, women are shown stoically enduring the risks and adventures of domestic life on the frontier. The pendant to *Captured by Indians*, entitled *Belated Wayfarers* (1852), depicts an entirely masculine but charming and gentle view of the West. The two men in this painting, readily identifiable to those in the West as overgroomed and overdressed Easterners, have lost their way and drifted off to sleep by the comfortable light of their campfire. Bingham's purpose here was to signal the relative safety of the West to potential Eastern travelers. Both paintings, therefore, mediate the perceptions and expectations of Westerners and Easterners concerning each other.

The Squatters (1850), on the other hand, presents people of a different social category—frontier nomads—and comes the closest of any Bingham work to a depiction of the harsher side of frontier life. Squatters were pioneers who resisted becoming settlers by periodically relocating to the outermost edges of the expanding frontier. They showed little interest in farming the land, but preferred instead to live temporarily off its bounty, as the mounted horns over the cabin doorway seem to indicate. As the hunting grew scarce or settlers began to appear, the squatters would leave their cabins for more remote locations.

In a letter to the Art-Union, Bingham explained the meaning of the crude log cabin and the family standing before it: "The Squatters as a class are not fond of the toil of agriculture, but erect their rude cabins upon those remote portions of the National domain, where abundant game supplies their phisical [*sic*] wants. When this source of subsistence becomes diminished, in consequence of increasing settlement around, they usually sell out their slight improvement . . . and again follow the

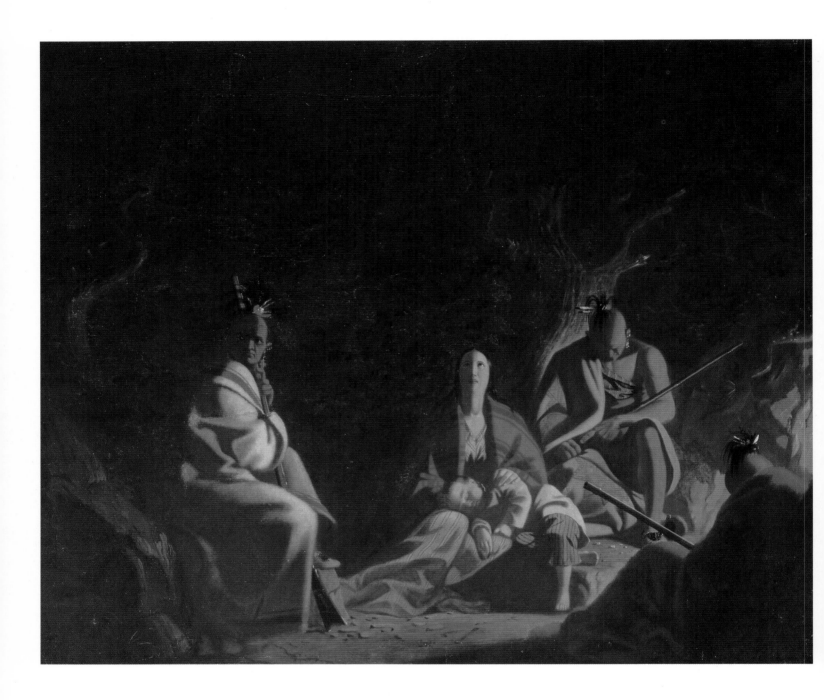

Captured by Indians

1848. Oil on canvas, 25 x 30″
The Saint Louis Art Museum.
Bequest of Arthur C. Hoskins

Along with The Concealed Enemy
(1845), Captured by Indians *is one
of Bingham's few paintings of an
American Indian subject; it depicts the
capture of a white woman and her child.*

*Although the Indians around her seem calm
and unthreatening, the woman is terrified and
looks heavenward for guidance and strength.
This is a rare moment of emotion in Bingham's
work.*

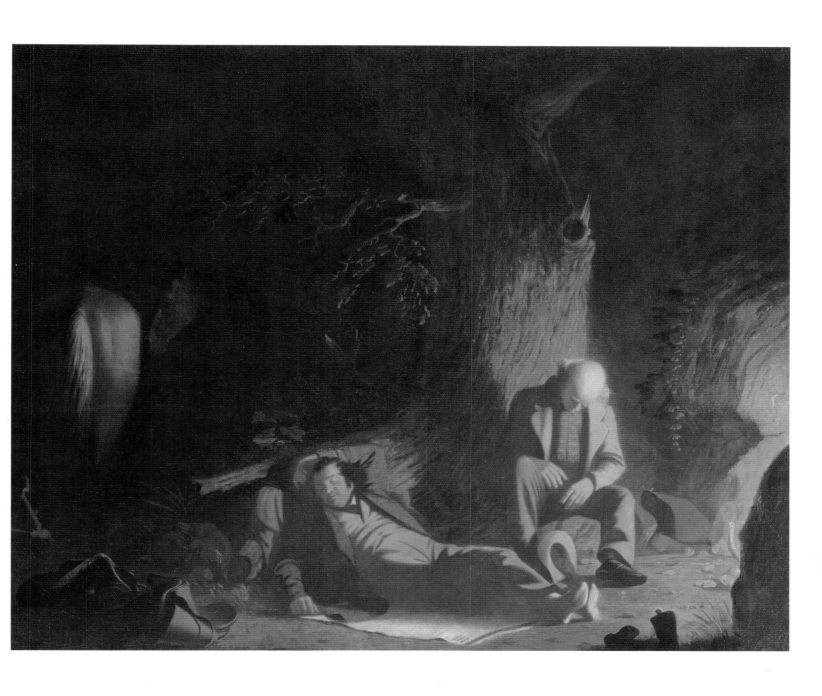

Belated Wayfarers

1852. Oil on canvas, 24⅝ x 29⅝"
The Saint Louis Art Museum.
Gift of Arthur S. Hoskins

Belated Wayfarers *depicts two tired,
well-dressed travelers from the East who
have passed into innocent sleep while
studying their map by a campfire.*

receding footsteps of [the] Savage." The squatters were, in effect, a moving borderline between the Indians and the white settlements. Their presence was yet another subject which Bingham, as the recorder and historian of Western life, felt compelled to document and to explain to those who lived in the more cosmopolitan East.

Another important painting from this period is *The Emigration of Daniel Boone* (1851), which commemorates Boone's journey west, leading a long column made up of his own family and five others, from North Carolina to Kentucky. As the first painting by Bingham to depict a specific event in time, this work could be considered a history painting rather than one in the genre category. It may be seen as a guide to the kind of image Bingham hoped to paint in the United States Capitol one day. This work—which Bingham first completed in New York and later reworked in Missouri, making the setting and the sky more dramatic and foreboding—was far more developed than the artist's first depiction of Boone, a signboard for a rural hotel. Here, Boone becomes a messianic figure who leads his flock between the parted mountains to the American equivalent of the Promised Land. Bingham's depiction of Boone had been preceded by paintings like P. F. Rothermel's *The Pioneers* (1849) and William Tylee Ranney's *Boone's First View of Kentucky* (1850).

Walking at the head of the procession are Boone, his guide, and the scout, who leans over to tie his shoelace. Boone's wife, Rebecca, and their daughter follow on horseback. For Bingham, the Boones constitute a kind of frontier Holy Family. His view, and that of the Whig party, encouraged family settlement as a key element of Western development. Historical fact, Christian iconography, and national progress are thus united in Bingham's procession. He returns to a hero whose image he saw being painted by Chester Harding more than thirty years earlier and whom he himself had first painted more than a quarter of a century before. Boone strides toward the viewer in soft light, but his figure has the stiff solemnity of an ancient Greek sculpture. Passing between two blasted trees, he wears an immaculate fringed buckskin suit and carries a rifle over his shoulder. His wife, in a brown hooded garment, sits sidesaddle on a powerful white horse. They leave behind them a dark, foreboding land, steadfastly moving to a brighter future and implicitly beckoning the viewer to join them in their inevitable march.

Bingham tried to sell this painting to the Art-Union, but did not meet with success. Its serious tone may have dissuaded the Union's committee from purchasing it; in addition, the committee had, only the previous year, purchased and engraved William Ranney's *Boone's First View of Kentucky*. Despite this rejection, Bingham arranged to have the painting published by Goupil & Co. as a lithograph that appeared in 1852.

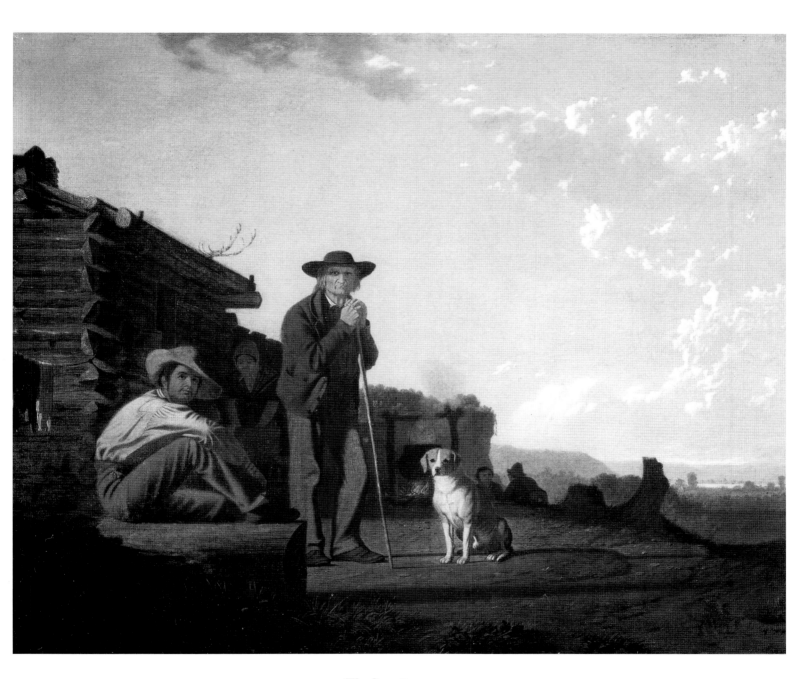

The Squatters

1850. Oil on canvas, 23 x 30″
Bequest of Henry L. Shattuck in memory
of the late Ralph W. Gray. Courtesy,
Museum of Fine Arts, Boston

*Squatters were a class of nomadic people
who perpetually moved just in advance
of new settlers. Bingham said they "erect
their rude cabins upon those remote por-
tions of the National domain. . . . When
this source of subsistence becomes dimin-
ished, in consequence of increasing set-
tlement around, they usually, set out . . .
and again follow the receding footsteps of
[the] Savage."*

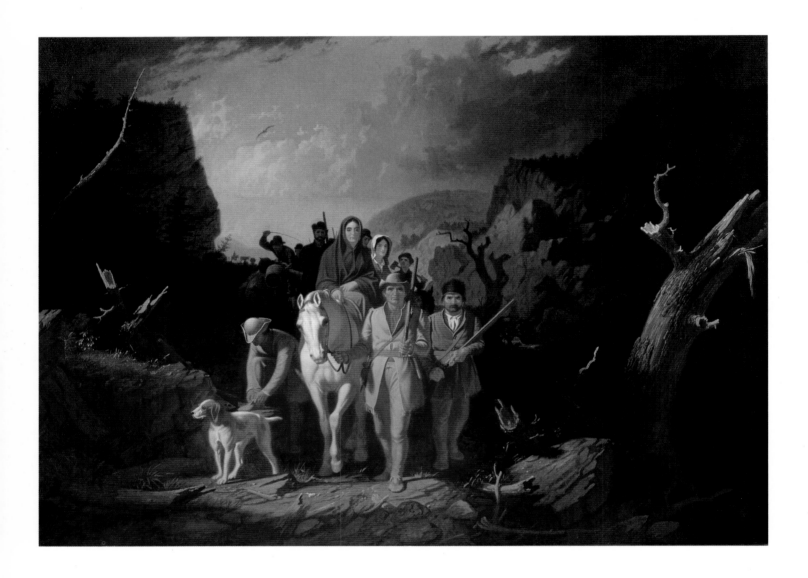

The Emigration of Daniel Boone

1851. Oil on canvas, 36½ x 50″
Washington University Gallery of Art, Saint Louis.
Gift of Nathaniel Phillips, Boston, 1890

Bingham painted this canvas in New York in the early spring of 1851 and probably repainted the background the next year, after the Art-Union decided against purchasing it. It depicts Boone, the "Columbus of the Woods," leading his own and other families to settle in the West.

Claude Regnier, after George Caleb Bingham, *The Emigration of Daniel Boone*

1852. Hand-colored lithograph, 18¼ x 23¾″ (image)
Missouri Historical Society, Saint Louis

This lithograph of The Emigration of Daniel Boone *was made prior to Bingham's extensive reworking of the background. It was produced by Goupil & Co., a publishing firm that exerted an important influence on Bingham as the role of the Art-Union diminished in the early 1850s.*

John Sartain, after P. F. Rothermel, *The Pioneers* or *The Western Emigrant*

1849. Engraving, 4 x 6″

Bingham was acquainted with Rothermel, who reportedly complimented some of his paintings. Bingham may have adapted Rothermel's image of a pioneer husband and wife in The Emigration of Daniel Boone *two years later.*

Charles Grignion, after William Hogarth, *Canvassing for Votes*

1757. Etching and engraving, 15⅞ x 21¼"
The British Museum, London

The compositional structure and ironic tone of this Hogarth engraving established a prototype for Bingham's The County Election (1851–52). The use of a wooden table for imbibers seems to have been transferred directly from the earlier image. Equally important is the use of generic rustic architecture, a view into the distant countryside, and clusters of types of characters. All these elements create a firm case for Hogarth's engraving having been a model for Bingham.

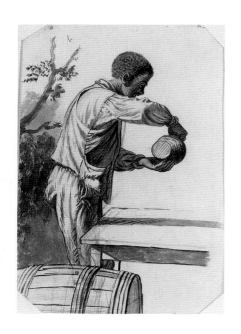

Negro Boy

1851–52. Brush, black ink, and wash over pencil, 12¼ x 8¼"
Courtesy of the People of Missouri

In this study for the figure at the far left edge of The County Election *(1851–52), the stubble-faced pourer is depicted with foliage behind him. In the completed work, he wears a battered hat and an apron and is not shown full-figure.*

Bingham's idea to paint a version of this subject for the United States Capitol did not end with this work. Writing to Rollins from Düsseldorf in 1858, Bingham restated his willingness to furnish a study for the proposed painting to the appropriate committee in Washington. But nothing came of his offer.

Ever since his election defeat at the hands of Erasmus Sappington in 1846 and his painting of *The Stump Orator* the next year, Bingham had been thinking of creating a large, multifigured picture that would deal directly with the electoral process. *The Stump Orator,* despite the stiff and relatively passive pose of the main figure, was purchased and distributed by the Art-Union. But Bingham continued to prepare himself for the more complex work he had in mind—both by means of smaller genre pictures like *Country Politician* and *Canvassing for a Vote,* in which he refined the expressive gesture of an ingratiating politician and the poses of his listeners, and by more challenging constructions like *Shooting for the Beef,* which involved the placement of numerous figures in a landscape.

It was in the large and curiously heroic painting entitled *The County Election* (1851–52) that Bingham finally fused his past experience with his ambitious aspirations. The work is curious in that, although it has no clear dramatic focus, it nevertheless appears heroic. That ambivalence may be explained, however, by its unusual subject. The painting is nothing less than a narrative presentation of the abstract principle of democratic government, as interpreted by a panoramic assemblage of citizens

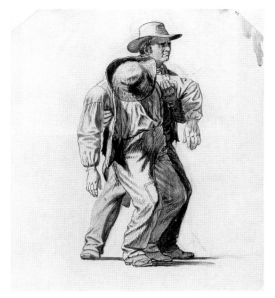

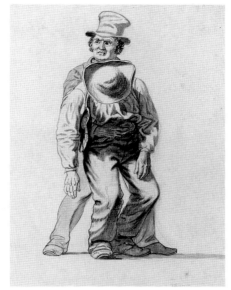

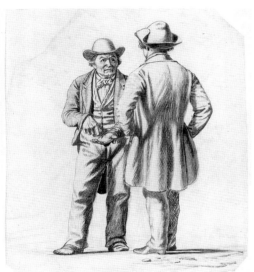

Left to right, top to bottom:

Early Celebrants

1851–52. Brush, black ink, and wash over pencil, 11⅜ x 9″
Courtesy of the People of Missouri

While some Bingham drawings differ significantly from the final canvas, others vary only in nuance. There are two drawings of the so-called Early Celebrants, *studies for* The County Election *(1851–52). This first established the basic format for the painting, but Bingham appears to have rejected the method of support as too awkward.*

Early Celebrants
(second version; recto)

1851–52. Brush, black ink, and wash over pencil, 11⅝ x 9″
Courtesy of the People of Missouri

The second drawing of Early Celebrants *shows the standing man supporting the front figure by holding him around the waist. In the final painting, Bingham turned the standing figure's head toward the central action of the work.*

Two Citizens Conversing

1851–52. Brush, black ink, and wash over pencil, 11½ x 9¼″
Courtesy of the People of Missouri

Except for the hat of the man on the right, the drawing of Two Citizens Conversing *is similar to the format used in* The County Election *(1851–52). One man gestures with his index finger and cupped hand, a detail that appears in other genre paintings by Bingham:* Country Politician *(1849) and* Stump Speaking *(1853–54). This vignette is a dramatic counterpoint to the limp figure of the drunken man to its immediate left in the final work.*

The Veteran of '76

1851–52. Brush, black ink, and wash over pencil, 11⅝ x 9″
Courtesy of the People of Missouri

This drawing demonstrates how Bingham worked out the pose of each figure, even those only partially seen in the final composition.

from rural America. In this perspectival view of a small town, the rustic architecture, land, and sky serve as a container for the numerous and varied figures in the foreground. Though the communal act of voting is the purported focus of the composition, this activity itself is relegated to the right side of the painting. Voting was exclusively a male prerogative, and there are no women shown here. In fact, the churning assemblage is a virtual celebration of all the ages and types of men, of their virtues and vices—from the young to the old, from the poor to the prosperous, from earnest citizens to swindlers. Bingham's expansive electoral panorama owed some of its compositional details and its congested activity to the widely known print by Hogarth entitled *Canvassing for Votes* (1757).

The spectacle spread before us is a dynamic experiment by the

Electioneering Types

The initial pose of the electioneering man was changed in the completed The County Election *(1851–52): there, he tips his hat to the prospective voter rather than reaching forward with his hand. Bingham's fresh solution is indicated in the pencil sketch in the lower right corner of the drawing.*

County Clerk

On both sides of this two-sided drawing, the county clerk is depicted as an old man sharpening his quill. In The County Election *(1851–52), a young, fair-haired boy performs that activity, oblivious to the vast assemblage of people milling about behind him.*

artist, an attempt to see how democracy was being defined in the West. We are witness to the process of a people inventing their government. Unlike the East, where democratic government had been practiced and refined over time in carefully structured halls of government, the West had not yet created structures of its own to handle the process. A free-wheeling brawl—complete with drunks, con men, the serious and the frivolous—unfolds before us. The scene is set out-of-doors, not in an official setting but on a street beside a wood frame building. The equalizing embrace of democracy takes in all.

The picture is skillfully and rhythmically arranged as a series of figural clusters. The crowd seems to ebb and flow from the shaded areas at the left to the sunlit figures on the steps at the right. From left to right in the foreground, we see a genial black man serving a hearty drinker who slouches back in his chair with an upraised hand; a man holding a limp, drunken voter; two serious-minded men thoughtfully discussing the candidates; a couple of boys playing mumble-the-peg, a game that involves throwing a knife; a line of men mounting the stairs to be sworn in and vote; three men conversing and another three gathered around a newspaper; a drunken man, or brawler, slumping with bandaged head on a bench.

The real subject of *The County Election,* then, is the diversity and the equality of the protagonists. Their varied, eccentric personalities are drawn together and encapsulated by a single activity, the outcome of which reflects their communal response. At the top of the stairs leans a staff with a small blue banner inscribed with words that summarize the scene: "The Will of the People The Supreme Law." While the range of personalities in the painting might suggest this inscription is ironic, it is in fact Bingham's faith in the will of the people that motivated him to paint this picture and its successors in a trilogy of works that came to be known as the Election series. As Nancy Rash has pointed out, Bingham felt that political decisions should be reached by letting the electorate voice its opinion rather than by imposing on people solutions created behind closed doors. In his paintings, the act of voting is as varied and rich a weave as human nature.

There are many extant drawings that relate to Bingham's genre paintings. These drawings are highly finished works of art that probably derived from earlier, more tentative studies from models. Bingham posed his models in convincingly informal positions and dressed them in a range of attire, both rustic and more formal. Infrared photography indicates that Bingham essentially drew or transferred the outlines of many figures from these drawings directly onto the canvas itself. In some cases, the drawings acted as templates to be used to transfer figures from

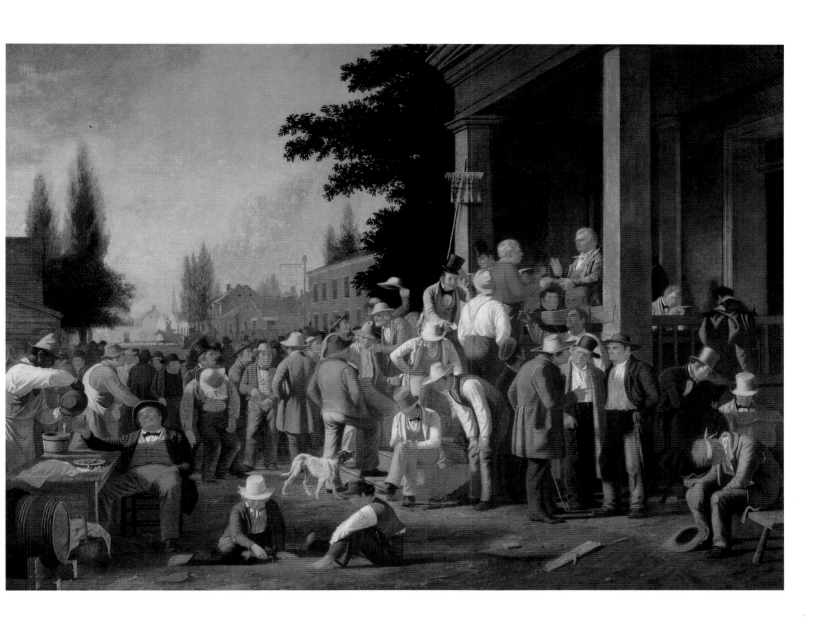

The County Election

1851–52. Oil on canvas, 35 ½ x 48 ¾ ″
The Saint Louis Art Museum. Museum Purchase

Though Bingham completed this canvas first, it ultimately became the middle painting of the trilogy that has come to be known as his Election Paintings. The other two works in this group are Stump Speaking *(1853–54) and* The Verdict of the People *(1854–55).*

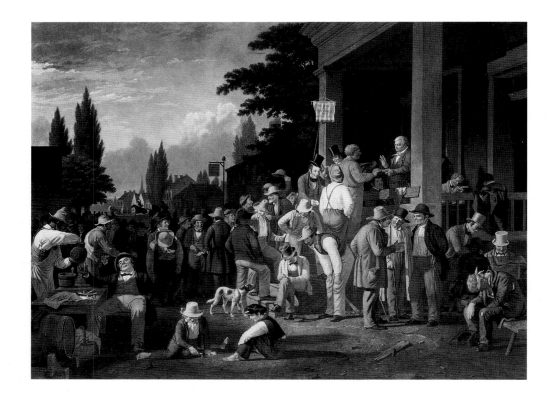

John Sartain, after
George Caleb Bingham,
The County Election

1854. Hand-tinted etching and engraving,
26 x 32⅝″ (plate)
The Saint Louis Art Museum.
Museum purchase

This print of The County Election *is extraordinarily faithful to the larger original canvas. The printmaking process translated the painted image into linear patterns. In some details, however, like the small notices tacked to the porch column and the elimination of several figures, the print differs from the original.*

The County Election
(second version)

1852. Oil on canvas, 38 x 52″
From the Art Collection of the Boatmen's
National Bank of Saint Louis

More vibrantly colored and somewhat larger than the first version of the painting, this second version appears to have been used by Bingham to promote sales of the engraving while Sartain was still working on it.

paper to canvas. While some figures are almost identical to those in surviving drawings, others indicate that Bingham did make refinements between the drawings and the final painting. For example, in one drawing for *The County Election,* the black man has neither a hat nor an apron and, in another, the jolly drinker whom he serves is not as relaxed and smiling as in the final work. It is quite possible that Bingham, adapting freely from his drawings, made such changes improvisationally on the canvas itself.

Seeing the favorable response that *The County Election* elicited and inspired by the example of the Art-Union, which had successfully distributed thousands of engravings to its members, Bingham believed he could profit from disseminating this image nationwide. He therefore gave the painting to John Sartain of Philadelphia for engraving. One of the country's most distinguished engravers, Sartain had engraved a portrait for the artist in 1843. His line-and-mezzotint translation of *The County Election* was masterful, and it carefully rendered printed equivalents for the shading, color, and textures of the painting. Bingham made a number of changes for Sartain's print, and some of these also appear in the second version of the painting (1852).

Bingham's changes were intended, in general, to emphasize the national characteristics of the painting. One variation involved changing the title of the newspaper in the extreme righthand corner from *Missouri*

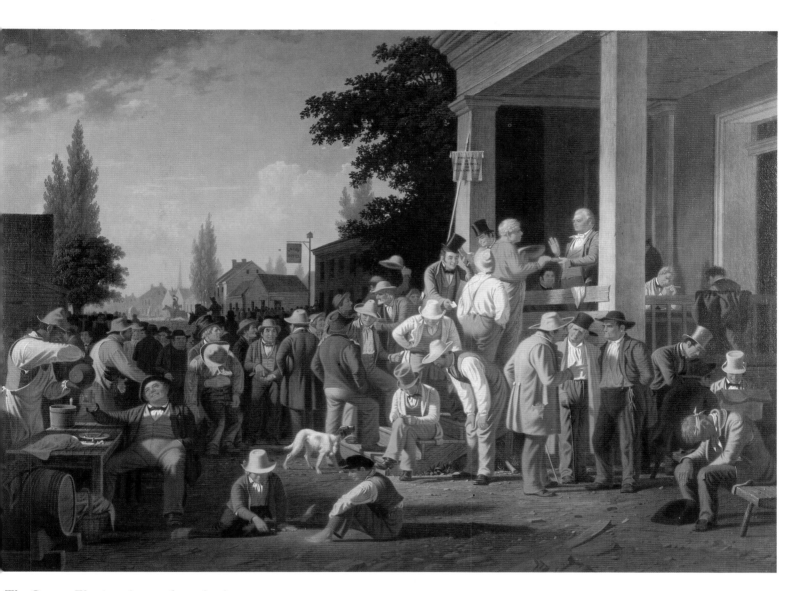

The County Election (second version)

Republican to *The National Intelligencer.* In writing to Sartain concerning this alteration, Bingham revealed the broad relevance he hoped the print would achieve. Once the change had been made, Bingham reported, "There will be nothing left to mar the general character of the work, which I design to be as national as possible—applicable alike to every section of the Union, and illustrative of the members of a free people and free institutions." This same goal—a truly national character—was the essential aim of all the paintings in Bingham's Election series.

While Sartain was working from the original, Bingham painted a second version of *The County Election* to take with him as an aid in obtaining subscribers for the print. This second canvas is several inches higher and almost four inches wider than the first, and it is more intensely colored, with much stronger blue accents in the clothing and sky. Two figures from the right foreground of the original painting—the man flipping a coin and a boy watching him—have been eliminated in the second version. This change may have been made to achieve a more coherent, readable scene or to eliminate the irony that a coin flip implies in an election setting.

When Bingham unsuccessfully offered the first version of *The County Election* to the American Art-Union in early 1852, it seemed precisely the kind of painting that would have appealed to the group. Yet by that time, the Art-Union, which had so supported and directed Bingham's finest work, was on the brink of collapse. It effectively ended in 1852, when a disgruntled artist successfully brought about the closing of its lottery as a form of illegal gambling, but its decline had been under way for more than a year, from the time it had been legally constrained from allocating paintings by lottery. Bingham, for one, was increasingly dissatisfied with what he regarded as the Union's "gross favoritism" in its purchases of paintings and in its choice of works to be engraved and distributed. (His rejection of the Art-Union was one of the reasons for his attraction to Goupil & Co. as a print publisher.)

The end of the American Art-Union, which had previously paid for and distributed nearly two dozen Bingham paintings and thousands of prints of his work, redirected the artist's career. It virtually forced him to market his own prints. It denied him a relatively steady source of income and a reliable means of distribution for his paintings as well as a highly visible and well-attended exhibition venue. Lost as well was the guidance that the Art-Union had provided regarding the kinds of paintings it thought would be successful. Without a conduit for selling his paintings, Bingham believed that popular and financial success would rest on the dissemination of his prints. Considering that some paintings, like *In a Quandary* and *Country Politician,* were actually commissioned for the

purpose of being made into prints and also that the Art-Union's *Jolly Flatboatmen* print and other, self-generated, prints were highly successful, it becomes clear that the print market had a powerful influence on the artist's work.

As works of art, the lithographs of Bingham paintings commissioned by Goupil and others are relatively commercial in their appearance. It is the engravings, with their ability to capture subtle effects of light and shade, that best duplicate the work. Further studies of Bingham's personal finances may reveal the ultimate wisdom or folly of his investment in printmaking. We do know, however, that he was devoted to having high-quality prints made of his work, and he willingly endured the substantial personal and financial costs involved in producing them in the hope that a great many would be sold. Commenting on the making of the *County Election* print, Bingham noted in a letter to Rollins that Sartain appeared to be "taking a great deal of care in the execution of the work, making the line greatly preponderate over the *Mezzotint*. The line process is very slow and tedious." In fact, Bingham traveled to Philadelphia in 1853 to supervise Sartain's work and, more specifically, to see if he could stimulate the highly skilled but painfully slow printmaker to work more quickly.

While in Philadelphia, Bingham began to think of *The County Election* as the middle section of a three-part series having a quintessentially American subject: the electoral process. Sensitized by the Art-Union's emphasis on national themes as well as by his personal experiences and earlier depictions of frontier politics, Bingham realized that "national imagery" could be found not just in the activities of river and rural life but in the democratic process itself. The idea of executing a suite of related paintings about such a generic but defining activity was daring and innovative. The three works Bingham envisioned would treat the campaign, the actual election, and the announcement of the results (*The County Election* being a presentation of the second theme). The three final paintings vary in size, and each has a different internal relationship between the size of the figures and the overall painting. As Nancy Rash has noted, the prints of the three election paintings are the same size, and it may be that they are the works that present the Election series in the most unified way.

During his work with Sartain in 1853–54, Bingham embarked upon the painting that would serve as the first in the series. Originally referred to as *The County Canvass*, it was ultimately titled *Stump Speaking*. The painting involved a substantial revision of the composition of *The Stump Orator* (1847), an unlocated work that prefigured all three paintings in the Election series. In *Stump Speaking*, Bingham has made several changes in

the earlier painting that contribute to a more unified work of art: the raised podium that separates the speakers from the assembled, the gracious pose of the orator, the silhouetted man standing in the foreground who has his back turned yet allows viewers to project themselves into the painting, and the top-hatted figure at the far right, who serves as an effective compositional element. The potbellied, jowled citizen with yellow vest and green jacket on the left (who has been identified as the Missouri Democrat Meredith Miles Marmaduke) and the lean, erect patrician seated at the far right balance the composition, while obscuring the earnest opponent, who with great concentration takes notes on the weaknesses of the orator's harangue. Several anecdotal additions, like the three small boys and two dogs in the foreground, seem intended to connect *Stump Speaking* with similar vignettes in *The County Election*. In fact, one of the most engaging figures in *Stump Speaking*—the apple-cheeked, barrel-chested rustic who listens possibly with drunken bemusement— was adapted from the earlier picture and moved to a more central location.

Bingham was delighted with the process of painting *Stump Speaking* and thought that when it and *County Election* were engraved, "I shall have laid the foundation of a fortune sufficient to meet my humble expectations, and place my little family beyond the reach of want, should I be taken from them." His work on *Stump Speaking* progressed organically, the number of figures gradually expanding beyond what he originally planned. Bingham reported to Rollins from Philadelphia how "a new head is continually popping up and demanding a place in the crowd, and as I am a thorough democrat, it gives me pleasure to accommodate them all." Of the orator himself, the artist stated, "I have endeavored to personify a wiry politician, grown gray in the pursuit of office and the service of party. His influence upon the crowd is quite manifest, but I have placed behind him a shrewd clear headed opponent, who is busy taking notes, and who will, when his turn comes, make sophisms fly like cobwebs before the housekeepers broom." Through his own bitter experiences with electoral politics, Bingham was quite aware of the illusions of appearance, the blandishments of the persuasive speaker, the elusiveness of truth, and the possibility of injustice in the process. Yet, countervailing this skepticism are his optimism and faith in the binding powers of free speech and communal judgment.

Once the Art-Union had disbanded, Bingham began to view his paintings more as vehicles for prints than as objects that could be readily sold themselves. In 1854, while still waiting for Sartain to finish the engraving of *The County Election*, he gave Goupil & Co. the publishing rights for both *The County Election* and *Stump Speaking*. This arrangement

Stump Speaking

1853–54. Oil on canvas, 42½ x 58″
From the Art Collection of the
Boatmen's National Bank of Saint Louis

The most darkly painted of the three Election series canvases, Stump Speaking *reinterpreted Bingham's first large political painting,* The Stump Orator *(1847; unlocated).*

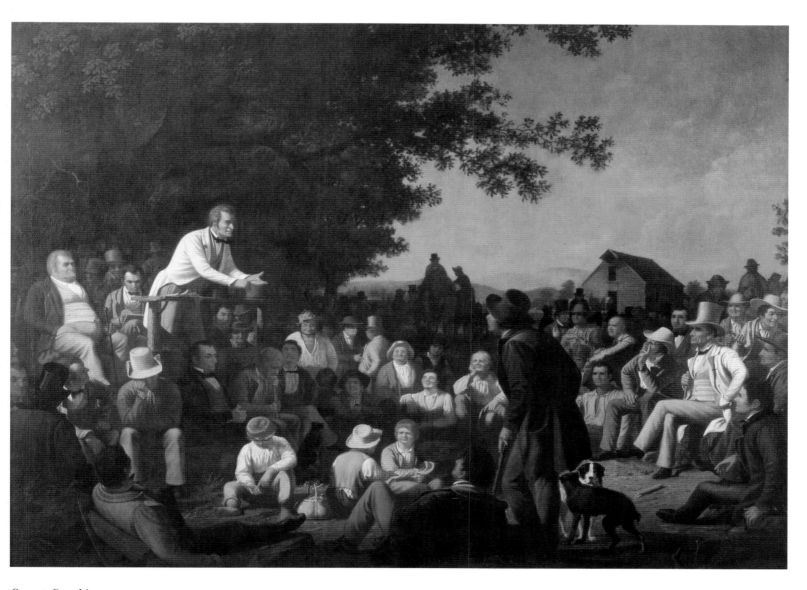

Stump Speaking

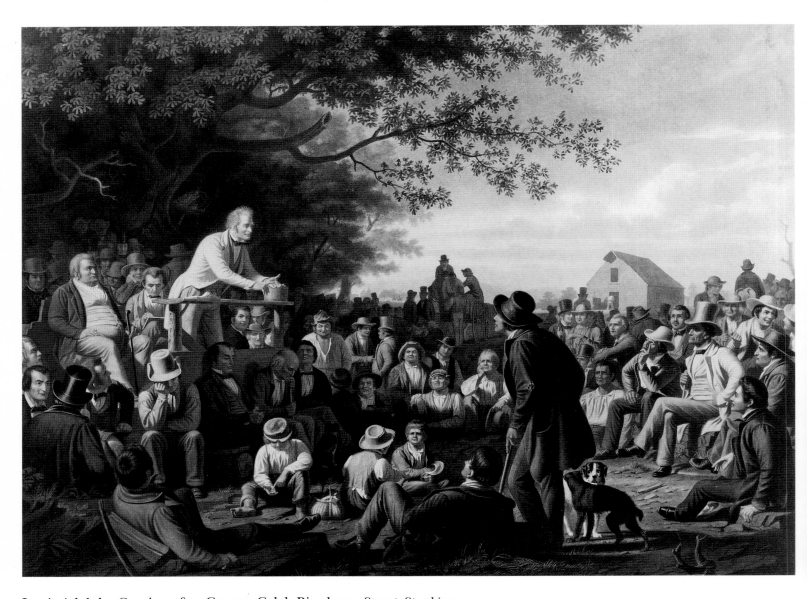

Louis-Adolphe Gautier, after George Caleb Bingham, *Stump Speaking*

required that the two paintings be sent to Europe so that plates could be made from the originals.

The final painting in the Election series trilogy, *The Verdict of the People* (1854–55), complemented the themes and compositions of the previous two. Its fascination, like that of the other two, derives from the amalgamation of "types" of individuals. Bingham's approach is the inverse of that found in such neoclassical works as Jacques-Louis David's painting *Oath of the Horatii* (1784–85), which conveys a political narrative with such astringent clarity that elaborate details are not needed. Bingham's view of the political process is far more flexible, humane, and eccentric. He explained to Rollins that *The Verdict of the People* was "well calculated to furnish that contrast and variety of expression which confers the chief value upon pictures of this class." As with the other two works in the series, the artist binds together a wide range of figures and makes the risk of chaos an affirmative quality. In fact, the disparity among the figures serves as an analogue of democracy itself. The theme of the entire series—that the democratic process is as an amalgamation of individuals who collectively speak with one voice—gives tangible form to an otherwise intellectual and nonvisual phenomenon.

The final painting is the most crowded of the three. Writing to Rollins from Philadelphia, in 1854, Bingham stated that he had "already commenced *thinking* for another large composition, which I will entitle '*The Verdict of the People.*' I intend it to be a representation of the scene that takes place at the close of an exciting political contest, just when the final result of the ballot is proclaimed from the stand of the judges." *Verdict* is the picture that the artist hoped would "*cap the clymax*" of the series, and it related significantly to the structure of *The County Election*. *The Verdict of the People* repeats but reverses the earlier work's arrangement of a large street, a prominent civic building, and a view into the distance. As Nancy Rash has noted, "The watermelon stand at the lower right was a pendant to the cider stand in the earlier work, the slumped figure an exact reversal of one of the children playing mumble the peg." But the rustic town, now seen at a slightly later point of development—as evidenced by the numerous buildings on both sides of the street—is a prosperous, growing community. As Bingham was aging, the West was maturing as well.

At the time Bingham was preparing to paint *The Verdict of the People*, his letters to Rollins expressed his concerns about the Kansas-Nebraska Act, which had been introduced in Congress in 1854. The Act left up to "popular sovereignty" the question of whether each new territory to enter the Union would be slave or free. Violence would erupt soon after the passage of the Act, as Kansans prepared to vote on the slavery issue.

Louis-Adolphe Gautier,
after George Caleb Bingham,
Stump Speaking

1856. Hand-tinted engraving,
23⅜ x 30¼″ (image)
National Museum of American Art,
Smithsonian Institution, Washington, D.C.
Gift of International Business Machines
Corporation

Gautier's engraving is less distinct than Sartain's 1854 print of The County Election. *It has a softer, less linear quality.*

As Barbara Groseclose has written, in the 1990 Bingham catalogue, "The slavery question and the issue pertaining to it raised by the Act would drive [the distinguished Missouri Senator] Thomas Hart Benton from the Democrats and help break up the Whigs." It is against this dramatic, emotional, tumultuous backdrop of national and regional political events that *The Verdict of the People* is played.

The most animated of the three Election paintings, *The Verdict of the People* shows some figures smiling broadly and gesturing dramatically. As before, the foreground elements serve as counterpoints to the action unfolding in the middle ground. The tragic, isolated figure of the drunken man, the beautifully painted jugs, cloth, and cup in the wheelbarrow that the black man energetically pushes, and the vignette of the man slicing watermelon for the small boys—all contribute to the painting's dynamic energy. The work has its peculiar and whimsical aspects: the strange, Pinocchio-like shadow of the man which is cast on the wooden board and at which the little boy points with amusement; the man in the middle ground at the center who holds up his top hat in a way that forms a circle; and the man at the right who wears three hats, which he has won in wagers.

The figure with furrowed brow who sits at the center of the composition, calculating the votes of the defeated candidate, seems to be a pictorial descendent of the whittling man with a similar expression in *The Stump Orator*. Just above this man's head, a slip of paper shows the closeness of the race: 1,406 to 1,410 votes; the allusion to Bingham's ill-fated "victory" over Sappington is evident. On the right, the smiling man with outstretched arm anticipates the central figure in Bingham's last major river painting, *Jolly Flatboatmen in Port* (1857). The American flag, suspended across the main street and silhouetted against the sky, snaps in the breeze directly above the fallen man in the foreground. It serves both as a symbol of the embattled Union and as a summation of the dialectical process that Bingham articulated in the Election series.

On a porch at the right edge of the painting stands a group of women with a sign reading "Freedom for Virtue [Re]striction for Vice," a slogan that has been identified by Nancy Rash as a reference to the temperance movement and the slavery question. The women, therefore, might be members of the female temperance societies of the time, for whom virtue consisted of abstinence from alcohol. During the 1850s, the temperance issue was linked with the abolition of slavery; both slavery and intemperance were seen as immoral impingements on individual liberty. And this connection is underscored in the foreground of Bingham's painting by the black man pushing a wheelbarrow toward the drunken white man.

The Verdict of the People
1854–55. Oil on canvas, 46 x 65"
From the Art Collection of the Boatmen's
National Bank of Saint Louis

The Verdict of the People *is the largest, last, and most dynamic of Bingham's three major political paintings. Filled with a sense of urgent energy, it is close in size to his next important genre painting,* Jolly Flatboatmen in Port *(1857). Only two proofs are known of the lithograph that was made of this image in Berlin, while Bingham was living in Germany.*

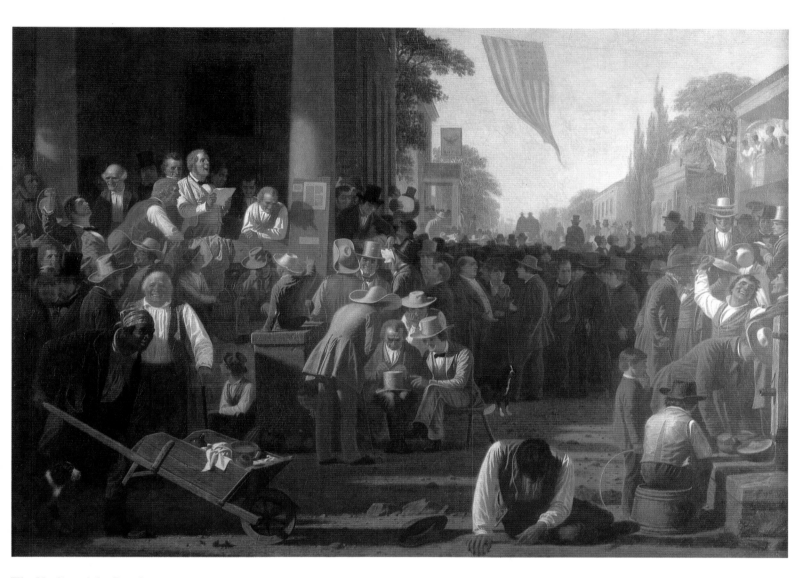

The Verdict of the People

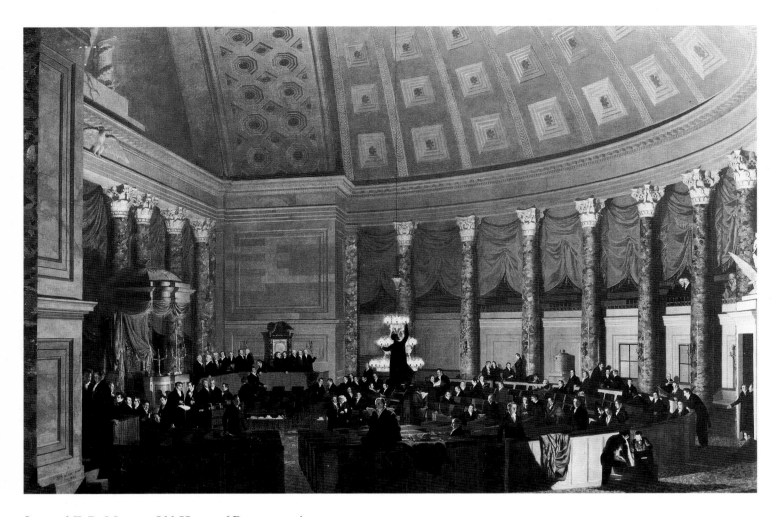

Samuel F. B. Morse, *Old House of Representatives*

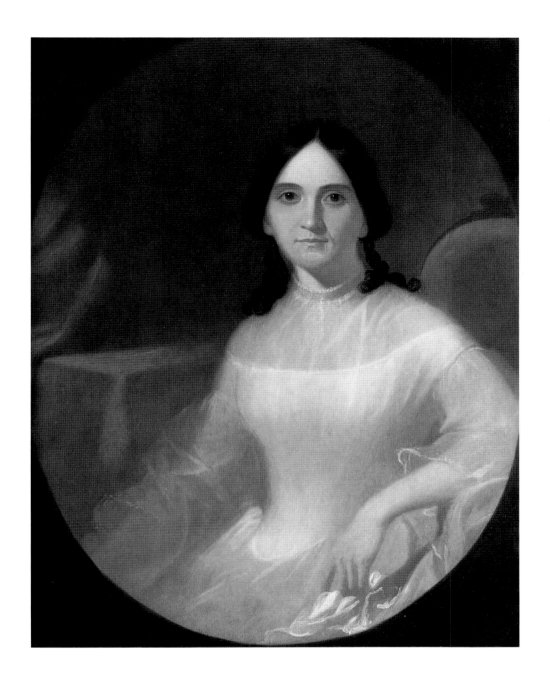

Eliza Thomas Bingham

1849–50. Oil on canvas, 35½ x 27½"
Collection Mr. and Mrs. Walter Knestrick

*This portrait was painted around the
time of the subject's marriage to
Bingham in Columbia, Missouri, late
in 1849. She was the daughter of a pro-
fessor at the University of Missouri who
was also an ordained Baptist minister.
Twenty years old when the portrait was
done, she bore one child, James Rollins
Bingham, in 1861. She died in 1876
at the State Mental Hospital in Fulton,
Missouri.*

Samuel F. B. Morse, *Old House of
Representatives*

1822. Oil on canvas, 86½ x 130¾"
In the Collection of The Corcoran Gallery of Art,
Washington, D.C. Museum Purchase 11.14

*A far cry from Bingham's depictions of
freewheeling politics in the West, Morse's
decorous view of government in action is
set in the old United States Capitol
building in Washington.*

It is a testament to Bingham's success in these three paintings that
the democratic electoral process, overriding the particular conditions of
individuals, issues, or groups, emerges as the true subject of the series
and the best hope for resolving the nation's differences. In this sense,
the paintings become a panoramic plea for preserving and improving
the Union in the face of the intense sectional disputes of the 1850s.
Bingham's freewheeling view of government differs from that held by
John Trumbull and Samuel F. B. Morse, two early-nineteenth-century
American painters whose visions were both more literal and more his-
torical than Bingham's. How staid and decorous are Trumbull's *The
Declaration of Independence, July 4, 1776* (1786–97; Yale University Art

Unknown photographer,
Eliza Thomas Bingham

1850s. Tintype
State Historical Society of Missouri, Columbia

Bingham married Eliza K. Thomas almost a year after the death of his first wife. His second marriage lasted nearly twenty-seven years, until Eliza, too, died. She appears in this photograph wearing a shawl and a brooch with a photograph. Her fixed gaze seems to foretell the mental instability that surfaced later in her life.

Washington Crossing the Delaware

1856–71. Oil on canvas, 36⅝ x 57½"
The Chrysler Museum, Norfolk, Virginia.
Gift of Walter P. Chrysler, Jr., in honor of
Walter P. Chrysler, Sr.

Bingham started work on this canvas in Columbia, Missouri, five years after Emanuel Leutze's well-known depiction of the subject was exhibited to great acclaim in New York. Bingham began the painting shortly before receiving a commission from the Missouri state legislature for portraits of Washington and Jefferson for the state capitol, which prompted him to travel to Europe. While in Düsseldorf, he worked for some time in a studio adjacent to Leutze's.

Gallery, Trumbull Collection) and Morse's large painting *Old House of Representatives* (1822). Working nearly three decades after Trumbull and Morse, Bingham expressed a vision that was less idealized and more energetic, yet equally as affirmative.

By the time Bingham completed *The Verdict of the People,* he was a far more confident artist than in 1845, when his paintings first gained acceptance in New York. In the intervening decade, he had moved between Eastern cities—Philadelphia (1852, 1853, 1854, 1855, 1856) and New York (1849, 1850–51, 1852, 1853)—and Arrow Rock, Saint Louis, Columbia, and other points in Missouri. Although one could say he still traveled as much as an itinerant portrait painter, he was, by 1855, not only technically skilled and an astute observer of politics, but he had also gained great knowledge of the contemporary art world.

During the same period, Bingham's personal life was in turmoil. At the end of 1848, his wife, Sarah, died in Arrow Rock at the age of twenty-nine of complications from childbirth; only a month later, the couple's infant son and fourth child, Joseph, also died. The next year, Bingham married Eliza K. Thomas, the daughter of a professor at the University of Missouri, in Columbia. In 1851, his mother died in Arrow Rock. Yet these setbacks did not overwhelm Bingham's stability and

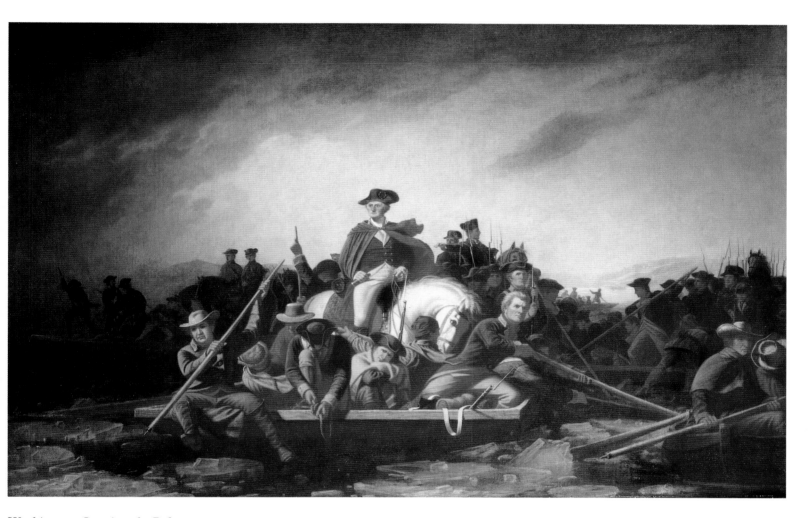

Washington Crossing the Delaware

William Tylee Ranney,
Marion Crossing the Pedee

1850. Oil on canvas, 50⅛ x 74⅜"
Amon Carter Museum, Fort Worth

Ranney's Marion Crossing the Pedee
*may have encouraged Bingham to
paint his version of Emanuel Leutze's*
Washington Crossing the Delaware.
*Bingham was probably familiar with
the engraving of Ranney's painting
by Charles Kennedy Burt—published
by the American Art-Union—before he
left for Europe. When Bingham and
his family arrived in Düsseldorf, the
artist immediately entered the circle of
American painters around Leutze.
Bingham eventually developed competi-
tive feelings toward Leutze, which may
have further strengthened his resolve to
continue working on the subject of
Washington's historic feat.*

sense of artistic purpose. The dozen years of his artistic maturity, from
1845 to 1857, were an island of relentlessly creative energy between his
development and his decline.

Toward the end of this period, an event occurred that appeared to
signal Bingham's long-awaited emergence as a painter of historical sub-
jects but that actually eventually contributed to his artistic decline. In
1856, he received a commission to paint full-length portraits of George
Washington and Thomas Jefferson for the Missouri State Capitol
Building in Jefferson City. Coincidentally, at the same time, he had
begun work on a painting that he hoped would serve as a prototype for
a large historical work. Its subject was Washington crossing the
Delaware, the same theme as a huge painting by Emanuel Leutze that is
one of the best-known examples of nineteenth-century American histo-
ry painting. Leutze's work received considerable attention and critical
acclaim when it was shown in 1851 at the Crystal Palace Exhibition in
New York, and it had a profound impact on Bingham, who had long

wished to paint ennobling moments in American history. It appears that Bingham began working on his own version of the subject in Columbia in early 1856 and completed it at Independence and Kansas City nearly fifteen years later. Bingham kept the painting, which was auctioned along with other possessions in 1876, after his widow's death.

Instead of showing Washington in a longboat, as Leutze had, Bingham placed the Father of Our Country rather incongruously on horseback among soldiers crowded aboard what appears to be a Mississippi flatboat. (William Tylee Ranney's *Marion Crossing the Pedee* may have influenced Bingham's choice for Washington's vessel.) Of the soldiers with poles in the foreground, only the one in the far righthand corner has the energy to guide the boat through the blue-green ice. The tensely posed figures in their eighteenth-century attire rather comically suggest Bingham's poised and confident boatmen of the 1840s and 1850s. Ironically, shortly after beginning to work on this painting, Bingham would find himself living and working near Leutze in Düsseldorf.

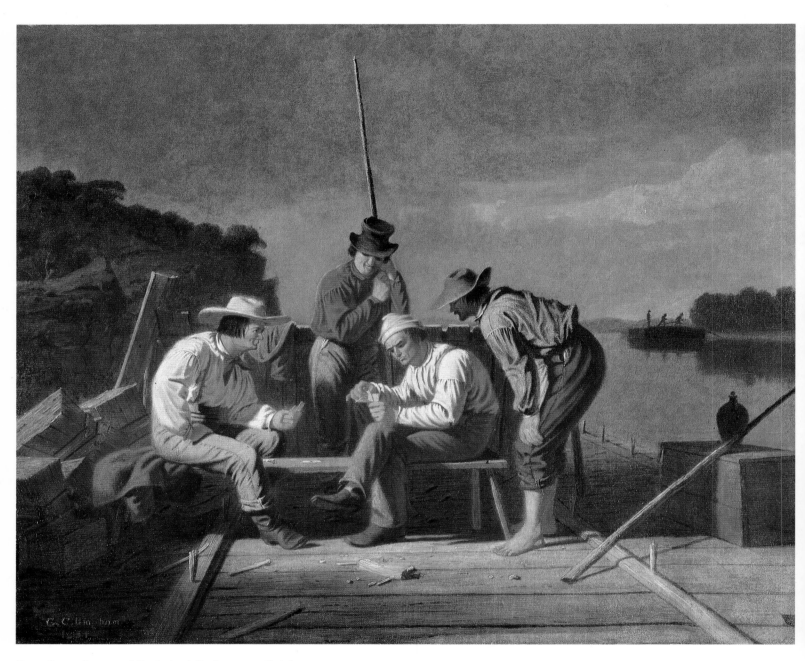

In a Quandary or *Mississippi Raftmen at Cards*

IV. *The Missouri Artist in Europe and the Late Years*

Whereas, in the early 1850s, Bingham's prime concern was his Election series, in the second half of the decade, his attention shifted to official portraiture. The difference in quality and appearance between the genre paintings and the official portraits is dramatic, though both sets of work reflect Bingham's powerful commitment to politics.

The painter who had traveled to Eastern cities in the 1830s to broaden his horizons had never had a reason to roam any farther. But now, with a large public commission by the Missouri state legislature, Bingham perceived the necessity of going to Europe, and he made plans to travel to Paris to paint his portraits of Washington and Jefferson.

To prepare himself for his commissions, Bingham traveled to Boston in June and July of 1856 to copy Gilbert Stuart's portraits of George and Martha Washington (1796; Museum of Fine Arts, Boston, and The National Portrait Gallery, Smithsonian Institution) and then to Philadelphia to copy a Stuart portrait of Thomas Jefferson (Collection Donald Straus, New York). He took his copy of Stuart's Washington portrait (Mercantile Library, Saint Louis) to Europe to use as a study for the commission.

It is surprising that Bingham chose France, over England and Germany, for his destination, since he had previously been attracted to English portrait and landscape artists and, as for Germany, there were active American artists' colonies in both Munich and Düsseldorf. Bingham appears to have selected Paris as his destination since he could see great works of art there that he might emulate in his official portraits. The forty-five-year-old artist regarded his European trip as the capstone of his artistic education and, quite possibly, as the final step in gaining the skills and experience to achieve a great national commission and rise to the level of a history painter.

Another motivation for choosing France as a destination, and indeed for the entire trip, was Bingham's relationship with Goupil & Co., which was based in Paris. Goupil had already published lithographs of *The Emigration of Daniel Boone* and *In a Quandary* in 1852 and of

In a Quandary or *Mississippi Raftmen at Cards*

1851. Oil on canvas, 17½ x 21″
The Henry E. Huntington Library and Art Collections, San Marino, California.
The Virginia Steele Scott Gallery

Four years after completing Raftmen Playing Cards *(1847), Bingham painted this smaller nocturnal variant. The silhouetted figures on the distant flatboat are similar in form and design to those in* Fishing on the Mississippi *of the same year.*

Canvassing for a Vote in 1853 as well as a mezzotint and line engraving of *Stump Speaking* in 1856; all of the prints were executed in Paris from the paintings themselves. Two of those paintings, *In a Quandary* and *Canvassing for a Vote,* had actually been commissioned by Goupil for the express purpose of publishing prints based on them. The firm had also expressed interest in producing a print of *The County Election,* but Bingham had already entered into an arrangement with Sartain to do so. Bingham took *The Verdict of the People* along with him to Europe in the hope that he might find a publisher for it, and Paris was a likely location in which to find a suitable engraver for the painting.

Bingham, his wife, and daughter Clara sailed for Le Havre from New York on August 14, 1856, on board the steamer *Vigo.* On September 2, they arrived in Paris, which Bingham termed in a letter to Rollins "this great centre of luxury Art and fashion." Their family apartment, obtained through the assistance of Goupil, consisted of two small bedrooms and a parlor. The company also assisted Bingham in his search for an ample studio in which to paint the large commissioned portraits. But the studio Bingham found would not become available for more than five weeks.

At his first free moment in Paris, Bingham headed directly to the Louvre, where he was struck by the profusion of styles and subjects of the works of art he saw. He described the experience to Rollins:

> *The great collection of works of Art there from all nations and schools, perhaps affords a student advantages which he could not obtain elsewhere. But unless he possessed the power to retain a clear perception of nature through the various guises in which she is here portrayed, like a juror bewildered by a mass of conflicting testimony, he might find himself staggering in doubt, scarcely knowing whether he inclined to truth or falsehood. Yet amidst the many conflicting statements, presented by the masters of the various schools, there are numerous facts to be found . . . which may be laid hold of by a matured judgment—and used to great advantage.*

For an artist reared on engraved copies of works of art, who had spent a short time in Philadelphia and a few years in Washington, the Louvre was an unsettling experience. There he would have seen both Poussin's carefully constructed seventeenth-century paintings and such huge nineteenth-century compositions as Géricault's *Raft of the Medusa* (1818–19). Offered direct contact with a vast number of paintings from such a range of centuries, countries, and styles, Bingham felt like "a juror bewildered by a mass of conflicting testimony." His comment reminds us that his genre paintings were actually derived from a narrow base of pic-

Claude Regnier, after
George Caleb Bingham,
In a Quandary

1852. Colored lithograph, 14⅝ x 18″ (image)
The Saint Louis Art Museum.
Gift of Dr. Oscar Potter

This colored lithograph was prepared in France by Goupil & Co. for distribution in America. Claude Regnier also did lithographs of The Emigration of Daniel Boone *(1851) and* Canvassing for a Vote *(1851–52). In fact, both* In a Quandary *and* Canvassing for a Vote *were commissioned for the purpose of making lithographs based upon them.*

Claude Regnier, after George Caleb Bingham, *In a Quandary*

Jean-Louis-André-Théodore Géricault, *The Raft of the Medusa*

1818–19. Oil on canvas, 193 x 282"
The Louvre, Paris

During a two-month stay in Paris, Bingham may well have seen Géricault's mammoth painting The Raft of the Medusa. *He would have been struck not only by the size and drama of the picture but by the way the complex asymmetrical grouping reaches its crescendo in the crowning figure. In Bingham's* Jolly Flatboatmen in Port, *which he painted in Germany, the cloth waved by the dancing figure releases the tension of the pyramidal group.*

torial experience. His view of the West was not a worldly view, though it was a personal, specific one. Ironically, Bingham's art may have previously benefited from the artist's not knowing about the gamut of artistic choices open to him.

In addition to the bewildering variety of artistic styles, Bingham was troubled by the vast size of Paris and the difficulty of finding suitable studio space. Thus, in late October, within two months of their arrival in Paris, the Bingham family moved to Düsseldorf, a substantial artistic center but a much smaller city. Bingham's first impression was a positive one. He wrote to Rollins upon his arrival: "Düsseldorf is but a village compared with Paris, or with our large American cities, yet I question much if there can be found a city in the world where an artist, who sincerely worships Truth and nature, can find a more congenial atmosphere, or obtain more ready facilities in the prosecution of his studies."

When he arrived in Düsseldorf, Bingham called upon the American expatriate painter Emanuel Leutze. Leutze had moved to the city in 1841 and enrolled in the Düsseldorf Academy; he remained the pillar of the American artists' colony there until he left in 1858. Though Bingham would later see himself as competing with Leutze, who obtained a commission for a painting in the United States Capitol (*Westward the Course of Empire Takes Its Way,* 1862), he at first recounted that Leutze "received me as cordially as if I had been a brother, and without a moment's delay assisted me in finding a Studio. . . . I shortly obtained

accommodations of the best kind." Eventually, Bingham moved to a larger studio and apartment very near to Leutze's.

Bingham looked to Leutze and the Düsseldorf Academy to complete his artistic education. In that regard, he followed in the footsteps of other American artists who also worked with Leutze in Düsseldorf: Richard Caton Woodville in 1845–51; Eastman Johnson in 1849–51, and Worthington Whittredge in 1849–55. Two artists with strong connections to Saint Louis also preceded Bingham there: Carl Wimar, in 1852–56, and Henry Lewis, from 1853 until his death in 1904. Though no documentary evidence confirms it, Bingham probably knew Wimar and Lewis in Saint Louis, through their panoramas of Western life. He certainly would have seen Lewis in Düsseldorf (Wimar left Düsseldorf to return to Saint Louis shortly before Bingham arrived).

Emanuel Leutze, *Westward the Course of Empire Takes Its Way*

1861. Oil on canvas, 33¼ x 43⅜"
National Museum of American Art,
Smithsonian Institution, Washington, D.C.
Bequest of Sara Carr Upton

Bingham longed to obtain the governmental commission for a painting on the theme of westward expansion, but it went to Leutze instead. The canvas was eventually copied onto the interior of the Rotunda of the United States Capitol.

In 1849, the Düsseldorf Gallery, which displayed works by German artists from the Düsseldorf Academy, opened to critical acclaim in New York. The years of this gallery's existence—from 1849 to 1862—coincide with the period of Düsseldorf's most significant impact on American artists. By the 1860s, Munich and Paris, with their more realistic styles, superseded Düsseldorf as a destination for American artists. The relaxed, rural pace of the city and the small size of its artistic community—some five hundred people—appealed to Bingham. Moreover, the fact that teachers at the Düsseldorf Academy favored one particular style of painting suited his temperament. The Academy promoted a carefully prepared, meticulously finished Romantic-poetic style, which did not entirely exclude genre painting.

Bingham responded positively to Düsseldorf's prevailing artistic style, "which flourishes here by its own inherent vitality," as he wrote in a letter to Rollins on December 14, 1856. He noted in the same letter that the works of the Düsseldorf artists, springing from a "principle of execution so simple and so rational are characterized by a freshness of vigor and truth." In this sympathetic atmosphere, Bingham was eager to start on the George Washington portrait, for which he had executed a small study in Paris. The Jefferson portrait and the possibility of having a Berlin printmaker engrave *The Verdict of the People* were other projects that also occupied him.

The best-known work from Bingham's Düsseldorf period is not, however, a historical portrait but rather the last of his river paintings, *Jolly Flatboatmen in Port* (1857). Both the form and execution of this painting reflect the artist's absorption of a more rhetorical style of pictorial construction. Bingham's earlier paintings of flatboatmen generally featured a spare central motif balanced by a few flanking figures. By contrast, *Jolly Flatboatmen in Port* is off-center in composition, has numerous supporting figures, and opens up to a distant view rather than blocking it. While the title and the poses of the dancing man and auxiliary figures refer to the earlier *Jolly Flatboatmen*, the later work is distinct in style and grander in composition, setting, and size.

In a letter written to Rollins on June 3, 1857, from Düsseldorf, Bingham referred to the work as "a large picture of 'life on the Mississippi.'" This characterization may be helpful in viewing the work less as a river painting and more as an effort by Bingham to broaden his range of vision. In fact, Bingham went on to state his hope that this painting "promises to be far ahead of any work of that class which I have yet undertaken." His intention was to go beyond even the substantial accomplishments of his previous river paintings.

Jolly Flatboatmen in Port is most likely set at the end of the day. The

Jolly Flatboatmen in Port
1857. Oil on canvas, 46¼ x 68⅞"
The Saint Louis Art Museum.
Museum purchase

The central grouping of The Jolly Flatboatmen *(1846)—the boy tapping on a tin plate, the man playing a fiddle, and the dancing figure—has been retained in this painting, but is turned obliquely from the viewer and placed within a more complex composition. The dancing man, now in a more jig-like pose and holding a red cloth in one hand and his hat in the other, prances on the raised section of the flatboat. Like the politicians in Bingham's political paintings, he is both admired and ignored by those who encircle him.*

Jolly Flatboatmen in Port

flatboat, docked at the wharf in Saint Louis, is crowded with boatmen relaxing, dancing, and playing music. Further down the wharf, other flatboats and steamboats are docked beside the brick buildings. The flatboatmen have arrived in an active commercial center, a city far more complex and developed than the settings of the earlier river paintings. As in the architecture of the town in *The Verdict of the People,* Bingham suggests here that the West was reaching a higher stage of civic development. And he may very well have felt that such changes called for a grander style of painting.

The activity at the center of the picture is so lively that men aboard another flatboat have poled over and are about to tie up and join in the festivities. Yet, the scene must also be commonplace, since neither the two businessmen conferring over a document nor the children playing mumble-the-peg seem to notice the raucous merrymaking beside them.

Massing the figures to the left of the canvas, Bingham used the edge of the boat and the line of the dock to open the scene out to a vista of warehouse buildings and wharves. (The urban docks seen here might also relate to those in Bingham's unlocated painting from 1849 entitled *Saint Louis Wharf.*) The asymmetry of the composition, its complex amalgam of nearly two dozen figures, its reach to the soaring crescendo of the dancing figure, and its width of more than five-and-one-half feet suggest complicated new spatial elements and ambitions in the artist's formal vocabulary. Rather than extending Bingham's series of river paintings, however, *Jolly Flatboatmen in Port* is its concluding note, the last fully creative work in this great sequence. As an end point, it re-employs figures—some from more than a decade before—and reuses figure groups and settings from the earlier works.

The painting was intended as a grand statement—an American picture, executed in Europe, which in size and complexity was in the tradition of important European works. It updated the river paintings to more accurately depict antebellum Saint Louis. It achieved those aims, but not without certain costs, to become evident later. As Bingham became more knowledgeable of European art and more conversant with contemporary American modes of painting, he became more attracted to a theatrical rather than a straightforward mode of presentation. Bingham's direct experience of European painting collections had changed him. This picture, his last, transcendent river picture, integrated his past inventions with his aspirations at the time in perfect, complex stasis. It was a point of creative convergence and artistic achievement.

Unfortunately, almost all of Bingham's important portrait commissions—those of Washington and Jefferson, which he painted in Germany, and those of Clay and Jackson, executed in Missouri—were

Thomas Jefferson

1856. Oil on canvas, 25 x 21″
State Historical Society of Missouri, Columbia

To prepare for the Missouri legislature's commission of a full-length portrait of Jefferson, Bingham went to Philadelphia to paint this copy of a Gilbert Stuart portrait. He then sailed for Europe, where he executed his painting for the commission.

Thomas Jefferson

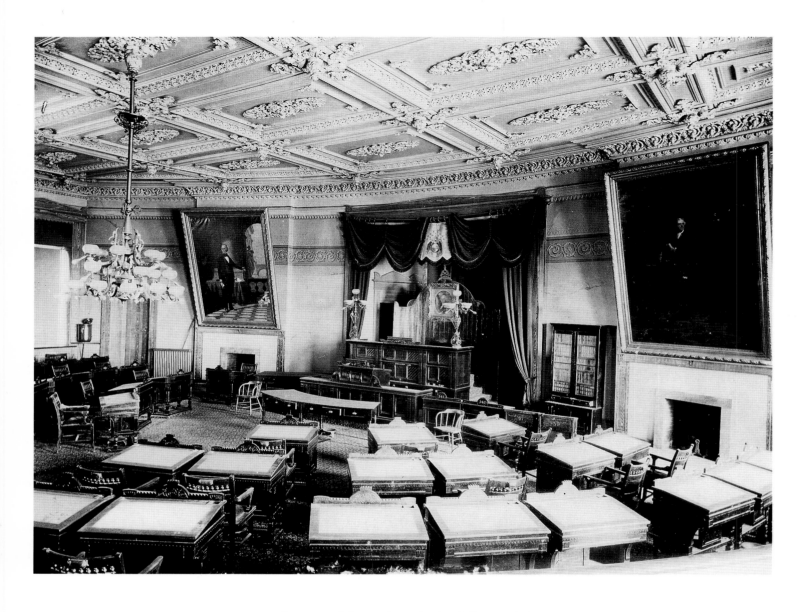

Senate chamber, Missouri State
Capitol Building, Jefferson City
Before 1911. Photograph

This photograph shows Bingham's portraits of Henry Clay (left) and Thomas Jefferson in place in the Senate chamber of the Missouri State Capitol, before the paintings were destroyed in a 1911 fire.

destroyed by a fire at the Missouri State Capitol in 1911. (Similarly, a portrait of Baron Humboldt, commissioned by the Mercantile Library in Saint Louis, was damaged in a fire, with only the head remaining untouched.) From preserved black-and-white photographs of these portraits taken *in situ*, however, it seems clear that by entering the realm of historical portraiture, Bingham had forsaken his earlier vision of depicting anonymous rustic Americans. He was willing, even eager, to realize his aspirations as a history painter and to take a path that built upon his background as a painter of portraits rather than genre scenes. And yet, simultaneously with these official portraits, he was working on the complex, important painting *Jolly Flatboatmen in Port* and even contemplating a version of *The Emigration of Daniel Boone* for the United States Capitol.

By this time, Bingham had learned that Leutze had been encour-

aged to submit a proposal for a painting at the Capitol, and he thought himself a better candidate. He expressed this view in a letter of July 18, 1857, to Rollins: "As there is yet no work of art in the Capitol, properly illustrative of the history of the West, it seems to me that a western artist with a western subject should receive especial consideration from this Committee." But Leutze's *Westward the Course of Empire Takes Its Way* (1862) rather than Bingham's proposal for *The Emigration of Daniel Boone,* would be selected for the Capitol building. In fact, it was the state of Missouri, not the Federal government, that would be Bingham's most important patron in the late 1850s and early 1860s.

Bingham returned to the United States in January 1859 to deliver the portraits of Washington and Jefferson to the Missouri State Capitol in Jefferson City. As Nancy Rash has noted, the paintings appear to have been devised and installed as pendants. In the tense atmosphere of pre–Civil War Missouri, the paintings were clearly antisecessionist; they stood, as the Election series had, for the virtues of union. The two portraits were warmly received by the legislators, and Bingham spent additional time in Jefferson City. Eventually, he obtained fresh commissions for portraits of Clay and Jackson from the Missouri legislature and of the German naturalist Baron Alexander von Humboldt from the Mercantile Library in Saint Louis. Bingham had returned to Düsseldorf by June of the same year.

Shortly after his return to Germany, the Bingham family learned of the death of Eliza's father. They reluctantly cut short their European stay and returned to Kansas City, Missouri, in September 1859 to be near Eliza's family. After coming back to Missouri, Bingham lived in Jefferson City (1862–65), Independence (1865–70), and Kansas City (1870–79), on the western edge of the state. He completed his commissions for the state legislature in his studio in Independence.

Apart from finishing the Jackson and Clay portraits upon his return to Missouri, Bingham also went back to being essentially a portrait painter who worked on commission from the local citizenry. One of the finest portraits of this period is *Dr. Benoist Troost* (1859). The extraordinarily lifelike gaze and genial bearing of the sitter suggest that Bingham was more comfortable painting intimate, less formal portraits than larger, "official" ones. This work, probably done shortly after Doctor Troost's death, is superior to many of Bingham's portraits painted with their subjects seated before him. One wonders whether the artist was freer to work with an absent subject and even whether he was committed to or interested in many of the subjects who sat for him. Bingham's late portraits, he admitted, were painted largely "to make the pot boil," without the intensity of the earlier works.

George Washington

1856–57. Oil on canvas, dimensions unrecorded (life-size)
Formerly in Missouri State Capitol Building, Jefferson City; destroyed by fire, February 7, 1911

This is one of the two original commissions given to Bingham by the Missouri legislature; the other is a portrait of Thomas Jefferson (1857–58).

Henry Clay

1860. Oil on canvas, dimensions unrecorded (life-size)
Formerly in Missouri State Capitol Building, Jefferson City; destroyed by fire, February 7, 1911

Sixteen years after Bingham executed political banners depicting Henry Clay, he was commissioned to paint this full-length portrait. He adopted a traditional oratorical pose for the distinguished senator from Kentucky.

Baron Friedrich Heinrich Alexander von Humboldt

1860. Oil on canvas, 16 x 13½" (restored fragment of original, full-length painting) State Historical Society of Missouri, Columbia

Bingham was commissioned by the Mercantile Library Association in Saint Louis to do a full-length portrait of the German naturalist. Eventually, the painting was cut down, and only this small fragment remains.

Dr. Benoist Troost

1859. Oil on canvas, 40⅝ x 30⅛" The Nelson-Atkins Museum of Art, Kansas City, Missouri. Gift of Board of Education of Kansas City, Missouri, 35–42/1

Bingham depicted Dr. Troost as if the viewer had just come upon him in his study; the doctor looks up from his reading and places his finger in the book to save his place. The owl-like stare of the tight-lipped, jowly sitter adds immediacy to the portrait, as do his fine, curly gray hair and pink cheeks.

Political events, however, would not permit Bingham's career to continue as it had. Though he had followed developments on the local and national political scene while he was in Europe, it was only after he returned to America that he realized fully how explosive and divisive the situation had become. Over the winter of 1860–61, in an atmosphere of impending conflict, Bingham spoke publicly for saving the Union. On June 5, 1861, nearly two months after the Confederate shelling of Fort Sumter, which ignited the war, Bingham noted in a letter to Rollins that "our country, through the luxurious pamperings of prosperity, has become sadly diseased, and is in throes through the effort of nature to

Dr. Benoist Troost

General Nathaniel Lyon and General Francis Preston Blair, Jr. Starting
from the Arsenal Gate in Saint Louis to Capture Camp Jackson

General Francis Preston Blair, Jr.

1871. Oil on canvas, 34¼ x 26½"
The Brooklyn Museum, New York.
Gift of Mr. and Mrs. Abraham M. Adler

This model for a full-length portrait of the Civil War general and successful politician depicts him in a rhetorical and forceful pose—surely about to begin a powerful oration.

General Nathaniel Lyon and General Francis Preston Blair, Jr. Starting from the Arsenal Gate in Saint Louis to Capture Camp Jackson

1862–65. Oil on canvas, 26 x 22¾"
Private collection

This double portrait was painted while Bingham was serving as treasurer of the state of Missouri. In 1863 he received a commission from the state legislature for a full-length portrait of the late General Lyon, whose capture of the secessionist garrison at Camp Jackson had helped steer Missouri toward the Union cause. After the war, Bingham completed the commission, producing an equestrian portrait that was subsequently destroyed in a fire.

regain a healthy condition." That same month, he also wrote, "We are all out of employment, and Art is far below everything else in such times as these. I am ready to turn my attention, for the time being, to any thing by which I can keep from sinking in debt, and secure the bare necessities of life for those who have a right to look to me for support."

Bingham's entrepreneurial and pragmatic spirit led him to seek out sources other than his art for income. By mid-May, he enlisted and was appointed a captain in the United States Volunteer Reserve Corps in Kansas City. In search of steadier employment, Bingham also solicited then-Congressman Rollins, as well as others. By early 1862, even as the nation was at war with itself, Bingham had obtained his first regular employment since serving in the Missouri legislature in 1848–50. He was appointed the state's treasurer by an old friend, Hamilton R. Gamble, who had been named governor of Missouri upon the flight of the pro-secessionist Governor Claiborne Fox Jackson from office. Gamble, like Bingham, was a longtime member of the Whig party. In assuming this

position, the artist moved to the state capital in Jefferson City, where he served out his term until 1865. During this tumultuous period, little painting was done.

One of the few works executed during this period dealt explicitly with a key event leading to Missouri's involvement in the Civil War. *General Nathaniel Lyon and General Francis Preston Blair, Jr. Starting from the Arsenal Gate in Saint Louis to Capture Camp Jackson* (1862–65) depicts military activities between Union forces (represented by Lyon and Blair) and those of the Secession (quartered at Camp Jackson and being rallied by Governor Jackson). The capture of Camp Jackson in May 1861, barely a month after the attack on Fort Sumter, tilted Missouri toward the Union, saved the state from additional warfare, and hastened Governor Jackson's flight from office. The actions of Lyon and Blair led to the naming of Bingham's future employer, Hamilton Gamble, as governor of the state. After General Lyon was killed in action in August 1861, the state legislature enacted a law to commemorate him in an official portrait, which would be placed in the State Capitol. The commission was awarded to Bingham in 1863, and he was undoubtedly working on the small double portrait of Lyon and Blair at the same time he was planning the large formal portrait for the legislature. The official portrait of Lyon was completed two years after the war ended and was destroyed in the 1911 fire in the State Capitol Building. (Unlike Lyon, General Blair went on to a successful political career after the war, and Bingham subsequently recorded him in a full-length portrait in 1871.)

The best-known work of Bingham's late years was painted after the close of the Civil War. *Martial Law* or *Order No. 11* looks back to the ongoing and increasingly lethal border warfare that plagued Missouri in the 1850s and during the war itself. Bingham had had firsthand experience of this danger: his home in Independence was very close to the Kansas border, and both his property and family were endangered by the border warfare.

The specific motivation behind Bingham's painting was an action of Union Brigadier General Thomas Ewing. Intending to put an end to the raids by vandals, known as "Border Ruffians," on families living on the Missouri side of the Missouri-Kansas border, General Ewing issued his Order No. 11 on August 25, 1863. As Nancy Rash has observed, the order was "unforgiving. It called for the immediate dispersal of all citizens living beyond a one-mile radius of Union military posts in the border counties. . . . An exodus began, with elderly men, women and children forced to leave their homes. . . . Within two weeks, the area was a desolate ruin, isolated smoking chimneys the only reminder of the population that had once lived there."

Bingham was enraged that innocent families were being punished and torn from their homes, many of which were looted and burned by the very troops who were charged with protecting families and property. His feelings about the order led him, several years later, to paint a large picture depicting, in Rash's words, "a scene of eviction and exodus on the Missouri border."

Bingham himself described the action of the painting and identified the relationships of its protagonists. The picture divides into two sections. In the left foreground, a young man has been shot by a soldier, who now places the gun back in his holster. A pool of blood flows from the dead man's head. The young victim's wife has thrown herself atop his limp form and rests her head on his chest. With clenched fist and outstretched arm, the victim's gray-haired father attempts to protest, but his daughter and grandson plead with him to restrain himself. The older man's wife has fainted and is supported by a black maid, and another daughter begs for mercy from the soldiers. Behind these figures, raiders loot the house, lowering rugs from the portico and piling clocks and furniture onto the wagon below.

The upper right section of the painting depicts a long line of women and children leaving their homes and carrying their few belongings. The signpost at the far right edge of the painting, reminiscent of the one in *Shooting for the Beef* (which indicated the miles to Boonsboro), states that Lexington, a town on the Missouri River due east of Kansas City, is twenty-eight miles away. While in Bingham's earlier paintings the subjects were involved with westward expansion, now homeless and disillusioned families were journeying in the opposite direction. From Lexington, the families would be transported to central Missouri. Behind this woeful procession and traveling in the opposite direction, a caravan of soldiers carries off its loot. The soldiers and wagons are heading into the distance, where fires smolder and plumes of smoke rise in columns against the blue green sky. In the right foreground, a black man and his wide-eyed son flee. In its depiction of devastation, carnage, and cruelty, *Martial Law* may be seen as the antithesis of those Bingham works extolling the democratic process in the West. Here, the artist attacks the suppression of individual liberties by means of an ad hoc military decree.

While rich in descriptive incident and regional historical interest, *Martial Law* is the most melodramatic work Bingham ever painted. In the portico on the left and the assembled crowd beneath it, Bingham returns to the format of *The Verdict of the People,* but he was more persuasive celebrating the virtues of rural life in the earlier work than translating his personal anger into painting here. As a documentation of human suf-

Martial Law or *Order No. 11*
(second version)

c. 1869–70. Oil on linen tablecloth, 56 x 78 ″
State Historical Society of Missouri, Columbia

Outraged by an 1863 military order which displaced Missouri families living within range of "border ruffians" who attacked from the Kansas side, Bingham set out to depict the effect of this rule on ordinary people. He made two very similar versions of this paint- *ing, which shows a family being evicted. The earlier work—now in the Cincinnati Art Museum—was completed between 1865 and 1868; this is the second version. Bingham is reputed to have said: "I will make this order infamous in history."*

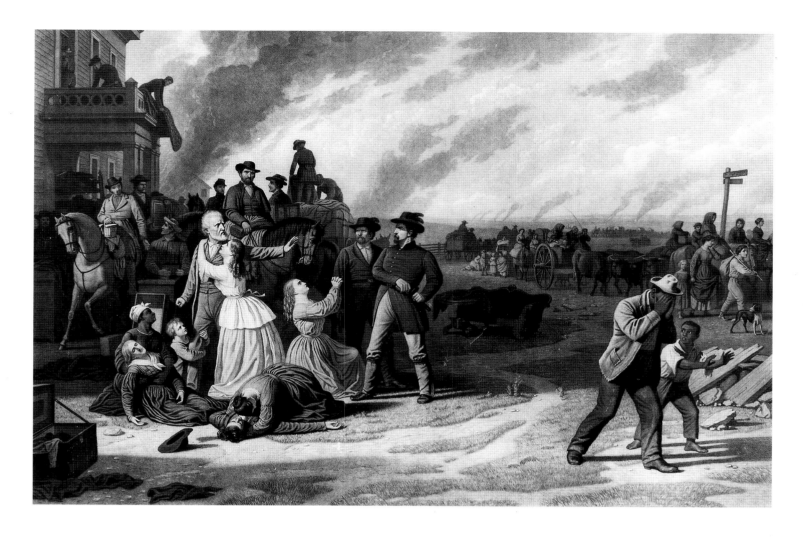

fering and loss, *Martial Law* depicts a nation far different from the one seen a quarter century before, when *The Jolly Flatboatmen* was painted. But just as that work and *Fur Traders Descending the Missouri* focus on earlier periods, so did Bingham, in the years after the war, look back to ponder its sources. As *The Jolly Flatboatmen in Port* depicts Saint Louis in the 1850s as a more highly developed commercial center, so does *Martial Law* faithfully reproduce the divisive nature of family life in western Missouri during the Civil War.

While Bingham was working on *Martial Law*, Major Dean, a Baptist minister in Independence, was imprisoned for refusing to swear allegiance to the Union. This injustice roused the artist's ire and prompted him to paint a work showing Major Dean in his jail cell. Six years after the first version of *Martial Law*, Bingham again traveled to Philadelphia to supervise Sartain's execution of a large engraving of the painting. By disseminating the image widely, he hoped both to gain monetarily and to propagandize his strong feelings on the subject. As he had done with *The County Election*, the artist made a duplicate canvas to assist him in

John Sartain, after George Caleb Bingham, *Martial Law* or *Order No. 11*

1872. Hand-colored engraving, 21½ x 31⅛″ (plate)
National Museum of American Art, Smithsonian Institution, Washington, D.C.
Gift of Francis B. Mays

Sartain's last engraving of a work by Bingham succeeded in disseminating the artist's view of the grim and fractious border warfare then taking place along the western edge of Missouri. This military scene depicts a failure of the system of democratic governance that Bingham's canvases of the 1850s had celebrated.

Major Dean in Jail
1866. Oil over photograph
mounted on paper, $14\frac{1}{2}$ x $14\frac{1}{4}''$
The President's Office, William Jewell College,
Liberty, Missouri

Bingham was moved by what he viewed as the shocking imprisonment of this Baptist minister, who had refused to take an oath of allegiance to the Union because he felt that the word and deeds of a man of the cloth should render that unnecessary. Bingham visited Major Dean in his stone cell in Independence —where he himself was living at the time—and reportedly took this photograph, upon which he painted. Bingham shows the minister calmly reading a book, flanked by the heavily barred window on one side and by his mattress, blanket, and newspaper on the other.

promoting sales of the print, while Sartain worked on his steel plate directly from the original.

Martial Law was the picture that Bingham was best remembered by, at the time of his own death and for many years afterward, and it continued until the 1930's to overshadow his earlier achievements. This may be because it focused on a painful, specific, and well-known episode in Missouri history, because the artist promoted it so vigorously at the end of his life, or simply because it depicted an event that was much more recent than the era of flatboats and rivermen. Many of Bingham's earlier paintings had been distributed to individuals by the American Art-Union and were no longer seen in public. The Mercantile Library in Saint Louis, a private organization, was probably the best place to view Bingham's work in the postwar era; it owned a number of important paintings, including *The County Election* and *Jolly Flatboatmen in Port* (both of which were sold to the Saint Louis Art Museum in 1944).

Although *Martial Law* provides an index to Bingham's ongoing, passionate involvement in questions of moral and legal justice, his commitment to art clearly waned after the war. He continued to hold other appointed political jobs (president of the Kansas City Board of Police Commissioners in 1874, adjutant-general of Missouri in 1875–76), which may have further contributed to his diminished interest in art during his later years. Bingham, who had been so in tune with the highest artistic sensibilities at mid-century, was incapable of remaining at that level from the Civil War onward. One may speculate about the reasons for the qualitative changes in Bingham's work, but this subject is clearly one that needs further study.

The cumulative effect of many factors appears to have paralyzed Bingham's artistic vision. As he grew further away from recollections of the Missouri of his youth, which had steeped his pictures in an elegiac, hypnotic atmosphere, he was increasingly able to paint only rhetorically posed pictures that were firmly rooted in the historical present. In his efforts to achieve recognition as a history painter, to become more of an "official" artist, and to depict the continuing evolution of the West, Bingham moved counter to what we now see as his truest talents. With the decline of the American Art-Union in 1852, Bingham's ability to sell paintings on the East Coast diminished, and by the postwar period, he was largely forgotten in the art world.

Ever since the 1840s and early 50s, when he had achieved acclaim from the American Art-Union for the national character of his genre paintings, Bingham had continued to hope for a major federal commission. While those hopes were to go unrealized, the state government of Missouri had been generous in its patronage. In fact, his portraits for the Missouri State Capitol Building in Jefferson City—Washington (1856–57), Jefferson (1857–58), Clay (1860), Jackson (1860), and General Lyon (1865)—constituted a pantheon of great historical personages. One could persuasively argue that the patronage of the Missouri legislature determined the cast of Bingham's late work as much as the American Art-Union had influenced his earlier paintings. In any event, it is obvious that the paintings for which he is best remembered now occupy a discrete twelve-year period, from 1845 to 1857, flanked by more sustained periods as a portrait artist.

Bingham's later style of historical portraiture deflected him from an original artistic path and committed him to follow a road that other painters had taken before him. The prestige and money from these commissions may have supported him, but they did not utilize his artistic strengths to advantage. Others have thought that his artistic ambition was undermined by the loss of the patronage of the Art-Union in 1852,

View of Pike's Peak

The Puzzled Witness

1874. Oil on canvas, 23 x 28″
Courtesy of Kennedy Galleries, Inc.,
New York

Along with Major Dean in Jail *(1866) and* Order No. 11 *(1869–70), this painting indicates Bingham's increasing interest after the Civil War in questions of justice rather than politics.*

the increasing difficulty in supporting himself by his art, and his failure to obtain the kind of national commission for which he strived. It may well be that Bingham was in an impossible artistic situation: cut off from the East Coast as a source for the sale of his works, he became increasingly absorbed in local issues rather than loftier ones.

Twenty years after he had painted a small group of landscapes, Bingham returned to the format in 1872, when he spent a summer in Colorado for health reasons. (As the 1870s progressed, his failing lungs and weakening health also clearly added to his artistic decline.) One of the pictures from Bingham's Colorado trip, *View of Pike's Peak,* rejects the cozy mood of his earlier landscapes in an effort to present a more heroic vista. Bingham may have been influenced here by the huge landscape "machines" of Albert Bierstadt and Frederick Church, whose monumental, technically dazzling views of both native and exotic settings were an integral feature of post–Civil War American landscape painting. Yet Bingham's landscape evinces a slackening of pictorial tension. The narrative element, centered around a hunter and his dog, is less integrated here than in the artist's earlier work.

Six years after *Martial Law,* Bingham painted his last original genre composition, *The Puzzled Witness* (1874). A late extension of interior genre scenes like *Country Politician,* this painting reflects not only

View of Pike's Peak

1872. Oil on canvas, 28⅛ x 42¼″
Amon Carter Museum, Fort Worth

This is the most complete surviving landscape from the artist's first trip to Colorado in 1872. Although nearly a quarter-century had passed since Bingham had painted his series of views of life along the Missouri and Mississippi rivers, even in this mountain scene he placed his lone hunter on the banks of a river.

James Rollins Bingham

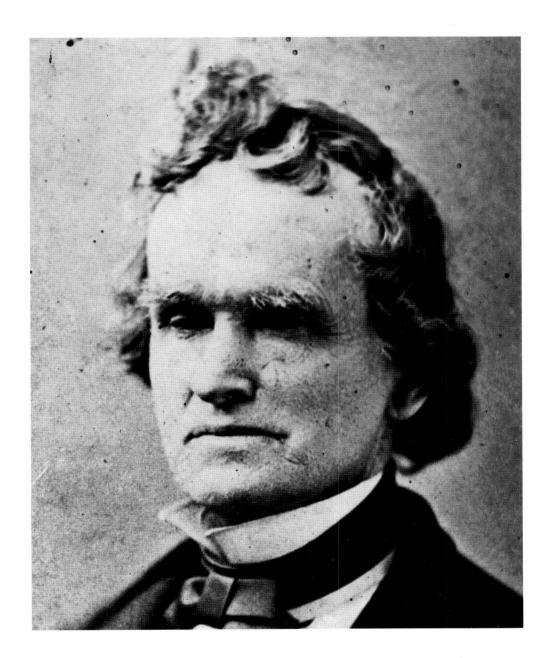

Unknown photographer,
George Caleb Bingham

c. 1870. Photograph
State Historical Society of Missouri, Columbia

In this bust-length photograph, Bingham has aged greatly. His eyebrows—thick and speckled with gray—the crow's feet around his eyes, and the wrinkles on his cheeks and near his mouth indicate his advancing years.

Bingham's long-standing passion for the systems of democratic government but also his own bewildered state. It recalls the artist's description of himself in Paris in 1856, upon seeing the multitude of paintings in the Louvre: "like a juror bewildered by a mass of conflicting testimony, he might find himself staggering in doubt, scarcely knowing whether he inclined to truth or falsehood."

Here, the single witness, stunned by the questioning of the more sophisticated lawyer, holds his hat with one hand and scratches his head with the other. Certain formal elements seen in *The Checker Players* are reprised: men of different walks of life sit at two ends of a simple wooden table, with the defense lawyer placed in the position of the bartender in the earlier painting. Bingham, who had long been interested in the

James Rollins Bingham

c. 1870. Oil on canvas, 27 x 22¼"
Collection Mrs. W. Coleman Branton

The nine-year-old son of the artist by his second wife, Eliza, is freshly and innocently painted. A later photograph of the boy indicates how well Bingham evoked the gentle character of his face.

workings of the law, may have been prompted to commit this interest onto canvas by his appointment in May 1874 as president of Kansas City's Board of Police Commissioners. Bingham's use of his new powers, including the right to close down saloons and gambling parlors, involved him more intimately in the legal system than previously. While he continued to seek out and to paint situations that reflected his moral positions, the results were no longer fully achieved works of art. *The Puzzled Witness,* like *Washington Crossing the Delaware,* suffers from a stiffness of composition and characterization.

The following year, Bingham was appointed adjutant-general of the state of Missouri, a position whose goal was to press Missouri's claims for Civil War restitutions from the federal government. To this end, he traveled again to Washington. In October 1876, Eliza Bingham, who had become increasingly withdrawn, fell seriously ill. Bingham wrote Rollins, "Her derangement exhibits itself in brilliant visions of Heaven, and her departed relatives and friends who are inhabitants thereof. She is certain that her Savior visits her and converses with her, instructing her what to do." Bingham committed his wife to the State Lunatic Asylum in Fulton, Missouri, where she died in November 1876. In June 1878, only a year before his own death, the artist married Martha Lykins in Kansas City. The widow of Dr. Johnston Lykins, a former mayor of Kansas City, Mattie was a friend of the Binghams who operated an orphanage just outside of the city. Along with Mattie, only two of Bingham's five children would survive him: Clara (1845–1901), by his first wife, Sarah, and James Rollins (1861–1910), by Eliza.

In his second, and last, self-portrait (about 1877), we can see the fatigue in the eyes of the artist. Painted shortly after his widowhood and before his last marriage, the portrait depicts Bingham as an artist, with drawing board in hand. He was suffering at the time from his own health problems—a bout of pneumonia in 1874 and a persistent cough. Though Bingham looks very youthful for his sixty-six years, gone are the intensity, determination, and passionate self-containment of the self-portrait of 1835. The year 1877–78 found Bingham in a retrospective mood; not only did he return to the self-portrait as a form, but he also painted a final version of *The Jolly Flatboatmen.* In this work, he combined the group of boatmen from the first version with the dancing figure from *Jolly Flatboatmen in Port,* but the finished painting itself reflects Bingham's own fatigue in its slack execution. Both of these late paintings indicate to what extent Bingham's artistic ambitions and achievements lay behind him. During his last years, he continued to travel from Boonville to Columbia, just as he had as an itinerant portrait painter more than forty years earlier.

The Jolly Flatboatmen
(second version)

1877–78. Oil on canvas, 26 x 36¼"
Daniel J. Terra Collection, Terra Museum of American Art, Chicago, 1.1980

The year before his death, Bingham returned to the subject of riverboats. This version of The Jolly Flatboatmen *combines the structure and arrangement of his 1846 painting of the same title with the dancing figure from* Jolly Flatboatmen in Port *(1857).*

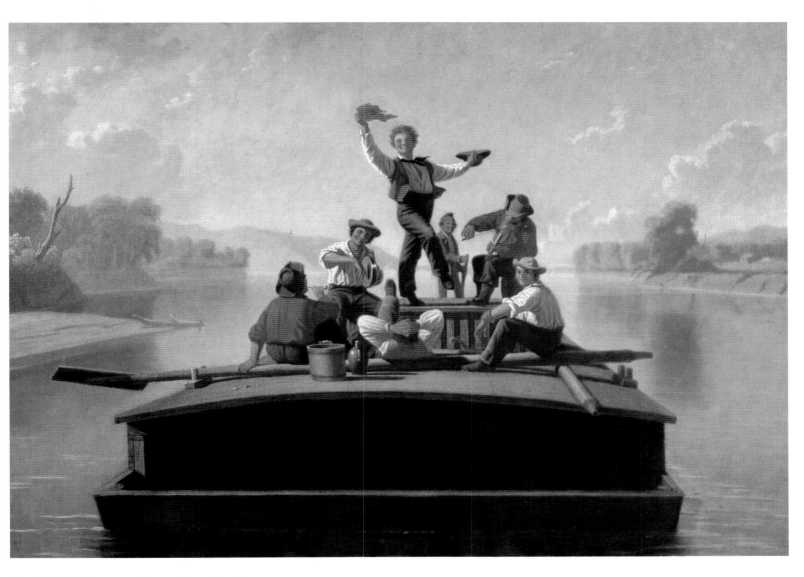

The Jolly Flatboatmen (second version)

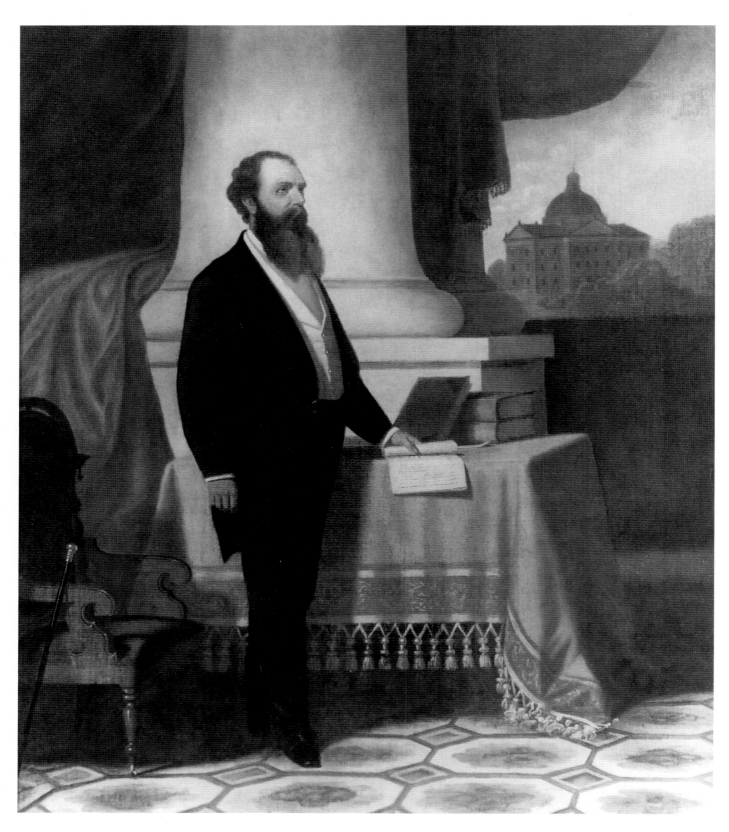

Major James Sidney Rollins

Even his last painting of his great friend and patron Major James S. Rollins represents a slackening of the energy of the earlier portraits. Depicted as a bearded and dignified patriarch, Rollins stands before a massive column, with the main building of the University of Missouri, which he helped to found, in the background. Occasionally a picture like *Palm Leaf Shade* (1877–78), a sunny confection of a painting, comes closer to the mark. But, like many of the late works, it is ultimately marred by a sugar-box sweetness.

In 1877, as a recognition by the state of his artistic achievements, Bingham was appointed the first professor of art at the University of Missouri at Columbia. In 1879, Bingham was to give a speech at the university on his artistic theory; he entitled it "Art, the Ideal of Art and the Utility of Art." Since he was not well enough to deliver the address, Major Rollins did so for him.

Bingham died in 1879, from cholera. Two or three decades had passed since his masterly paintings of life on the Missouri and Mississippi rivers and his highly original works synopsizing the American electoral process. The achievements of the earlier works were largely forgotten and would have to wait until a new century to be remembered.

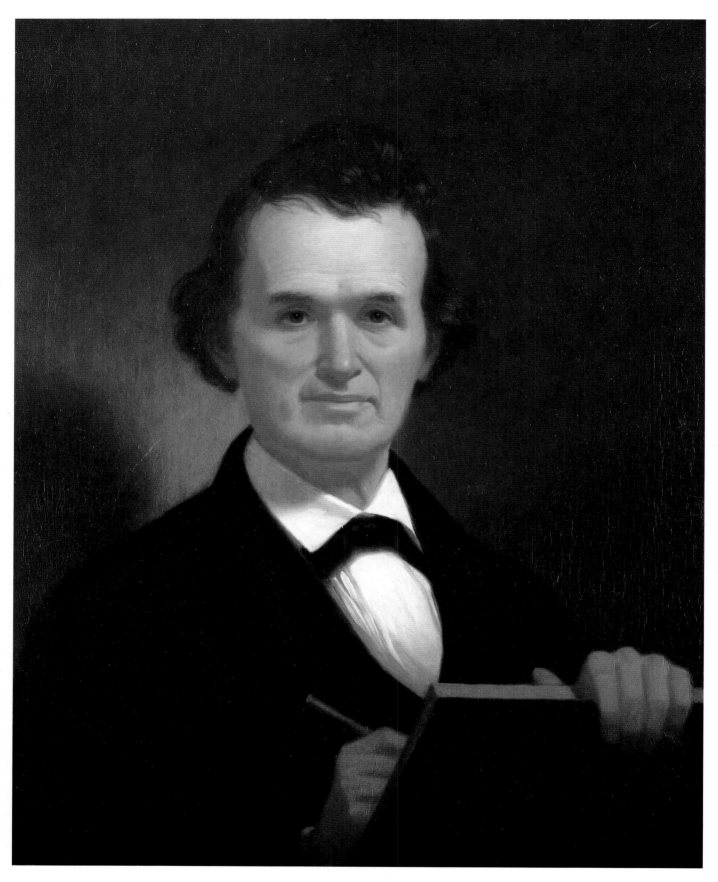

Self-Portrait

V. The Critical Fortunes of George Caleb Bingham

GEORGE CALEB BINGHAM'S JOURNEY OF self-discovery took him from being an itinerant portrait painter in a remote Western state to becoming the creator of paintings of Western life that are as evocative of national characteristics today as they were in 1850. The period of his artistic crystallization—when his vision was freshest and his ambitions highest, enabling him to evolve a heroic view of the commonplace activities of Western life—lasted for little more than a decade. But during those twelve years, from 1845 to 1857, Bingham was clearly the leading painter of the American frontier.

Bingham's career can be divided into three periods: his rise as an itinerant portraitist who became known, as a young man, as "the Missouri artist"; his middle years of national recognition, when his paintings of Western life were distributed by the American Art-Union in New York; and a time of artistic decline from the eve of the Civil War until his death in 1879. During this last period, regional political and military affairs played a more significant role in his life than his art did. The balance between these different roles—artist of Western life, politician, and historian—was constantly shifting throughout his life. While Bingham painted portraits in all three periods, the wide swings in the quality of his work give his overall career as an artist an abrupt and erratic quality. He is not remembered as a portrait painter today, but rather as a genre painter who portrayed the social attributes of the West for a primarily Eastern audience.

For some, Bingham remains a man whose achievement was primarily regional: he recorded the faces of the important Missouri families, and he symbolized and legitimized painting as a profession within the state. To others, he was an important political force in state politics during a turbulent period of Missouri's history. But for most people today, despite Bingham's strong identification with a particular state, he is no longer perceived in regional but in national terms. He is best known as a painter of frontier life when the American frontier was the Mississippi Valley. It may surprise both the art historian and the general reader that Bingham's scenes of Western life are few in number, that they occupy a

Self-Portrait

c. 1877. Oil on canvas, 27⅛ x 22⅛″
Lent by the Kansas City Public Library,
Kansas City, Missouri, to the Nelson-Atkins
Museum of Art, Kansas City, Missouri

More than four decades after completing his extraordinary first self-portrait, Bingham again painted himself. Two years before his death at the age of sixty-eight, Bingham appears far more relaxed and passive than in the 1835 painting. Though he depicts himself drawing, this late portrait has less spirit, energy, and ambition than the earlier canvas.

143

brief period in his life, and that his career was, to use a Freudian term, "conflicted," in his unrealized yearning to be recognized as a history painter, a recorder of great men, issues, and moments. In that regard, the series of portraits commissioned by the Missouri legislature—of relatively little interest to modern eyes—come the closest to fulfilling the artist's own aspirations. These incongruences lead one to ask what were the forces, external and internal, that encouraged Bingham to assume, realize, and then grow away from his role as a primary interpreter of the West.

There are two key segments of Bingham's career—the period when his descriptive and ingratiating depictions of the West spoke to a nation curious about the region, and the twentieth century, Bingham's critical afterlife, when he was perceived as an American master of national consequence. Of central importance to the first segment was the American Art-Union. For most of its existence, the Union encouraged Bingham, and during the height of his career, it bought nearly two dozen of his paintings. More important, the nationalist goals of the Union—to "paint native subject matter" and to "cherish American simplicity and freshness"—helped to steer Bingham into paths that were fruitful for his art. His particular artistic skills, his abiding interest in politics and political structures, his need for a steady means of income, and the reassurance that artists in the East were guided by similar principles—all these factors made the Art-Union an ideal support for Bingham. Through the Union, he was able to produce and sell images of frontier life that pleased those in the West and those in the East alike. When the Art-Union's support stopped, Bingham rarely ever confronted the fresh native subjects or contemporary issues with the success that he had during the years under its influence.

From before Bingham's death until the 1930s, Bingham as an artist tumbled into the depths of critical oblivion. At the time of his death, he was remembered for his political accomplishments and for the late, melodramatic history painting, *Martial Law,* rather than for the paintings we revere today. Many of his finest paintings, now considered to be national treasures, had long since disappeared from view. For approximately half a century, Bingham's name was barely mentioned in surveys of American art. In Missouri, his memory was preserved and nurtured by members of the Rollins family and by others with whom he had been close.

The decline in Bingham's critical fortunes in the late nineteenth and early twentieth centuries can be accounted for by a slackening interest in the homespun character of his rustic scenes. During those years, it was the art of Frederic Remington—Southwestern scenes depicting violent

confrontations between cowboys and Indians—that appealed more to Eastern tastes. Unlike George Catlin in the 1830s or Remington at the end of the century, Bingham was a Westerner who was interpreting his region. In addition, the remoteness of Missouri from the artistic communities on the East Coast was both a positive and a negative factor: it may have lent a special flavor to Bingham's work of the 1840s and 50s, but it also contributed to his later artistic isolation. There were no important examples of Bingham's Western scenes in the important public and private collections in the East. The relative scarcity of his scenes of Western life, the fact that they were completed more than twenty years before his death, and their subsequent disappearance from view within the artist's lifetime, all contributed further to his critical neglect.

George Caleb Bingham may have been the artistic product of the nineteenth century, but the change in his critical fortunes has been so dramatic that one could say he remains the intellectual property of the twentieth century. In the second quarter of this century, his important paintings began to enter public collections, and it is only in recent years that we have begun to place his work into the larger historical context of American art. His importance within the scheme of American art has continued to grow until he, like Thomas Eakins and Winslow Homer, has been accorded the title of American master. Fern Helen Rusk, who wrote the first serious monograph on the artist in 1917, stated in an article published in 1954: "Since I published my monograph on Bingham thirty-seven years ago, 'the Missouri Artist,' quite forgotten in 1917, has become as popular as he was in his own day." And the subsequent years have seen the appreciation of Bingham's talent grow further still.

In the 1930s, the Regionalist painters (Thomas Hart Benton, Grant Wood, and John Steuart Curry) based their representational style on indigenous American subjects. In their own way, during the Depression years, they attempted to redirect American art toward reassuring rural subjects. Their work and ambitions (including the rejection of "high" European art) cast a new light on Bingham's paintings. For Benton, Bingham had a very personal meaning. Not only was he a fellow Missourian who had lived and worked in both Independence and Kansas City, near Benton's own Kansas City studio, but more significantly, his work seemed to legitimize the rural themes of Benton's own painting. Benton became an outspoken, albeit self-serving, advocate for the reappraisal of Bingham.

During the Depression years, regional cultural institutions like the Saint Louis Art Museum and the Nelson-Atkins Museum of Art in Kansas City began to see Bingham's work as an important part of their local patrimony. Such institutions actively began to collect and exhibit his paint-

ings and to publish on his career. This revival of local faith in Bingham, which had remained relatively dormant for so many years, coincided with a national willingness to review his accomplishments. Both trends united during the Depression to propel him from relative obscurity to the front ranks of American artists.

In 1933, the Metropolitan Museum of Art in New York purchased one of Bingham's finest paintings, *Fur Traders Descending the Missouri*. The following year, an exhibition of twenty Bingham paintings was organized by the Saint Louis Art Museum. This exhibition presented such a fresh and relevant view of America that it traveled to the Museum of Modern Art in New York in 1935. This museum was an unusual, even strange, venue for the first cross section of Bingham's paintings ever to be seen in the East, and its acceptance of the exhibition underscored Benton's idea that there was an art-historical connection between the Regionalist painters and earlier American models. This connection now seems slim, and its comparison of Bingham and twentieth-century artists actually delayed a close appraisal of the real historical context in which Bingham operated. Just as the Apollo Association and the American Art-Union encouraged Bingham in the 1840s to address an Eastern audience, the Museum of Modern Art exhibition influenced subsequent Eastern views of Bingham. It is ironic that, in their own ways, two New York institutions would have such a profound and distinct impact upon "the Missouri artist" and his career.

Journalist Marquis W. Childs, in an article inspired by the Bingham exhibition at the Museum of Modern Art, noted, "For the first time a serious effort has been made to assemble a representative collection of the work of this forgotten American painter. Now that his work has been dusted off and cleaned up, it is difficult to understand why this painter was so long neglected. For it would seem that merely as a record of a peculiarly fascinating phase of the past his work should have held attention. But perhaps it was necessary to be removed from that phase by a certain number of decades before this was apparent. And possibly a shift in taste had to occur that we might outgrow a prejudice against paintings that seemed 'old fashioned.'" Childs also cited the rediscovery of the prints of Currier and Ives as evidence of a new twentieth-century attitude toward nineteenth-century rural American subjects. Suddenly, the "old fashioned" painting of the late nineteenth century seemed "modern" fifty years later.

The exhibition at the Museum of Modern Art was curious, perhaps even harmful, in its attempt to make Bingham "modern." While Bingham's work obviously appealed to contemporary eyes, little effort was made to understand the environment from which it came. This exhi-

bition may have deterred the kind of scholarship that is now finally under way—a scholarship that places Bingham and the forces that acted upon him in a more appropriate historical context.

Benton restated his theory of a bond between Bingham and the Regionalist enterprise in his introduction to Albert Christ-Janer's monograph of 1940 (and again in his 1972 preface to Christ-Janer's second book on Bingham, which was published in 1975). The publication of the Bingham-Rollins correspondence by the *Missouri Historical Review* in the late 1930s added an important building block to the growing edifice of Bingham scholarship.

Most of the books since Fern Helen Rusk's monograph of 1917 have emphasized Bingham as "the Missouri artist." This was the subtitle of the 1935 exhibition in New York, and a similar subtitle was used in Christ-Janer's first book. The appellation was current by 1840 as a sign of local pride; its revival in the twentieth century both acknowledges Bingham's place as the most important nineteenth-century artist from Missouri and underscores his deep connections to a specific region.

Much of the Bingham scholarship in the half century since the 1935 exhibition has involved the codification of his work. When Rusk wrote the first monograph on Bingham, many of the paintings she described were unlocated and the existence of some of these was based on speculation. With increasing regularity, from the thirties through the fifties, important paintings reappeared. For instance, these are the years in which some of Bingham's genre paintings entered public collections: *Fur Traders Descending the Missouri*, 1933; *Raftsmen Playing Cards*, 1934; *The County Election*, 1944; *The Concealed Enemy*, about 1945; *Western Boatmen Ashore by Night*, 1948; *The Trapper's Return*, 1950; *The Wood-Boat*, 1951; *Playing Checkers*, 1952; *Canvassing for a Vote*, 1954; *The Jolly Flatboatmen*, 1954; *The Squatters*, 1956; and *Belated Wayfarers*, 1958.

The return of many of Bingham's key paintings to public view was celebrated by the publication of E. Maurice Bloch's catalogue raisonné in 1967 and a traveling exhibition that took place the same year. With the appearance in 1986 of Bloch's revised catalogue, more than four hundred pictures have been thoroughly catalogued. It may be, however, that rediscovering Bingham's *oeuvre* has been more quickly accomplished than understanding his work and its implications. We now find ourselves in the "synthetic" phase of Bingham studies, in which scholars are knitting the artist into the larger pattern of American cultural history and more deeply probing the original meanings of his works. The present revival of interest in nineteenth-century American genre painting promises to continue to advance our understanding of Bingham.

Since the current state of Bingham studies is robust, it is now an

opportune time to reflect upon the artist's overall story, to view his life and works as an index of present attitudes and possibly as a blueprint for future areas of inquiry. It is to be hoped that the years ahead will see the reappearance of some of the pictures still missing from the artist's *oeuvre*. At the same time, forthcoming studies on the contextual aspects of Bingham's genre, landscape, and portrait work will certainly emphasize the diverse social and political meanings of his paintings. Just as important, a clearer view of the determined, pugnacious, ethical, political man who was George Caleb Bingham will also come into focus. We need to better understand the personality and character of "the Missouri artist" who, more than a century after his death, has been firmly elevated to the stature of an American master.

Chronology

1811	Born in Augusta County, Virginia, on March 20, the second child of Henry Vest Bingham and Mary Amend Bingham.
1819	During the summer, journeys west with family to Franklin, Missouri.
1820	Observes Chester Harding completing a portrait of Daniel Boone.
1821	Father buys a farm near Arrow Rock, Missouri.
1823	Death of father brings financial hardship upon the family.
1825	The family moves from Franklin to Arrow Rock.
1828	Lives in Boonville, Missouri, as an apprentice to a minister and carpenter. Witnesses an unidentified itinerant portrait painter and begins to paint portraits.
c. 1828–30	Paints a signboard (unlocated) for a tavern.
1834	Paints portraits of Doctor and Mrs. Sappington, earliest surviving works. Meets James S. Rollins in Columbia, Missouri, and the two begin a lifelong friendship.
1835	Travels in the spring to Saint Louis in search of portrait commissions.
1835–36	Stays in Saint Louis over the winter.
1836	Marries Sarah Elizabeth Hutchison in Boonville in April.
1837	Son Newton is born in March.
1838	Lives in Philadelphia from March to June and probably visits the annual exhibition at the National Academy of Design in New York. Submits a painting entitled *Western Boatmen Ashore* (unlocated) to the inaugural exhibition of the Apollo Gallery, New York.
1840	Submits six paintings (all unlocated) to the annual exhibition of the National Academy of Design. Attends the Whig convention in Rocheport, Missouri.
1840–44	Lives with his family in Washington, D.C.
1841	Newton dies in March, and second son, Horace, is born the same month.
1844	Returns to Missouri from Washington in March. Paints banners for the Whig convention in Boonville.
1845	Daughter Clara is born. Submits four paintings, including *Fur Traders Descending the Missouri,* to the American Art Union; all four are purchased by the Art-Union and distributed to its members at the group's annual lottery.
1846	Campaigns for state legislature from Saline County, Missouri, and is narrowly defeated by Erasmus Sappington in a disputed election. *The Jolly Flatboatmen* is purchased by the American Art-Union.
1848	Participates in the Whig convention in Boonville. Defeats Erasmus Sappington and is elected to represent Saline County in the state legislature. Wife, Sarah Elizabeth, dies

in November in Arrow Rock. Infant child, Joseph, dies in December.

1849	Marries Eliza K. Thomas in Columbia, Missouri.
1851	Mother dies in Arrow Rock.
1852	Attends the Whig convention in Baltimore.
1853	Spends the winter in Philadelphia supervising John Sartain's work on the engraving of *The County Election*. Begins the painting *Stump Speaking* in Philadelphia during the same period.
1856	Is commissioned by the Missouri state legislature to paint full-length portraits of George Washington and Thomas Jefferson. Travels to Paris with his wife and daughter in late summer. Family relocates to Düsseldorf by November 1.
1857–58	Remains with family in Düsseldorf.
1859	Returns alone to United States to deliver Washington and Jefferson portraits Receives new commissions from the legislature for portraits of Clay and Jackson and from the Mercantile Library, Saint Louis, for a portrait of Alexander von Humboldt. Returns with family to Missouri upon father-in-law's death.
1860	Delivers portrait of Humboldt to the Mercantile Library.
1861	Delivers his portraits of Clay and Jackson to the state legislature. Son James Rollins is born.
1862–65	Serves, by appointment of the governor, as treasurer of the state of Missouri. Lives in Jefferson City, the state capital, during this period.
1865	Begins *Order No. 11* in response to General Thomas Ewing's decree of August 25, 1863, and its consequences.
1871–72	Stays the winter in Philadelphia, supervising Sartain's engraving of *Order No. 11*.
1874	Is appointed president of the Kansas City Board of Police Commissioners.
1875	Is appointed adjutant-general of Missouri by the governor.
1876	Wife, Eliza, suffering from a mental disorder, is institutionalized in Fulton, Missouri, and dies there on November 3.
1877	Is appointed the first professor of art at the University of Missouri.
1878	Marries third wife, Mrs. Martha Livingston Lykins, in Kansas City.
1879	Ill with pneumonia in February, is unable to deliver lecture on art at the University of Missouri. Dies of cholera on July 7 and is buried in Union Cemetery, Kansas City.
1893	Estate is sold at Findlay's Art Store, Kansas City.
1910	First retrospective exhibition of Bingham's work is held at the University of Missouri, Columbia.
1917	First monograph on the artist, by Fern Helen Rusk, is published.
1933	The Metropolitan Museum of Art in New York acquires *Fur Traders Descending the Missouri*.
1934	The Saint Louis Art Museum organizes an exhibition of the work that travels to the Museum of Modern Art, New York, in 1935.
1940	Albert Christ-Janer's monograph, with a preface by Thomas Hart Benton, is published.

<table>
<tr><td>1967</td><td>E. Maurice Bloch's two-volume catalogue raisonné appears. A retrospective exhibition travels to Washington, D.C., Cleveland, and Los Angeles.</td></tr>
<tr><td>1986</td><td>A revised, single-volume edition of E. Maurice Bloch's catalogue raisonné is published.</td></tr>
<tr><td>1990</td><td>Exhibition organized by the Saint Louis Art Museum travels to the National Gallery of Art, Washington.</td></tr>
</table>

Selected Bibliography

Primary Sources

BINGHAM, GEORGE CALEB. "Art, the Ideal of Art and the Utility of Art." Public Lectures Delivered in the Chapel of the University of the State of Missouri, Columbia, Missouri, by Members of the Faculty. 1878–79. Course II, vol. 1, pp. [311]–24. Columbia, Missouri: Statesman, 1879. This public address, written by Bingham shortly before his death, was delivered by his lifelong friend and mentor James Sidney Rollins.

ROLLINS, C. B., ed. "Letters of George Caleb Bingham to James S. Rollins." *Missouri Historical Review* 32 (October 1937–July 1938): 3–34, 164–202, 340–77, 484–522; 33 (October 1938–July 1939): 45–78, 203–29, 349–84, 499–526. These selected and edited letters from the State Historical Society in Columbia, Missouri, are fundamental primary source materials on Bingham's life and work.

Books

RUSK, FERN HELEN. *George Caleb Bingham: The Missouri Artist.* Jefferson City, Missouri: Hugh Stevens Company, 1917. Originally a master's thesis, this slim volume helped initiate the rediscovery of Bingham in this century and began the process of codifying his work.

CHRIST-JANER, ALBERT. *George Caleb Bingham of Missouri: The Story of an Artist.* New York: Dodd, Mead, 1940. Thomas Hart Benton's preface to this book identified Bingham as the model for the Regionalist painters.

MCDERMOTT, JOHN FRANCIS. *George Caleb Bingham, River Portraitist.* Norman: University of Oklahoma Press, [1959]. This book was the first to include illustrations of Bingham's drawings, then in the collection of the Mercantile Library in Saint Louis and now administered under the auspices of the Bingham Trust.

BLOCH, E. MAURICE. *George Caleb Bingham: The Evolution of an Artist* and *A Catalogue Raisonné.* 2 vols. Berkeley and Los Angeles: University of California Press, 1967. These two volumes consist of an overview of Bingham's career, with an emphasis on his artistic sources, and a catalogue raisonné.

———. *The Drawings of George Caleb Bingham: With a Catalogue Raisonné.* Columbia: University of Missouri Press, 1975. Bloch's catalogue of the drawings—an important but relatively little studied aspect of the artist's work—leaves much room for further scholarship.

CHRIST-JANER, ALBERT. *George Caleb Bingham: Frontier Painter of Missouri.* New York: Harry N. Abrams, Inc., [1975]. This is the second book on Bingham by Christ-Janer and the second with a preface by Thomas Hart Benton, Bingham's fellow Missouri painter.

BLOCH, E. MAURICE. *The Paintings of George Caleb Bingham.* Columbia: University of Missouri Press, 1986. This volume significantly revises and expands the 1967 catalogue raisonné. Nearly all the artist's paintings are illustrated in this helpful work.

SHAPIRO, MICHAEL EDWARD, et al. *George Caleb Bingham.* New York: The Saint Louis Art Museum in association with Harry N. Abrams, Inc., 1990. This catalogue of essays by five art historians—Barbara Groseclose, Elizabeth Johns, Paul Nagel, Michael Shapiro, and John Wilmerding—accompanied the exhibition of Bingham's work at the Saint Louis Art Museum and the National Gallery of Art in 1990.

JOHNS, ELIZABETH. *American Genre Painting: The Politics of Everyday Life.* New Haven: Yale University Press, 1991. The author places Bingham in the broader sweep of American genre painting during the mid-nineteenth century.

RASH, NANCY. *The Paintings and Politics of George Caleb Bingham.* New Haven: Yale University Press, 1991. Rash's book bases its revealing new readings of Bingham's paintings on a deep understanding of Whig politics.

Articles

BLOCH, E. MAURICE. "The American Art-Union's Downfall." *New-York Historical Society Quarterly* 37 (October 1953): 331–59. Using the records of the New-York Historical Society, Bloch was able to piece together the sorry and rather sordid tale of the end of the Art-Union.

MCDERMOTT, JOHN FRANCIS. "George Caleb Bingham and the American Art-Union." *New-York Historical Society Quarterly* 42 (January 1958): 60–69. McDermott was the first to recognize the fundamental role that the Art-Union played in Bingham's career.

DEMOS, JOHN. "George Caleb Bingham: The Artist as Social Historian." *American Quarterly* 17 (1965): 218–28. This prescient article stimulated later work on the sociology of Bingham's West.

GROSECLOSE, BARBARA S. "Painting, Politics, and George Caleb Bingham." *American Art Journal* 10 (November 1978): 5–19. Drawing upon knowledge of Bingham's involvement in Whig politics, Groseclose's article opened the way for subsequent new interpretations of his political paintings.

LIPTON, LEAH. "George Caleb Bingham in the Studio of Chester Harding, Franklin, Missouri, 1820." *American Art Journal* 16 (Summer 1984): 90–91. This article published an important letter by Bingham that recollected his youthful encounter with Harding.

ADAMS, HENRY. "A New Interpretation of Bingham's *Fur Traders Descending the Missouri.*" *The Art Bulletin* 65 (December 1984): 675–80. Adams's article proposed that *The Concealed Enemy* and *Fur Traders Descending the Missouri* were pendant paintings intended to indicate primitive and civilizing states of Western settlement.

Photograph Credits

Index